ART AGAINST WAR

ART AGAINST WAR

D.J.R. Bruckner Seymour Chwast Steven Heller

400 Years of Protest in Art

Abbeville Press · Publishers · New York

PRODUCER:
Steven Heller
DESIGNER:
Seymour Chwast
ASSOCIATE DESIGNER:
Michael Aron
EDITOR:
Walton Rawls
ASSOCIATE EDITOR:
Lita Telerico

COVER
Never Again! *John Heartfield.*
1960. Poster. (ADK)

BACK COVER:
Blind Power. *Rudolf Schlichter.*
1937. Oil on Canvas. (BG)

*Library of Congress Cataloging in
Publication Data*

Bruckner, D. J. R.
 Art against war.

 Bibliography: p. 127
 Includes index.
 1. War in art. 2. Art. I. Chwast, Seymour.
II. Heller, Steven. III. Title.
N8260.B74 1984 704.9′499047 83-6342
ISBN 0-89659-389-4 (pbk.)

ACKNOWLEDGMENTS

In order to compile *Art Against War* we
asked many individuals to help us—most gave
generously of their time and encouragement.
Our heartfelt thanks go to the following:

Thanks to Lita Telerico and Michael Aron,
without whose patience and hard work *Art
Against War* never would have been com-
pleted. To Walton Rawls, our editor, who pro-
vided us with good advice and inspiration.
Also at Abbeville: Robert Abrams and Howard
Morris. Much gratitude goes to Reid Maki,
our research assistant in San Francisco, Theo
Wohlfahrt, our research assistant in London,
and Jennifer Rezucha, our research assistant
in Paris. Thanks to Edward Spiro, who photo-
graphed many of the pieces used in the book,
and to J. Martin Natwig and William H.
Smith, who also photographed for us. And
special thanks to Sarah Jane Freymann, our
literary agent.

During the research process we approached
many institutions whose directors and cura-
tors cooperated by allowing us to borrow
works, photograph material in their collec-
tions, and by answering our numerous queries.
Of these Dr. James Fraser and Reneè Weber
in the library at Fairleigh-Dickinson Univer-
sity (Florham-Madison Campus) and J. Rich-
ard Kyle of the Swathmore Peace Collection
provided invaluable assistance—we are in their
debt. At Fairleigh-Dickinson, which houses
one of the most extensive collections of satiri-
cal, cartoon, and poster art documentation,
we used the Richard S. Wormser Collection,
The Harry "A" Chesler Collection, The Wil-
liam A. Hughes Collection, and The Outdoor
Advertising Association of America Archives.
At Swathmore we had free access to all of
their peace-oriented collections. Also open to
us was the peace poster collection at the
Hoover Institution for War and Peace Studies,
at Stanford University. Further thanks go to
Mark Rogovin, director of the Peace Museum,
Chicago; Martha Heintz, the Fogg Museum,
Harvard University; Caralotta J. Owens, the
National Gallery of Art, Washington, D.C.; Dr.
Friedrich W. Heckmanns, the Kunstmuseum,
Dusseldorf; Maebetty Langdon, the Art Insti-
tute of Chicago, Dale K. Haworth, Carlton
College Collection; Sara Paulson, the Whitney
Museum of American Art, New York; Gisela-
Ingeborg Boulduan, Berlinische Galerie,
Basel; Evelyn Torres, VAGA (Visual Artists
and Gallery Association), New York; and
Cecil Coutin, Musée des Deux Geurres Mon-
diales, Paris. Thanks to The Museum of Mod-
ern Art, The Metropolitan Museum of Art,

The Kunstverein in Hamburg, The Prado Mu-
seum, and, of course, thanks to the New
York Public Library for making their valuable
collections accessible.

Many of the galleries we contacted were
very interested in the project as well. Thanks
to: Jane Kallir, director of the St. Etienne
Gallery, New York; Ronald Feldman, director
of the Ronald Feldman Gallery; Lee Naiman
of Lee Naiman Fine Art; The Allan Frumkin
Gallery, New York; The O.K. Harris Gallery,
New York; The Castelli Gallery, New York;
The Pace Gallery, New York; La Boetie Gal-
lery, New York; and the Kennedy Galleries,
Inc., New York.

A few private collectors lent us much-
needed materials: Special thanks to Ben
Goldstein, who generously opened his massive
collection of graphics, posters, and political
journals to us, and for his thoughtful and
helpful suggestions. Thanks to Jeff Rund, Net-
tie Lobsenz, and Pat and Phil Cornelius.

We contacted a number of contemporary
artists and received many fine pieces. Regret-
tably space was tight and some were not
used. We are grateful to all the artists who
contributed or submitted their work for con-
sideration: Robert Osborn, Hans Erni, Nancy
Reddin Kienholz, Edward Kienholz, Chas. B.
Slackman, Alan Cober, Rudolf Baranik, Leon
Gulub, Nancy Spero, Michael Biddle, Fritz
Eichenberg, Antonio Frasconi, Eugene Mi-
haesco, Edward Sorel, Brad Holland, Gunter
Grass, Roland Topor, Lou Myers, Tomi Un-
gerer, James McMullan, Robert Andrew
Parker, Milton Glaser, and Jurgen Waller.

Others who offered their support in a vari-
ety of ways are: Marilyn Recht, Nina Felshen,
Cathryn Schwing, Michael Flint, Shari Kasch,
Szymon Bojko, Walter Herdeg, Dascine
Rainer, Kevin Gatta, Caroline Genesi, Martin
Moskof, Nonie Locke, John Locke, Roger
Law, Kathinka Dittrich, and Ira Nerkin.

One last note: For this project we consulted
numerous books (listed in the Bibliography),
but special mention should be given to Ralph
E. Shikes' *The Indignant Eye*, the best con-
temporary reference book on the subject of
protest and satirical art.

CONTENTS

Der Krieg. *Alfred Kubin. 1918. Etching and aquatint.* (FDU).

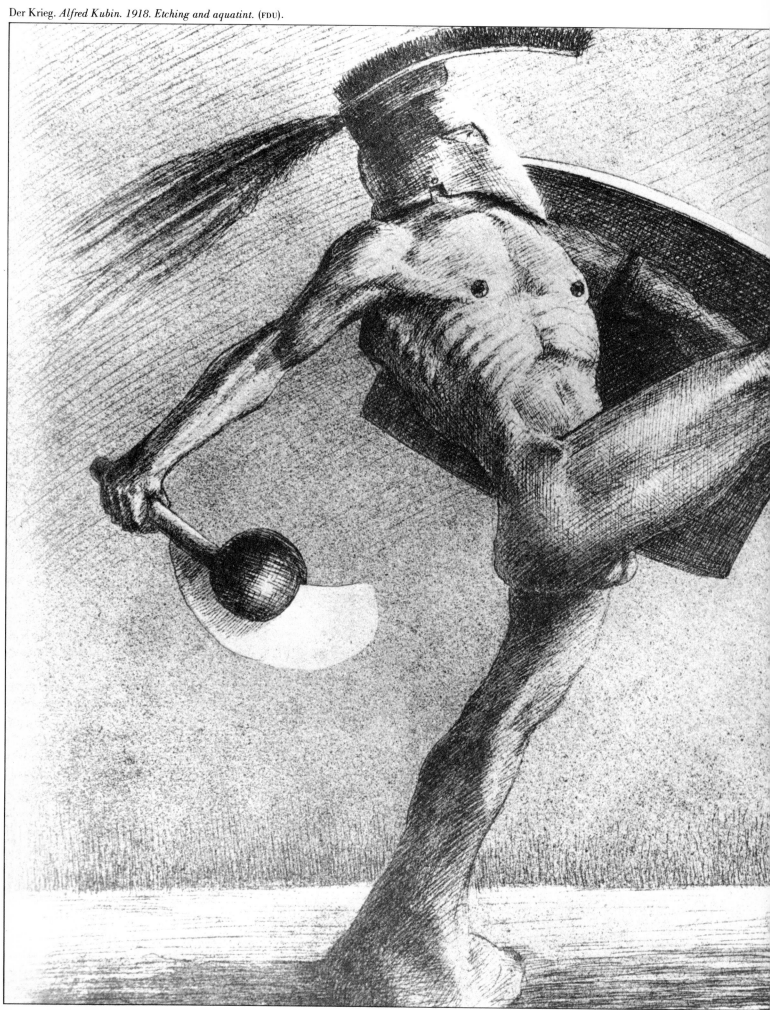

PREFACE

Art Against War is a survey of antiwar art from the past four centuries. It is not a history, political or otherwise, but an attempt to show how different practitioners in the visual arts—the well known, the respected, and the obscure—have criticized warfare. Don Bruckner has written a text about the pictures and a general introduction. Seymour Chwast and I chose the art from various private, library, and museum collections. Since the scope of this subject exceeds the space here, we have selected what we believe are among the most striking, acerbic, and well-crafted images in an arsenal of iconographic ordnance stocked from the beginning of the seventeenth century to the present. There is a lot to choose from, and selection has not been easy. We looked first for artistic merit, originality, and clear articulation of a point of view. Some pieces that may not stand up in all these areas are included for reasons discussed in the captions or text. We have organized the pictures roughly in chronological order (there are, of course, long periods when nothing of merit on the subject was produced), and selected them from several categories: antiwar art, in which war is overtly depicted as dreadful; antimilitarist art, which focuses on the makers of war; and personal art where war is depicted in a more intimate manner. We left out very obscure abstract art, because of its lack of clarity on the theme. We have tried to keep the ubiquitous symbolic and allegorical clichés—so endemic to this art—to a minimum. Many forms, styles, and media are represented, including painting and sculpture, prints and posters, illustration and cartoons, and we have included stills from significant films, plays, and dances. Expressionistic works stand beside more stylized ones if the sentiments are heartfelt or the message is communicated with great force.

Most of the work here comes from Europe, Russia, the United States, and Japan, and from different periods in each case. It is very difficult to find images from Asia, Africa, the Middle East, and South America from any period that are clearly antiwar. We have also omitted official, nationalistic, and propagandistic arts: images that foster hatred against an enemy or support any particular war, no matter how justified we may think it was. For the same reason we have left out civil wars and revolutions. In fact, the majority of work here represents reactions to wars between nations in which large civilian populations were the ones killed. Many of the most striking works here were produced after these conflicts ended.

Art Against War is a reminder that war is an all too often recurring theme in art, and that, moreover, if there is another world war there will be no art.

Steven Heller

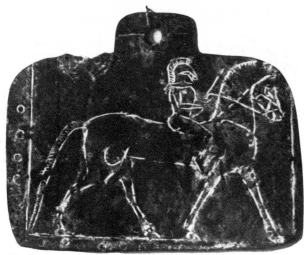

INTRODUCTION

Where does it come from? Art that specifically protests against war is an oddity in the tradition of art. People now are so familiar with it, in cartoons, posters, and movies—and it has been used by so many movements for different reasons—that there may be an assumption it is ordinary. The war god in Henri Rousseau's painting—a being almost sublime and tranquil—is not unfamiliar, and Pablo Picasso's *Guernica*, which is accepted everywhere as a protest against war, is the most famous painting in the world. Käthe Kollwitz's 1924 picture of a defiant youth bears the legend of a peace movement in Germany that is long forgotten while her picture remains celebrated. Most people are unaware that its legend—"war never again," which was the slogan Pope Paul VI used before the United Nations twenty years ago, was the trademark of that peace movement. One would have to be fairly blind not to know Robert Osborn's atomic bomb as a death's head, and in Europe Duane Hanson's polyester dead and mauled soldiers in his 1967 statuary assemblage in Germany's Lehmbruck Museum are as famous as many monuments. People everywhere have seen versions of Tadeusz Trepkowski's "Never," a bomb that contains the city it destroys.

Art against war has a history. It did not begin with Goya or even with Callot. And the images it uses have a longer history than the art. One day a historian of ideas ought to set it all down. Until then, a suggestive sketch might be useful for people looking at pictures in this book.

Art against war is obviously not art for art's sake, but its utilitarian purpose does not mean it is commonplace. In fact its tradition is not continuous; as an aspect of the whole range of art it is extraordinary, and usually it is quite personal. It is always occasional; the denunciation of war is seldom a theme exploited by the unthreatened. Goya's pictures of the horrors of war would alone justify his fame; but he did many other things in his life, and no school of antiwar artists sprang up to imitate him. Between the two world wars Kurt Jooss, the choreographer, profoundly articulated the stupidity, self-deception, sorrow, and menace of people involved in war, in his ballet *The Green Table*. It is ironic that, after he and his dancers fled Germany when the Nazis ordered him to dismiss the few Jews in his company, he was detained in England as an enemy alien for a time. And events silenced his message for a decade: he had no motivation for opposing the Allies' prosecution of World War II. Since then, for whatever reasons, no choreographer has so passionately expressed what Jooss did in *The Green Table*. Art against war has been a chancy business.

The subject matter of antiwar art is also less a common posses-

sion than that of most art. The common themes one can identify in it tend to disappear from art for generations or to turn up only in other guises. That lack of continuous development has tended to keep the symbolism of antiwar art relatively simple. There is, of course, a rich tradition of the images of peace in art: swords being turned into plowshares, the lion lying down with the lamb, and many others. One would have to write a whole library to trace the imagery of peace in Chinese art alone. But the idea of a peaceful kingdom is not an argument against war in any culture. Most often the kingdom, even a spiritual one, was achieved by a war well fought. The image of the untroubled paradise dominates cultures that make war a cult, holy or otherwise—in ancient Asian and more modern Moslem cultures, for instance.

Paradise stands at the head of the Hebrew tradition as well, not as a dream achieved but as a reality lost through personal evil. As the tradition developed, paradise was lost through the agency of the prince of devils who had lost heaven through personal evil and who was always at war with good after his fall. Some of the most memorable art in the Christian era that speaks to those scriptures shows St. Michael the Archangel as a warrior defeating Satan. It is true that, as early as the Book of Leviticus, one finds war cited as a punishment for human wickedness; but, in the Hebrew tradition, that idea was not developed much until the very late writings of the prophets, and it was not developed very far even there. Otherwise in the Western world before the Christian era it is difficult to find even that spare notion of war as something fundamentally wrong, or even as an event to be avoided at all costs except extinction. To most of the ancients even extinction was no excuse; better dead than defeated is a very old motto.

In any medium in any era the artist either has public brains or he finds another occupation. His position makes the search for an unambiguous outburst against war in the ancient world an unrewarding one. Virgil, the great poet of imperial Rome, was hardly a warmonger. Even in his epic poem, where the origins and destiny of Rome are shaped by wars, the poet and his hero constantly complain that fighting is a terrible duty imposed by unquestionable gods. In one of his early poems he had a shepherd (the voice is that of a veteran) say that "a god has given us the leisure we enjoy"—the freedom to be farmers, not fighters. And later it was Virgil who celebrated the *immensa majestas pacis Romanae*, the majestic Roman peace (law and order) that was so widespread no one could measure the distance to the far-off places where it ended. But, of course, he was praising Augustus Caesar who imposed the peace by waging the largest civil war known to the ancient world. The poet may have loved peace, but his dilemma reveals the limitations of a civilized and sophisticated man of that era.

It is often said that Aristophanes' *Lysistrata* is an antiwar play. During the playwright's lifetime the Greeks certainly experienced a lot of warfare and many of them doubted much was accomplished by it, but the play is by no means a clear denunciation of war. It would be just as easy to argue that it is a blast against women, or against blind commitments. In fact, we do not know

exactly how Aristophanes' audience understood that play.

The first unambiguous condemnation of war one finds in the ancient Western tradition is probably in *De Rerum Natura*, in which the Roman poet Lucretius repeatedly described the war god Mars as a brute and stupid. For a Roman such language was grossly profane. The poet meant it to be: in the poem he linked religious intolerance with destructive violence and war. That notion was to prove fruitful to artists from the seventeenth century to our own time, as were two other ideas in Lucretius' poem: he observed that a life and death struggle is a fine thing to watch from a distance when the observer is in no danger, and he expressed as powerfully as anyone has ever done pity for the families of men who went out on great enterprises and never came back.

But an artist does not work outside his own culture, and most surviving ancient art—poetry, painting, and sculpture alike—was meant to record triumph. That is especially true of the art in the great monuments and temples. Many artists did not try to hide the suffering of the defeated. In an Egyptian temple painting more than 3,000 years old a pharaoh and his troops ride roughshod over small Nubians, crushing them under foot and wheel. The attitudes and expressions of the diminutive victims give one no reason to think the artist was pitiless. And there are victims of that kind on reliefs from Sumeria and Babylon; the ancient world was full of them. On the column of Trajan in Rome is a captive enemy about to be put to death by the sword, whose face and limbs express such fright that the stone seems to cry out.

However striking the images, it is a problem perhaps insoluble to discover what a contemporary of the artists actually saw. The fate of a soldier dying in defeat was grim to the ancients; one has only to think of accounts of them in the epics of Homer or Virgil to understand how grim. But the lot of the dead was worse because they lost, just as the lot of the defeated among the living was worse. One might feel pity for them, as one does for the Persian survivors of the triumph of the Greeks in Aeschylus' *Persae*. But pity for the individual or even for the kingdom does not amount to a statement against war. The ancients were more likely to conclude that the victims fought in the wrong war or on the wrong side or that they fell under the influence of the changing interventions of various deities. The possibility of divine intervention is another factor one has to remember when one is looking for outspoken antagonism to war in the art of the ancient world.

A different perception of divine intervention changed the situation in the Western world. For the slow evolution of war as the image of an evil affliction of the individual and the destroyer of the world, the key text is the Apocalypse of St. John. In a few pages it conjures up not only the four horsemen set loose to ravage humanity—war, the red horse, is the second of the four—but devastation from the sky. The language of the Apocalypse brings together resonant symbols not only from the Old Testament but from the very Roman triumphal monuments people could see in every city of the empire at the time the New Testament text was written. War, the second horseman, appears when the Lamb breaks the second seal: "And out came another horse, bright red,

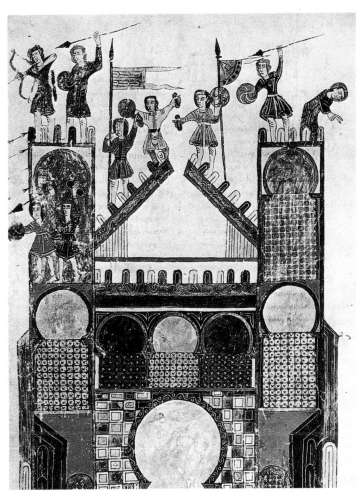

The Codex Gerundensis Beatus (Apocalypse of Gerona). (DETAIL) *(Astor, Lenox and Tilden Foundation,* NYPL*).*

and its rider was given this duty: to take away peace from the earth and set people killing each other. He was given a huge sword."

Within a few verses, seven angels with seven trumpets appear:

The first blew his trumpet and, with that, hail and fire, mixed with blood, were dropped on the earth; a third of the earth was burnt up, and a third of all trees, and every blade of grass was burnt. The second angel blew his trumpet, and it was as though a great mountain, all on fire, had been dropped into the sea: a third of the sea turned into blood, a third of all the living things in the sea were killed, and a third of all ships were destroyed. The third angel blew his trumpet, and a huge star fell from the sky, burning like a ball of fire, and it fell on a third of all rivers and springs; this was the star called Wormwood, and a third of all water turned to bitter wormwood, so that many people died from drinking it. The fourth angel blew his trumpet, and a third of the sun and a third of the moon and a third of the stars were blasted, so that the light went out of a third of them and for a third of the day there was no illumination, and the same with the night.

The association of those images with war is clear from very early Christian texts. That they have great staying power will be evident to anyone who remembers that grandfather of all modern nuclear-war apocalyptic novels, Walter Miller's *Canticle for Leibowitz*, with its extraordinary history of total devastation of the earth a second time around. And almost anyone can remember a painting or drawing he has seen with those images, or others drawn from them. That they would be attractive to artists is not mysterious. The literature of the West is filled with ramified images from the Apocalypse from the second century to our own times.

For visual evidence one need only look in the twenty-odd

manuscripts of the commentary on the Apocalypse written about twelve hundred years ago by Beatus of Liebana in Spain: a roster of images that turn up for many centuries in antiwar art. The sophistication of the art in the Beatus manuscripts makes it clear that the pictures rose from a tradition that was old when they were done even though that tradition is now lost. The art is magnificent; the wars it depicts are bloody and threatening, and sometimes the victorious warriors are wicked, but enjoying their triumph; and all the warriors are contemporaries of the artist.

There may be earlier examples known to art historians. But to anyone casually surveying the depiction of soldiers in art through the centuries, it is evident that an artist realized a dramatically different kind of freedom in the Romanesque era. If he was illustrating a Biblical text, on parchment or on the wall of a church, he had some protections ancient artists did not have. The text he was drawing on was taken as the word of God, so the artist was freed, to a point, from glorifying national history. And if he showed his contemporaries in scenes of terror or blood he was somewhat protected because he was illustrating a divine utterance, and not just *a* divine utterance but the *only* one: if it said war was evil, it said so uncontradicted.

On a deeper level the image of the soldier changed for Christians in the early centuries. A soldier was a familiar figure in ancient art and, whether triumphant or defeated, he was pictured in stylized ways as heroic. That is not the way the soldier was presented to early Christians for at least three hundred years. In the Gospels Roman soldiers led Jesus to crucifixion, stood guard over him while he died, and cast dice for his clothes. And it was soldiers who committed both Saints Peter and Paul to prison in Rome where they died. On a more personal plane soldiers rounded up Christians for execution during imperial reigns stretching from Nero to Diocletian. Nine or ten generations of persistent bloody persecution tends to change the perspective of people; and in the earliest collections of lives of the saints it is clear that a Roman soldier who was converted was practically sanctified on the spot. Of course, with rare exceptions he also became a conscientious objector on the spot. By the fourth century the view of the soldier was one no pre-Christian ancient would have recognized. One has to look only into a few texts of church fathers who, beginning with St. Jerome's lamenting the endless sounds of the battle drum in unceasing warfare, drive home the point that war is divine vengeance for wickedness.

Of course, we do not know how many contemporaries heard those messages or how many hearers believed them, but the texts form the tradition that lasted when others had disappeared. So, if Christian kings from Charlemagne onward were just as anxious as ancient rulers to be remembered for their military prowess (and in not a few cases bishops wanted to be remembered the same way), in at least some churches and some texts the soldier was seen as repugnant and war was depicted as evil. A not untypical example is the famous drawing of the *Good and Bad Regiment* from the cathedral at Canterbury, which dates from the early twelfth century. The bad regiment is a military unit whose soldiers are killing

The Battle. *Hans Holbein. c. 1490. Woodcut.* (FDU).

one another under the watchful eyes of competing devils and angels, and the good regiment is tilling the soil on a farm. When we see woodblock engravings from the early Renaissance in which soldiers are stalked by death as they cut down their enemies or, more strikingly, in which armed men fight an enemy who is death or the devil, we can see the lineage clearly. By then the images were a language commonly known.

In the ninth and tenth centuries another figure appeared in art who was better known from literature in the ancient world—the innocent. Romanesque Bible illustrations often show scenes that are ostensibly of the Psalms or Macabees or other battle references, but which are in fact pictures of contemporary warfare. One is struck by their emphasis on slaughter and suffering not only on the battlefield but in fortresses where people under attack are clearly noncombatants. The realism of these pictures is especially striking because they often appear in manuscripts in which New Testament scenes are still, in the language of the times, traditional—i.e., Roman. The realism of many pictures of real wars in the early Renaissance, especially in the sixteenth century, owes something to those Romanesque illustrations of scenes from the Old Testament. Of course, by the sixteenth century, the medium artists used was important to the impression they wanted to give. In painted illustrations on medieval manuscripts there is bound to be a certain softening of the impression, no matter how realistic the battle scene—and that softening was carried over into murals done as late as the middle of the fifteenth century in the Vatican and in churches from Naples to Toledo. But a sixteenth-century woodcut that shows forests of spears held by thousands of soldiers advancing through a valley or on a hill has a kind of physical power that cannot be softened: in the popular medium of the time the artist became the benign ally of brutal expression.

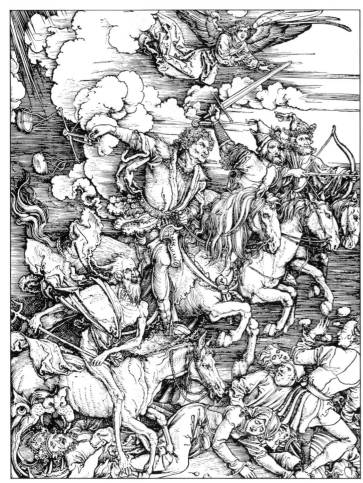

The Four Horsemen of the Apocalypse. *Albrecht Dürer. 1496–1498. Woodcut.* (FDU).

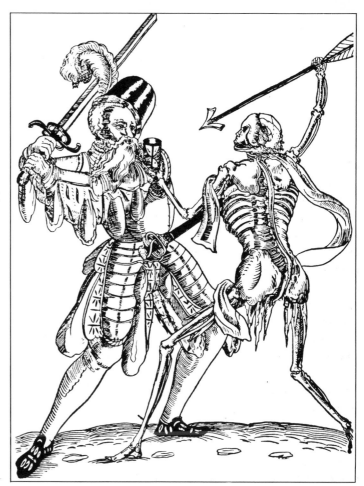

Soldier and Death. *Wolfgang Strauch c. 1490. Single sheet broadside.* (FDU).

Wars in the sixteenth century, to be sure, were of the kind that might inspire an artist to use stores of religious imagery; they were ferocious and they were fought over religion. That the issue was religion, at least on the surface, meant that the wars were of personal interest to larger segments of the population than most medieval wars had been. To artists that dimension meant a complication of the symbols they used. Albrecht Dürer's pictures of the four horsemen of the Apocalypse had a different meaning in the 1500s than they would have had only a generation earlier. If wars were fought to determine which doctrine truly saved men's souls, the picture of a soldier fighting death itself as an adversary took on a meaning we might forget today.

In most of the art of that time, images that had developed through many centuries were used simply on one side or other of the struggle. But there were philosophers and poets who were looking at larger questions; for instance, what were wars really fought *for*? Erasmus was merely the most eloquent, not the only, writer who questioned what kings really wanted from war in ways that intimated he did not think it was salvation or the good of ordinary people. Poets—Aretino the most notable of them—could aim malicious jibes at kings and popes for going to war first on one side and then the other of various causes or alliances, their only sure intentions being to honor pacts with hell. But the artist Pieter Brueghel may have opened up a new idea in his picture of *The Battle of the Moneybags and Treasure Chests*. On the face of it, it ridicules greed. But the battle is a recognizable war, and no one who saw the picture then or afterward could miss the suggestion that real men at the time were tearing one another's guts open in the same way as the moneybags and chests, for purposes that had something to do with getting a bundle of coin. His was an idea that would have great effect on art against war in the late nineteenth century.

That is not to suggest that in Brueghel's time many people had sophisticated ideas about how wars made money or for whom. Everyone who had a vote in current affairs knew there was a banking system. The great German banking house of the Fuggers raised enormous sums to finance wars and it published a newsletter that was the richest source of information and gossip in the world: banking was known, better than it is now. But, to artists as well as to ordinary people, the money from and for war was the king's. Everyone could see that money was being made: some in plunder or, as in the case of the Turks and English, in that romantic form of grand theft known as piracy, but most of it in materials like cannon, powder, shot, iron, alloys, coal, timber, brass, and huge mercenary armies. There was a difference: unlike modern bankers, people below the thrones who were amassing wealth from war did not try publicly to shape government policy. Popular histories in our time, along with movies, fiction, television series, and plays, articulate all these matters in familiar terms we can understand and that therefore are wrong in a sense. The people involved in the lucrative transactions in those times seldom articulated them in any way that would approximate our notions. Brueghel's was a moral idea that happened to turn out to illustrate the truth centuries later.

However, war did change in the art of the sixteenth century. That art is far distant from the age of the Crusades when all kinds of armed conquests were glorified in poetry and pictures. In the Renaissance official art was transformed most interestingly, turning back to classical allegorical representations of triumph and to Roman and Greek themes. The poets of the time did not neglect to mention, sometimes in scatalogical verse that one would hesitate

to translate even now, the hypocrisy of this triumphant glory. In that century the battle of Lepanto is rather unusual in that it inspired a number of fairly realistic representations of all-out war, heaped with slaughter on both sides. But on the whole, in a century of almost constant warfare, there was not much art, except the kinds of propaganda that turned up in illustrations for tracts against one enemy or another, that depicted war as ultimately evil.

The history of art that is against war altogether coincides with the first widespread popular resistance to war, during the Thirty Years War that ended in 1648. Virtually every principality from France to the Ottoman Empire and from the Balkans to North Africa became involved in that war in one way or another. Unlike any European war since Roman times it had no real truces or interruptions that were not dictated by weather. Between a quarter and a third of the entire German population perished in it. In general the battlefronts were in western or central Europe, but in some years they were also stretched from Vienna east to the Ottoman borders. It would have been difficult for an ordinary person in Europe in those decades to avoid being touched directly by the warfare. If he lived between the Rhine and the Russian empire the chances of his getting shot at, looted, burned out, shanghaied into service, robbed, raped, or enslaved were very high. Statistics applicable to armies before that time suddenly applied to whole populations.

Miguel Cervantes had been often eloquent about sixteenth-century war in his books; he was a soldier and was wounded and enslaved, so he knew war. The wars he wrote about were fought in places other than his countryside in Castile, and they involved recognizable enemies. But the first great German picaresque novel, *The Adventures of Simplicius Simplicissimus*, written by a survivor of the Thirty Years War, describes a world Cervantes would not have recognized. It was one in which murder, rape, looting, and kidnapping were the ordinary events of life, not in some distant land but at home, where combatants and civilians alike eventually neither knew nor cared which side they were on and where all values, especially the value of human life, were degraded even faster than the currency.

In political terms, what was happening was the creation of modern Europe, a few great armed states welded together by conquest into military and industrial empires, some of them fed by imperial holdings stretching around the globe. The making of such creatures required the whole world as an anvil. Even Spain, the greatest warring nation in modern history, felt the blows of the Thirty Years War in a new way. To read descriptions in histories will tell you little about reality; one has to imagine what reality seemed before then. From about 1480 until 1700, in the era of the great Hapsburg rule of Spain, it would be difficult to find a single year when the central Iberian power, the Castilian state, was not at war. For over one hundred years its warfare stretched from Germany to Africa and on to the empire in North and South America and the Philippines. During the sixteenth century the total population of Castile dropped by at least fifteen percent; from generation to generation the decimation of that population in war and

imperial ventures is appalling, but the Spanish infantry was absolute wherever it could get a footing and maintain its supplies. It was not until the seventeenth century that war came home to Castile unbidden and not till the Thirty Years War that there was any popular suffering in battle. Before then, a Spaniard might go to war, rule the world, and change history without ever hearing a shot fired at home. After 1618 everything changed. And it was not only in Spain. Even England, the long-protected island, was ripped apart in that era by civil war that was directly related to the long war on the continent. The early seventeenth century was the age in which commerce and travel had become global and so had war. In reality, the Thirty Years War was the first world war, not the one given that name three hundred years later.

If war became democratic, so did the art that responded to it. Artists had the means to make it democratic. Printing presses were everywhere; there was money to be made from books and pamphlets, and so there was money to buy illustrations. Moreover, the battles of Reformation and Counter Reformation were in part intellectual, and they had the ironic effect of spreading literacy. Teachers now might envy the motivation: to save your soul you ought to be able to read or to be close to someone who could. Furthermore, the turmoil in politics had the effect of making many people—merchants, writers, and artists among them—increasingly independent of the state. By its end the Thirty Years War had occasioned an enormous amount of popular debate, which often meant a deliberate personal and passionate statement by a subject against his own ruler.

Utopias had been thought of before the seventeenth century; the book that gave the word to our language was published in 1518. But a century later the ordinary discussion was about how to get ships and go off into new worlds to establish utopias; and part of every program published by every utopian group from the seventeenth until well into the nineteenth century was the abolition of war. If you look through books of controversy, chapbooks, and emblem books of that era, you will find illustrative art that reviles war and dreams of peace in increasingly complicated symbolism. Nor can it be argued that in a turbulent time the machinery of the various states could not suppress rebellious art or writing as easily as they did in former times. The machinery of state in the sixteenth century and before—Star Chamber, Inquisition, whatever—was notoriously inefficient even against very conspicuous people. That machinery could not have stopped a Callot from lampooning war in pictures in any previous time. The fact is that before the seventeenth century there was no Callot to draw war as a monstrous engine devouring living human beings.

Callot's images from the era of the Thirty Years War are of inestimable value in the lineage of antiwar art. Previous artists had used kings or popes or princes as images of the gods of war; they showed war as death, soldiers as depraved. Callot located the wickedness of war in the machinery used in war. His vision was powerfully subversive. It separated the viewer's feelings about the state, the monarch, the army, and the culture from his feelings about war. Even a good soldier, seeing Callot's pictures, could find

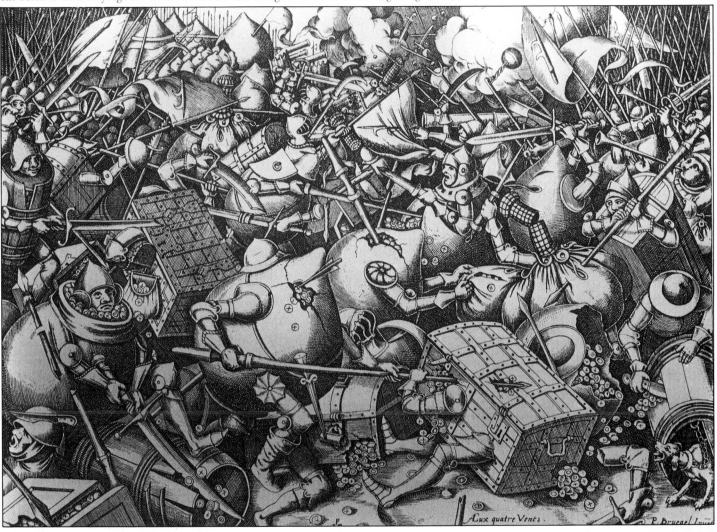

justification for feelings against war. The draftsman had created a great metaphor even before poets found words for it.

To realize what Callot's insight had done for art you need only compare the drawing of his great war cannon with two contemporary ones: the first from a Protestant pamphlet depicts the devil as a Catholic prelate devouring citizens and venting them out of his other end as soldiers; another of the same period shows the wolf war god despoiling the countryside and devouring people. The first is broadside political invective; the second is antiwar art. Each has a power, but neither has the unforgettable force of Callot's art. His enormous prestige made antiwar art more than merely respectable, and he was willing to use other artists' imagery, combining it into new symbols or raising it to consummate mastery. In his 1634 *Temptation of Saint Anthony* he uses an idea one can see in the wolf war god picture and a monster clearly derived from Hieronymous Bosch to create a dying devil of war spewing tons of weapons out of its speared belly. With Callot the repertory of antiwar images is virtually complete. There are a few exceptions, such as the image of statesmen ostensibly seeking peace while they actually plan for war, but not many. The vocabulary of antiwar art, whatever its later refinements, was established in the work of Jacques Callot.

What historians would call, without a trace of irony, the successful settlement of the Thirty Years War led to a long period in which there was little antiwar art. On the whole, peace came from exhaustion and, on the whole, it lasted long. The various wars that can all be clustered under the rubric of the gradual dismember-ment of Spain, and that broke out now and then for one hundred years, were relatively small military events, however important they may have been in the history of commerce or of empires. Louis XIV fought some disastrous battles in the Low Countries at the end of his reign, but they did not arouse the kind of popular protest they would inevitably have called forth had they occurred half a century earlier.

A reading of late-seventeenth and early-eighteenth century literature suggests another reason for the silence. By the late seventeenth century there was a kind of frenzied determination among intellectuals to avoid any further war over religion, and the underlying assumption seems to have been that avoiding that kind of confrontation would mean avoiding disastrous wars. A reader of English literature need only look through the works of a few writers between 1660 and 1740—John Dryden, William Temple, Jonathan Swift, Joseph Addison, Richard Steele—to pick up the refrain. The tone is different among French writers, but the message is the same: avoid differences and look for rational solutions to every identifiable problem.

Ironically, the rational solutions they discovered tended in some cases to arouse the passions of the intellectuals and the masses *for* one kind of war—revolution. There was less concern about warfare by the end of the eighteenth century than about what could be got out of it, whether that was empire or freedom. The art of war developed prodigiously throughout the century, but on the whole the artists tended to glorify the achievement of war—in the official art that celebrates the battle of Blenheim in the tapestries of Blenheim Palace at the beginning of the century, or

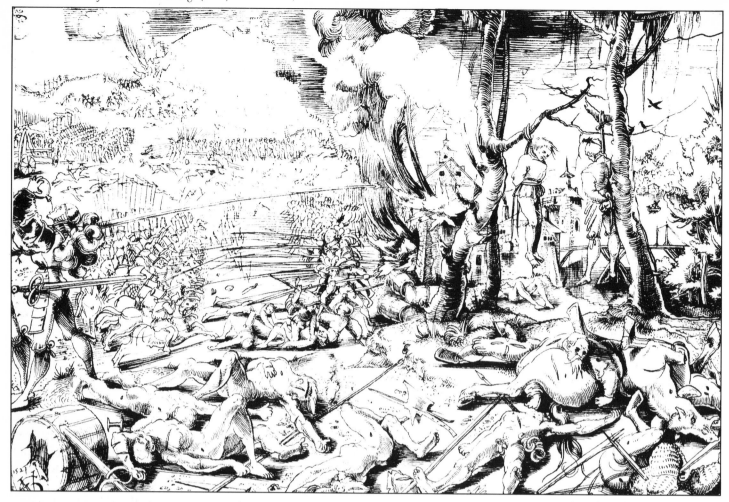

the flood of popular art that accompanied the French Revolution and the rise of Napoleon at the end of it. An occasional lampoon might make a king or a general ridiculous. But an age in which Voltaire could admire Frederick the Great was hardly a time when artists were inspired with a horror of military power.

Napoleon made a difference. When Charles de Gaulle visited Moscow fifteen years ago he astonished his Russian hosts who had taken him to see the monument between the airport and the center of the city marking the spot where the German advance in World War II stopped. De Gaulle uttered: "What a people!" referring not to the Soviet defenders but to the Germans who had advanced farther into Russia than Napoleon.

The emperor had that effect on most people in Europe until shortly before he did in fact invade Russia. He codified French law. He overran Europe, overthrowing in his course many institutions that thinkers thought oppressive. He sold the American West to Thomas Jefferson for pennies an acre. His popularity with artists and intellectuals in France is incontestable, and it was hardly less in Germany, Austria, Italy, and even for a while in Spain. Only in England was he feared from the beginning, and in part that fear arose from English disapproval of the French Revolution that preceded him; and that disapproval arose partly from the success of the American Revolution a decade earlier. As Napoleon's conquests advanced, some British artists cartooned him and his wars in ways that would be only anti-French art, except that a few of the artists combined old antiwar symbolism in new ways that had an effect on artists for the next 150 years.

At the height of his career Napoleon invaded Spain. When the powers allied against him worried about what to do, Prince Metternich advised doing nothing, saying of the French that "it is no longer the nation that fights." To an Austrian, whose people had learned exhaustion in the Thirty Years War, the futility of the French foray was evident. Even before that invasion, incursions of French troops and emissaries into Spain had produced a civil war that was almost as bloody as the invasion itself. The effect of the bloodshed of those years on Francisco Goya changed the history of art. His *Disasters of War* is a magnificent panoramic protest against war itself, a series of stunning pictures that needed no text, no captions, no explanations, and which have a power that not all the war movies of this century or even news pictures of war on television have diminished.

Their effect on artists has been lasting: line, structure, light, and the arrangement of figures in his pictures are imitated in cartoons one sees every day. Goya was also cunning about his display of people and machinery. For instance: artists had been drawing and painting rifles, generally in prints of soldiers firing at one another, for three hundred years before his *Disasters* were begun in 1810. Goya threw a light behind his bayoneted rifles, raised in the hands of uniformed soldiers who were firing at civilians trapped against a stone wall. After Goya there are no innocent rifles in art, no more sticks uttering puffs of smoke and fire, and no clean uniforms. Denis Raffet in dozens of subtle lithographs did a great deal to glamorize Napoleon; Goya did a great deal more to humanize Napoleon's victims, and the victims of every warrior.

The Napoleonic saga marked several other important changes in the way people looked at war and the state. The Congress of Vienna, which parceled out Europe after the wars, imprinted itself on the popular imagination as much as the wars themselves. People understood that it was no longer possible for a king to raise an

army and go to war in the way kings had done since the time of the Roman emperors. Now whole nations went to war and nations perished. Honoré Daumier's lithograph of death as the inventor of the arms race in the middle of the nineteenth century is testimony to the ordinary understanding of what was to come after the war of 1870. His work is also a good classic catalog of popular understanding of the underpinnings of war at the time—the appeals to patriotism, the rapacity and laziness of the generals, the luxury of the military establishment, the outpouring of national wealth for armaments, and the total perversion of language (he did, after all, have Peace being crowned with a coronet of bayonets).

Actually, the writers were ahead of the game. It is true that Florence Nightingale's horrifying reports to the London newspapers in mid-century had little effect except to improve military medicine, but in the long run they gave people a very different view of the reality of war: if there was glory in empire there was human cost in maintaining it. On the continent it was the writers who first warned people about the catastrophe that was finally to occur in 1870, and it was the newspapers that gradually brought home the realities of war in the various empires—in reports from Africa, India, and Southeast Asia, reports that contradicted all the official versions of empire and that eventually supplied pictures of war not only for the artists but for poets and novelists. There is a history of the underground effect of journalism in the nineteenth century that is yet to be written. When one reads accounts of the war of 1870 and then of other wars down to the Boer war, one is appalled at the continual increase of massacre in the second half of the nineteenth century. The great pile of skulls that the Russian artist Vasily Vereshchagin pictured, being pecked at by ravens, in his *Apotheosis of War* of 1871, expresses vividly the effect the self-slaughter of France had in that war, but it is a mild prediction of the slaughter that was done quietly in empires outside Europe during the next forty years.

That there was a thirst for conquest in the face of death is evident in European accounts of the American Civil War, newspaper stories that are often more graphic than the stories in American papers of the time. The reporters from Europe were often sent for the same purpose generals from different countries were sent, as observers of the Civil War to report on new weapons and of new strategies used without restraint. Later the European powers were also to send general staff personnel to watch P. T. Barnum's circus, to learn how to move great unwieldy forces and deploy them quickly. It is a pity that no artist picked up that idea, which was quite ancient: a Roman historian had referred to one clever bellicose politician of his time as *conditor civium bellorum*, the circus rider of the civil wars. What a picture that would have made! And what a picture Thomas Nast the American did in fact produce, after the American war but when Europe was sinking into warfare a decade later, a picture of death as the great war monument. There is a lot of the American Civil War in that print.

The German invasion of France in 1870 was principally of interest to artists in those two countries, of course. But it is significant that, in the years following, it was principally artists in Germany, the victor, who protested against the growth of military forces and the industrial machinery that maintained them. There is one unforgettable German print of a great dragon rising out of an industrial plant ready to destroy a heedless armed soldier on the attack in the foreground. To a nation by then intoxicated with the imagery of Wagner's Ring operas it was a powerful message.

The library of German antiwar art in the years between 1870 and 1914 is much larger than that of any other country. It has been studied quite often by German scholars, but it deserves more. One aspect that artists themselves might benefit from having explained is the mixture of motives. There are many elements, but what anyone in our time would immediately notice is the pointed identification of finance, industry, and the army and how often the figures represented are not only anti-Prussian but anti-Jewish. There is a tangled history behind the cartoons of the time that makes one wish he knew more about the realities of social history.

However, until the great European powers—France, Germany, and England—confronted one another in a show of force over what they called the reorganization of Morocco in 1911, it is hard to perceive a common realization among artists or writers that another continental war on the scale of that in the age of Napoleon was in the offing. In the forty years before World War I there was a

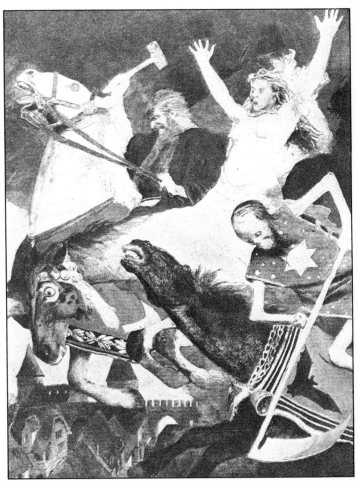

Der Krieg. *Arnold Bocklin. Date unknown. Oil on canvas. (Neue Pinakothek, Munich).*

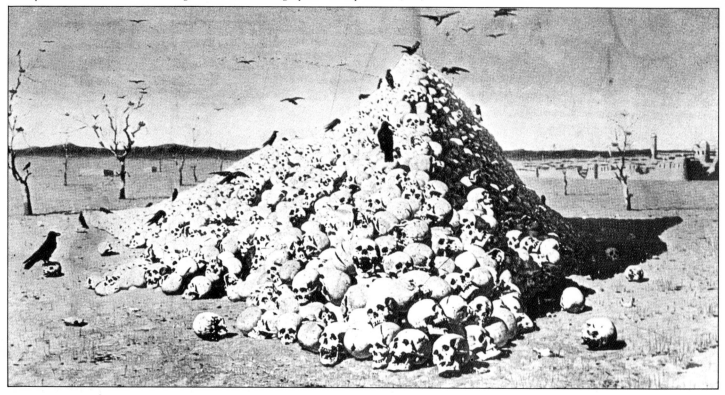

good deal of art, and more literary satire, about the many international conferences held to insure peace; but without the reality of massive war, it was hard for anyone to bring the point home.

As governments took increasing pride in showing off their weaponry around the turn of the century, the point became more evident, of course. When August Macke, in *Der Blaue Reiter*, the manifesto of the Munich art school in 1913, emphasized the relative impotence of the artist by declaring that "a Krupp cannon is a mighty argument," everyone knew what he meant. People living in Germany, of course, had an advantage: the regime gloried so much in the military that citizens knew more about it. It is, after all, an unusual empire in which the chief arms manufacturing family, the Krupps, would name their greatest cannon for the mother of them all—Big Bertha. Until World War I began the German artists understood all that better than those in other countries. But, at that time, most people seemed a bit insensitive to what the German war machine meant. General Friederich von Bernhardi, of the German General Staff, published a book in 1912 called *Germany and the Next War* that admirably outlined World War I. It was understood at home. It was also published in French and English, but few seem to have read it in those languages.

By the time World War I began, governments had learned a lot from artists. During the Napoleonic wars the British government had distributed prints to stir up patriotic passion. During the uprisings of 1848 various governments in Europe used illustrated broadsides and pamphlets to dissuade rebellion; and the Austrian, Neapolitan, and Papal governments did the same thing a decade later when Count Cavour was whipping up Italian nationalism. But in the opening months of World War I government presses ran constantly, producing posters, pictures, and pamphlets to stir up patriotism; art was used with great effect by all the combatant governments as propaganda against the enemy. Not all the propaganda came from governments: in the first year of the war opposition from writers and artists was quite exceptional.

But after 1916, when the war had become a relentless death machine, art against war became a flood. Even Paul Nash, an

official artist sanctioned by the British government, produced landscapes of the Western Front that shocked the public in London. The new technology of warfare, especially airplanes, became prominent in antiwar cartoons in England. In France a few artists made what are almost comic-book scenes of the realities of war on a personal level, such as the *Nights of War* that mimicked illustrations of romantic novels of the time. The *Nights of War* is a triptych showing the blue night when soldier and girl fall in love under a lamppost, the white wedding night with the girl alone in bed, and the red night of battle with the soldier plunging into carnage; the colors of the flag used in that context are quite effective.

The spread of romanticized realism into popular art had come at the right time: in a war in which there were thirty-five million casualties, with seven million killed, there was enough misery to be depicted. And a good deal of the power of the art of World War I comes from its individuality. In most countries there were political movements against the war, especially among socialists, but they were not very large and produced little common vocabulary in art. On the whole the antiwar art of the era was marked by personal passion; it was not campaign art, but an outcry.

In the twenties and thirties, as indeed in recent years, much antiwar art was politically inspired in one way or another, and a lot of it represented party positions. Socialist movements in Europe made resistance to war one of their principal causes, and populist movements in the United States had their own version of resistance. Communists stressed the antiwar theme throughout Europe and in this country, in some cases joining the socialists in the effort but often producing a fairly doctrinaire strain of art as well as writing that was clearly inspired by the party in Russia—where there was no antiwar art to speak of between the two world wars. By now that kind of propaganda art is fairly easy to recognize, quite often because it is simply passionless.

But the historian of art will have a problem in sorting it all out eventually. If governments had learned early on to use art for their

own purposes in promoting opposition to an enemy, artists could find new ways to protest. But then a spiral developed: governments would go on co-opting the artists' methods, and artists, including those who wanted to promote programs of political parties opposing the governments, would use still other artistic methods in their own polemics. Especially when one is looking at antiwar art of the 1930s, and at some of it now, one has to keep the political history of the era in mind. That is not to say that there is no powerful or excellent art in some of the most partisan antiwar pictures—or, for that matter, in some government poster art.

World War I saw the development of one new medium that had a powerful effect on the depiction of war: motion pictures. Movies had been made before, but the war was a tremendous field of action for movie photographers. In the years after the war directors of fictional films in Europe and the United States imitated the real battle scenes of the war, but infused them often with images from older antiwar art. The medium had a terrific effect on many other arts, too, notably the theater and dance where antiwar themes drawn directly from films and film techniques can be found easily in the middle and late thirties.

As for the films themselves, the library of antiwar movies is so large by now in so many countries that it is hard to choose the right scene to include in a book like this. But there are some here that suggest the range, not documentaries but movies made to a script with an antiwar theme. A documentary, or, for that matter,

a television news broadcast, might produce an image that a shrewd artist can use in a statement against war. But, without the intervention of the artist, even the most striking pictures of war are ambiguous at best and can be used in many ways. *Dr. Strangelove* cannot be used in many ways: it says what it means.

Between the two world wars the principal antiwar art in Europe appeared in Germany and the Low Countries, but it stopped in Germany after 1933 when Hitler came to power. A good deal of it is predictable—picturing women protesting against war or demanding that it never happen again, or wounded veterans, or the great fields of crosses bearing the graves of dead. And there was some mordant art ridiculing the various peace or disarmament conferences of the twenties, art that is reminiscent of similar art before World War I. In the United States in that period much of the art, whether it was produced by antiwar or left wing or populist groups or by newspaper cartoonists and independents, tended to repeat themes of the 1914–16 era; it warned not only against war but against involvement in foreign politics. In many cases you cannot easily separate left-wing and utopian idealism from native isolationism in the sentiments expressed; and indeed the entire spectrum of those opinions might be expressed in a single artist's personal political commitments, as it was in the career and work of Rockwell Kent.

In the early years of World War II there was very little antiwar art anywhere. There were protesters, more among writers and

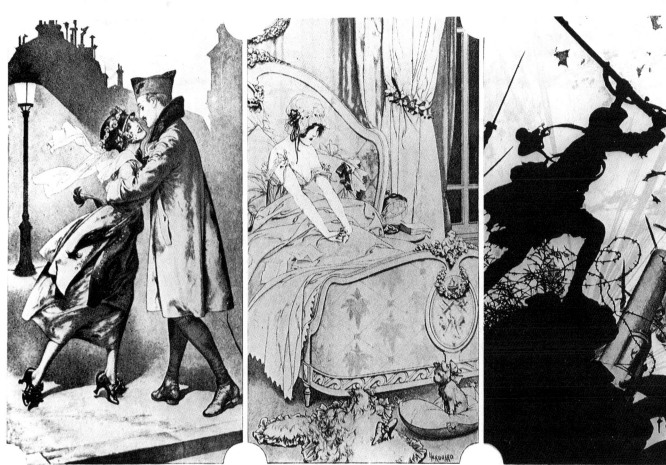

The Blue Night/The White Night/The Red Night. *C. Herouard. 1918. Pen and ink.* (FDU).

The Wisemen From the East. *Louis Raemaekers. 1915. Hand-colored lithograph.* (SCPC).

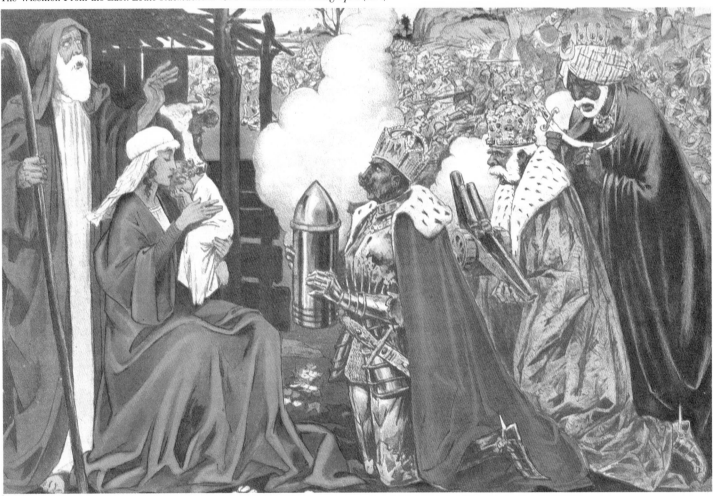

intellectuals than among artists, but not many. There was plenty of opposition in England to the bombing of cities and in much of the United States to entering the war at all. But those sentiments tended to be lost after 1941. Not many wars in history have aroused as little popular protest on any side as that one. However complex and different the reasons for that, it is remarkable.

Since 1946 the volume of art against war has grown steadily in the Western world, most rapidly in the United States. This is not the only country that has fought wars since 1946. But in none has there been quite the broad outpouring of antiwar art that one sees here. France fought disastrous wars in Southeast Asia and then in North Africa in the fifties, but you will search its popular art long to find many images against war itself, no matter how opposed people may have been to the actions in Vietnam or Algeria. And, of course, there has been a great deal of antiwar art in Germany again and, for the first time, in Japan. There is so much antiwar art around us now in so many media that people in North America, Europe, and Japan may tend to forget that it is seen by only a minority of people in the world. Unless it has a government purpose, you will not find antiwar art in the Soviet Union, China, India, or the Middle East; there is little in Africa and, outside the churches, none in Latin America.

Where it appears, art against war has become sophisticated in imagery. A great deal of antiwar art through the years has pictured principally the weaponry of the previous war; in that respect the artists were about as advanced as most of the generals. The use of the atomic bomb in World War II changed the artistic perception somewhat. It does not take a superhuman imagination to see what many nuclear weapons would do to the earth. But by now nuclear bombs alone are old hat. The technology of modern warfare is much more complex and effective. On the whole it is newspaper cartoonists and some movie directors in recent years who have kept current on the whole range of war technologies and who have realized in their imagery that all forms of organization are weapons if nations decide they are. To depict some current realities requires immense knowledge and rare synthetic imagination.

On the whole the language of antiwar art has become dense and complex, filled with images drawn from centuries of use that have become independent of their origins. Thus, many people now will understand immediately the antiwar message of a picture based on passages of the Apocalypse who have never read a word in that book. Even many of the artists no longer know where the symbolism comes from; a separate language has grown up. By now there even can be effective expressions of sentiment against war in some forms of abstract art, as in Gunter Grass's hands threatening one another with stones or taking up quills as weapons.

Many of the dominant themes are biblical. Th. Th. Heine has a huge armored angel pouring blood out on the earth and George Grosz has a war horseman spreading murder over the earth, the horseman himself dressed in a gas mask; both obviously come from the Apocalypse. Another picture has the three kings of Christmas presenting weapons to the child Jesus, the whole thing drawn in the style of a Renaissance tableau. In one cartoon soldiers in a firing squad execute Jesus as a traitor. Death, in the biblical images of the leader of the dance of humanity, or as king of the world or the grim reaper, is common in antiwar art now: in the appearance of the nuclear cloud as the death's head, in cartoons of the grim reaper cutting off the heads of whole nations, or in modern variations of Cruikshank's death triumphant on the war memorial to Napoleon or Thomas Nast's lush drawing of death as

the conqueror on the world's war memorial. The theme of the dead as the great majority, exploited brilliantly by Daumier in *My Harvest*, was as effectively used by the cartoonist Paul Conrad one hundred years later in a picture of a single soldier in Vietnam reading President Nixon's statement that "this is probably America's last war" while behind him 45,000 dead affirm that, "One thing for sure, it's our last."

The image of the leaders of nations—whether they are government leaders or industrialists or bankers or diplomats—as the makers of war has become so common now that it can be abbreviated by artists without any loss of meaning. For a generation before Jooss's *Green Table*, with its striking dances of peace that turn into the dance of death, there were two generations of artists who developed the notion that disarmament conferences and peace negotiations produce wars; note the striking 1924 Belgian lampoon in which one sees obverse and reverse of a medal—the conferees at the peace table on the front, their hands full of weapons behind them on the back of the medal. The notion of deception in such situations, or the idea that leaders who call for peace are actually intent on destruction, is so common now that a cartoonist can convey whole pages of meaning by simply stamping a national leader's face on a symbol of peace: we have all seen Russian or American statesmen, or generals or churchmen, as doves of peace.

People looking at the antiwar images in this book may be more interested, however, in tracing the vocabulary of war technology as it appears in pictures. When the German gun Big Bertha was caricatured as a lethal hausfrau in a pre-World War I cartoon, the vocabulary was still basically that of Callot. There is a tremendous leap from that image to Tomi Ungerer's drawing of death as a soldier firing human heads from an automatic rifle while decapitated bodies are spit out of the weapon as spent shells. And the advent of effective air warfare in this century has given artists a new world of images. Will Dyson in England caught the essential idea in his 1916 cartoon of a monkey hanging from an airplane dangling a bomb over a city. By now the image has become the bomb carried by a rocket not only from place to place on earth but among the planets. Osborn's death's head as mushroom cloud or the grisly humorous skeleton playing a piano on a devastated landscape have become, a generation later, visions of a devastated earth seen from out in the universe.

In a few cases a single artist may employ the entire vocabulary with the mastery of a great poet, as Goya did 170 years ago, or as A. Paul Weber has done in our time. Weber has used not only the techniques but the images, figures, backgrounds, and themes of Renaissance and eighteenth- and nineteenth-century artists as well as ideas from literature including the Bible, *The Divine Comedy, The Adventures of Simplicius Simplicissimus,* the novels of Tolstoy, and the poetry of Goethe. He has also drawn on popular modern media—the methods of film and the language of broadcasting and advertising. In picture after picture he has brought together, in rare concentration and with rarer wit, fundamentals of Western culture and the familiarities of everyday life to shape

his relentless and striking antiwar images. When one looks away, one can criticize him for overdoing it, for being a kind of Savonarola of the antiwar movement; but, when Weber has your attention, it is hard to keep enough distance to be able to criticize.

There is a great deal more to be seen in the pictures in this book, and the book itself is only a suggestion of the long tradition of art against war. One aspect of this type of art is very important: it is ultimately democratic in nature. It has, as Sir John Rothenstein said of a generous artist, "public brains." Rarely, abstract art may make an effective statement against war. But there is no coterie art that is cogent antiwar art. In some ways the democratic aspect of antiwar art makes it look naive to modern viewers, or coarse. The many systems of thought or criticism that have affected every mental discipline in the last hundred years may have an effect on the way the antiwar artist expresses his ideas. But the resulting picture will simply lose its public if it stays within any of those specialized systems. From the beginning, the artist who wanted to produce revulsion or horror at war addressed a mass audience in a language the audience already possessed. There is no point in expressing protest against a present reality in a language that only will be understood by many in the future—especially when the artist's point is that, unless things change, there will be no future. In the most basic sense, the art in this book is vulgar: it speaks to everyone. That is the base of its emotional power.

D.J.R. Bruckner

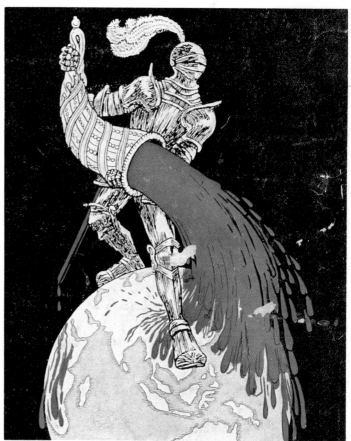

Der Krieg. *Th. Th. Heine. 1917. Pen and ink with second color. Cartoon reproduced in* Simplicissimus. (SCPC).

ART AGAINST WAR

Death: "I will never rest till I can kill no more." *Russian cartoon reproduced from* Der Weltkrieg in der Karikatur. (FDU).

TOP
Satirical pictorial broadside about war. Anonymous. Circa 1630. Woodcut. (FDU).

BOTTOM
German caricature of an automatic soldier-maker from the Thirty Years War. Anonymous. Circa 1630. Woodcut. (FDU).

OPPOSITE PAGE
Satiric Symbol of War. *Jacques Callot. 1634. Etching. Detail from second state of* The Temptation of St. Anthony. *(Joseph Pulitzer Bequest, 1917, MET).*

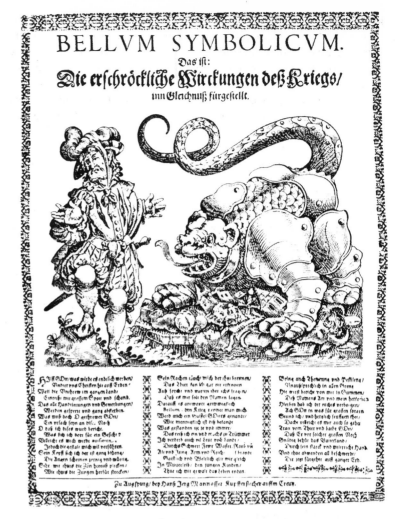

MOST ELEGANT DAMNATION

Jacques Callot's book of antiwar etchings is the grandfather of all modern art against war. His pictures were commissioned by no one; their sales made him wealthy. They combine a mastery of art that is entirely personal with an enormous artistic and humanistic learning. And they are, on the whole, as bitter as any body of antiwar art ever executed.

Callot had all the opportunities his age could offer. He was born into a well-to-do family in Lorraine in 1592 and at sixteen began a three-year study of engraving in Rome, followed by a longer period in Florence where he was a Medici protégé. His early etchings and engravings reveal a fascination with the luxury of the court of the grand dukes; his etching of the Fair at Impruneta, rivaled only by his own later Fair at Grondeville, is one of the greatest plates ever made, containing 1,100 people, a gross of dogs, hundreds of birds, and more than 100 horses and donkeys. Before he was thirty, Callot was the greatest master of realistic depiction of human action; his record of the commedia dell' arte, the most complete ever made of that popular theater, is as good a catalog of character as one will find in any European or English dramatist of the age.

He died before he was forty-five, leaving more than 1,400 plates behind; the mere number of them is dumbfounding; the quality of all but a few of the early ones would challenge any artist to equal. When he returned from Italy to his family's home in Nancy in 1621, a relatively peaceful time was ending in the small duchy of Lorraine that was being swept up into the Thirty Years War. Half the duchy's population died in that war.

Callot and his family were intense partisans in the war, not only in the interests of Lorraine but on the Catholic side. He made trips into the Low Countries where he saw some of the fiercest battles fought in the war, notably the Spanish siege of the city of Breda that he recorded in the six plates called "The Siege of Breda," published in 1628. At first sight they might be a tribute to the victorious Spaniards. In fact they are startlingly realistic pictures of war containing thousands of figures, few of whom are not suffering. They amount to a great indictment of war itself, and they were recognized as such immediately.

Not all the recognition was cognizant, it must be said. Years later, when the troops of Louis XIII had reduced Lorraine to subjugation in a ferocious campaign, the king and his chief minister, Cardinal Richelieu, asked Callot to commemorate their triumph just as he done for the Spaniards of Breda. It was one of the few times in his life that Callot threw off his gentleness and his courtly manners and told them in a language any peasant could understand that he preferred not to.

His bitterness against war increased as he grew older and his anger became independent of the cause of either side. One of his most famous plates is a rather casual production: the satyrical picture of war as a diabolically monstrous cannon ridden by a dog-monkey and touched off by another diabolical animal. The cannon's wheels grind people down and its mouth fires volleys of weapons. It is scatalogical, brutal and funny at once, and its scorn is made more eloquent by the elegant lines and balances of the artist. In the end it is the delicacy of the thing that makes it unfor-

gettable: The hellish cannon is belled.

That he meant to reach a wide audience is unmistakable; his prints often carry lines of verse under them in the manner of popular emblem books of the time. His greatest outburst against war has verses of that kind, although the power of the pictures might overwhelm whole epics.

"Miseries of War" consists of six small plates and 18 larger ones executed in 1632 and 1633. They convey the one subject Callot treated that seems to have got away from him a bit. Each print is awesome in conception and design as well as in content; but they do not quite fit together. They leave one feeling that in some way they were torn out of the artist and that that impression would be the same if they were not small engravings but huge canvases. It is hard to avoid the conclusion that their message is close to despair.

Callot had a wonderful respect for human intelligence and for disciplined sanctity. The "Miseries of War," along with the second plate of his "Temptation of St. Anthony"—in which the brutality of war lurks behind the surface of the picture like a vision of hell—remind one that Callot was a serious student of war: its methods, command, the excitement and camaraderie of it, its sense of movement and finality, its indifference to deaths of heroes and victims, its subversion of ordinary understanding, its exhilarating frenzy that ends in nothing. Perhaps what makes the "Miseries of War" one of the greatest books ever produced about war is its display of war as the ultimate horror produced by the most intelligent, dedicated, and skilled activities human beings can think of.

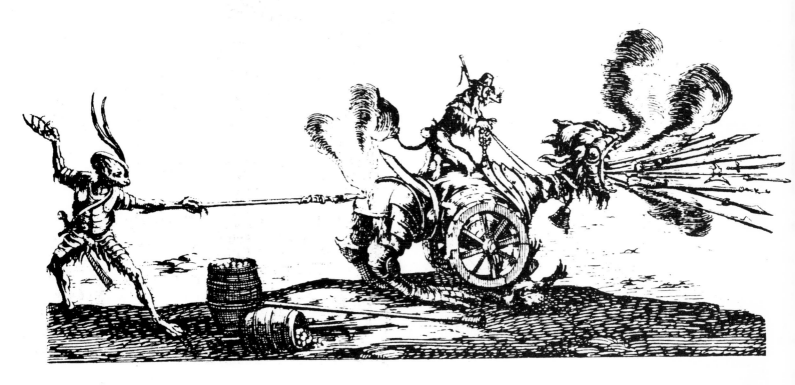

Iſrael ex. Cum Privil: Reg.

WAR'S JUSTICE

The original engravings are 4½ by 8½ inches. Consider the detail in them: while one man is being burned, another is digging a hole for another burning; the pole to which the victim will be tied lies nearby, along with the saw and the ax that shaped it. A church and a house are already on fire. Home, church, and humanity all perish together at once; the most stable and most fragile parts of society go up in smoke. Death is utterly egalitarian here. On the right the next victim, with his arms tied behind his back, is accompanied by a woman, and the suggestion is clear enough that she too is manacled. Callot forgot nothing. As the fireman lights one death pyre, his accomplice is still steadying the restraining upright, and the bellows that lit the taper lies against the firepot.

The verse under the scene on the right refers sarcastically to the fine exploits of inhuman hearts from whom none can escape. One tortures a man to make him reveal where his money is; the others steal out of spite, kidnap, murder, rape. The scene is in stark contrast to the one above, unrelieved in its bloody brutality from which not even the small animals in the foreground have managed to flee. This is perhaps the most horrifying of several prints in which Callot pictured the savagery of the soldiers of the Thirty Years War against the noncombatant population they fell upon.

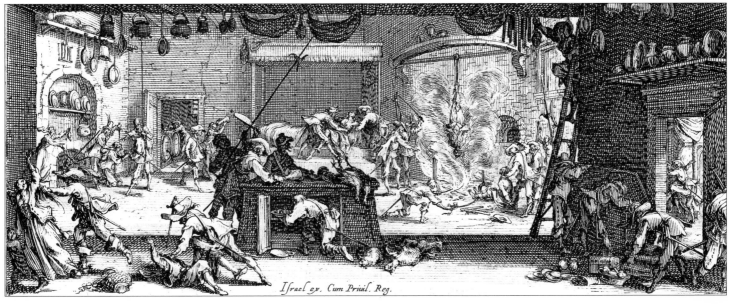

Israel ex. Cum Priuil. Reg.

GODS GOING TO WAR

A few years after the death of Callot, Peter Paul Rubens, who had seen much of the same war Callot saw in the Low Countries, completed for another Medici, who had ordered it on commission, a vast canvas (6 feet 9 inches by 11 feet 3 inches) called *The Horrors of War*, which still hangs in the Pitti Palace in Florence where the Grand Duke of Tuscany placed it at the beginning of 1638. By then Tuscany was as much under the firm control of Spain as Rubens' homeland was; the Medici grand dukes had contributed heavily to Spain's campaigns in the Thirty Years War and Rubens had painted canvases honoring their victories. It would be hard to think of a family that was then more dominant in what we would call the Establishment of the world.

That such a painting on such a scale should have been commissioned by that family from that painter is very surprising. And the painting remains unique among the monuments of great ruling families. Its luxurious pageantry and color may not tell most of us how horrible war is, but it has remained a powerful message to rulers into our own times and was repugnant to one as late as Benito Mussolini, who did not object to its luxury but to its message.

Rubens was a learned man by any standards. In 1638 he wrote a detailed letter about the painting to a friend in which he deliberately recalled the poem of Lucretius in which Mars the war god could be tamed only by Venus. Rubens wrote that in the painting Mars rushes out, leaving open the doors of the temple of Janus that were opened only in times of war, ignoring Venus but pulled on by a fury bearing a torch who is accompanied by disease and starvation, the companions of war. What touched him most, he said, were figures representing music, architecture, literature—all thrown down with their instruments broken and trodden under the nailed boot; and a woman and her child being crushed under foot because war tended to end the beginnings of new life.

For a princely civilization that understood itself in such symbols for many generations, the Rubens canvas is a message of tremendous power. Many of us now think of brutality only in terms of coarseness; there have been people whose language and images were more sublime but whose understanding of brutality was not necessarily less profound, and the Rubens canvas spoke to them about war in a way they were seldom spoken to.

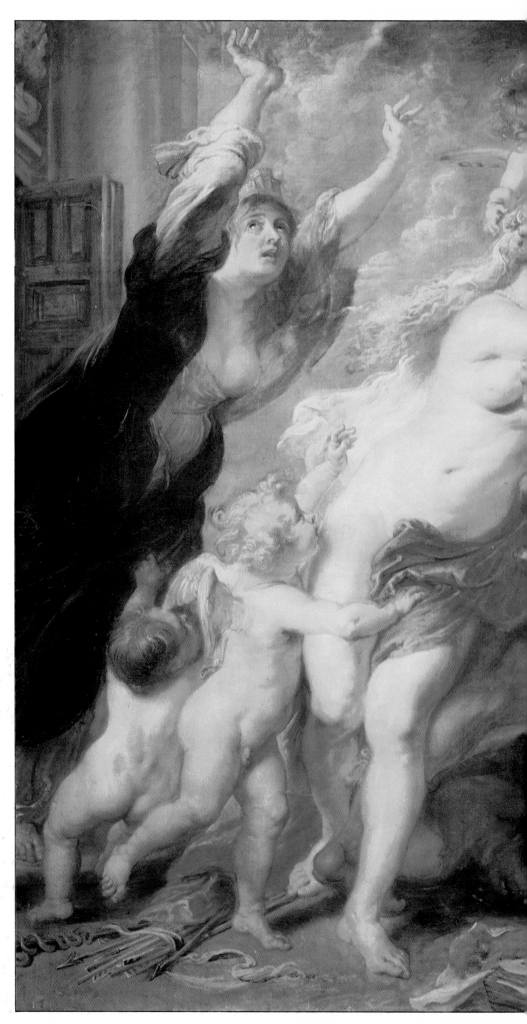

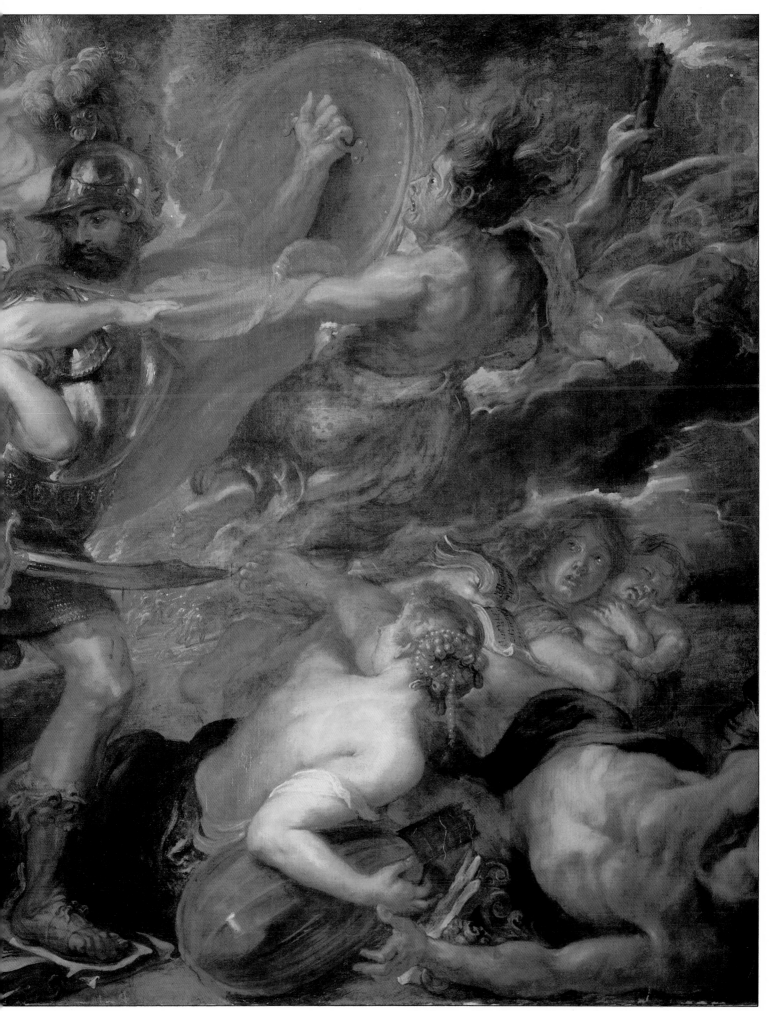

The Horrors of War. *Peter Paul Rubens. 1637. (Courtesy Scala/Art Resource).*

BRUTES AT WAR

Very little antiwar art in any century was as grand or elegant as the work of Rubens or Callot. Most of it in the 17th century appeared in broadsides that would convey a simple message quickly.

The famous print of the Wolf War God, made in Germany about 1630 by an artist who did not sign the plate and remains unknown, is 8 inches high and 10¼ across, about the size of a sheet of letter paper, and was engraved on copper. It is more akin to the woodcuts of a century before than to the art of Callot.

The wolf was a familiar figure of evil in German folklore. In this print he tramples out the grapes of wrath in the foreground while he devours booty and victims; he holds spoils in one paw and wields a spear and two firebrands in his right hand. Only the head is wolf. He has a human leg and a goat's back leg, a human arm and an animal's foreleg and paw, and a devil's tail. In the left background war rages: cities and churches burn, refugees flee, a woman and child are murdered. On the right, the Wolf War God has been killed, his stomach cut open to reveal plunder and human victims spilling out of his insides while in the far background a peaceful city rises against a sunrise that might suggest eternity or an earthly peace. It is hardly a refined picture, but it is a powerful statement about the realities of war in an allegorical mode turned realistic.

That popular method of expression could easily be turned to propaganda, obviously, and it often was. There are thousands of angry statements against opponents from that century. One of the more interesting series, that is not an unfair example of the type, is the "War Scenes and Cruelties of the French in the Netherlands, 1672–73" by Romeyn de Hooghe.

ABOVE

Wolf War God. *Anonymous. Circa 1630. Broadsheet copper engraving (Stadtbibliothek, Ulm).*

RIGHT

The triumph of Christian charity. *Romeyn de Hooghe. 1673. Dutch cartoon from* Der Weltkrieg in der Karikatur. (FDU).

The armies of Louis XIV invaded Holland in 1672 and a flood of books describing French atrocities, and of pictures like de Hooghe's, were influential in bringing many countries into alliance with Holland; the war eventually turned into a serious debacle for the French. The large de Hooghe prints are all fairly inflammatory, a few of them disgusting. But the artist had a sense of movement and of sweeping composition that makes the pictures almost classical art, despite their gruesome depiction of rape, torture, murder, and conflagration. It is one thing to see soldiers pouring hot oil on a victim, and quite another to see a baby speared through the middle and tossed into the air.

The fact that these barbarities were pictured against backdrops of military apparatus familiar to everyone—the ships, cavalry, battle banners, and formations of the French—made them a good deal more believable. Virtually every atrocity that can be seen in the allegorical pictures of two centuries can be found in them, and more, but the mythical elements have all disappeared. What de Hooghe gave his viewers was a version of My Lai in the reign of the Sun King.

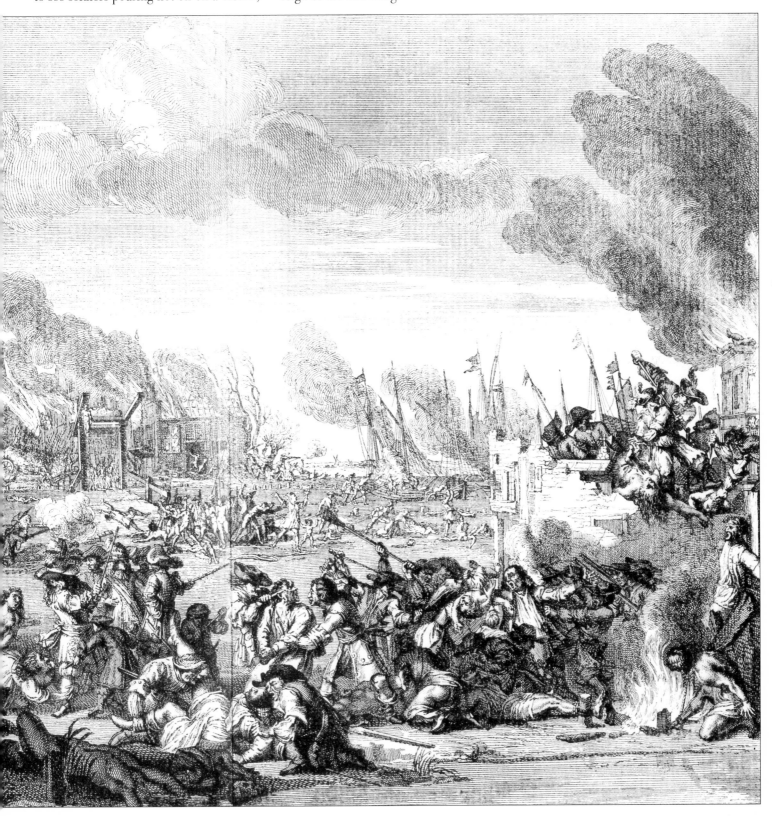

NOTHING—IT SPEAKS FOR ITSELF

Francisco Goya's two huge canvases depicting the events of May 2 and 3, 1808, were actually painted six years later when the painter was nearing seventy. Napoleon invaded Spain in 1808, toppled the government, and put his brother Joseph on the throne. On May 2 there was a popular uprising against the French that was brutally suppressed by the Arab mercenaries Napoleon had brought in from Egypt. The first of the two 9 by 12 foot paintings shows the uprising and the second, *The Third of May 1808*, the execution of rebels. Art critics have argued over them for 170 years, but they have been imitated by artists ever since. There is no denying their ferocity and power, which come in part from the distortions of perspective and of the people in them. No artist has more forcefully evoked the brutality of war, and it is doubtful that any but Van Gogh has so effectively transferred his own personal anguish onto a canvas. One aspect that makes these paintings so painful is the anonymity of the military forces and the vivid personalities of the defeated civilians.

In some ways Goya was a less likely candidate than Callot to be the great spokesman against war in his age. At the time of the French invasion he was past sixty, long accustomed to living in royal society, the official court painter, the urbane satirist of social foibles, and a rich man. No artist in Europe was more honored and probably none more pampered. In the world of art his authority was unassailable. In the event, he used it absolutely. The art he produced between 1810 and 1814, portraying the savagery of the six years of war that ended in that last year, reflects all the mastery of his earlier years in technique and the great gift he had of conveying character and passion in a face, the position of a hand or leg, or in the juxtaposition of people of obviously different capacities and intentions. But in the antiwar works it seems a new artist was suddenly born in the old man. Alto-

The Third of May, 1808. *Francisco Goya y Lucientes. 1814. Oil on canvas.* (S.P.A.D.E.M./MDP).

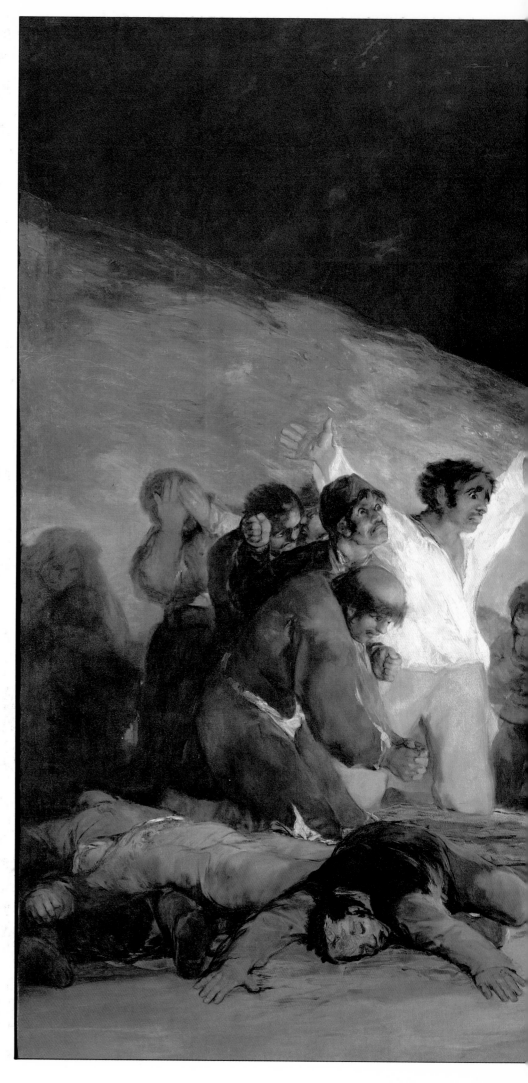

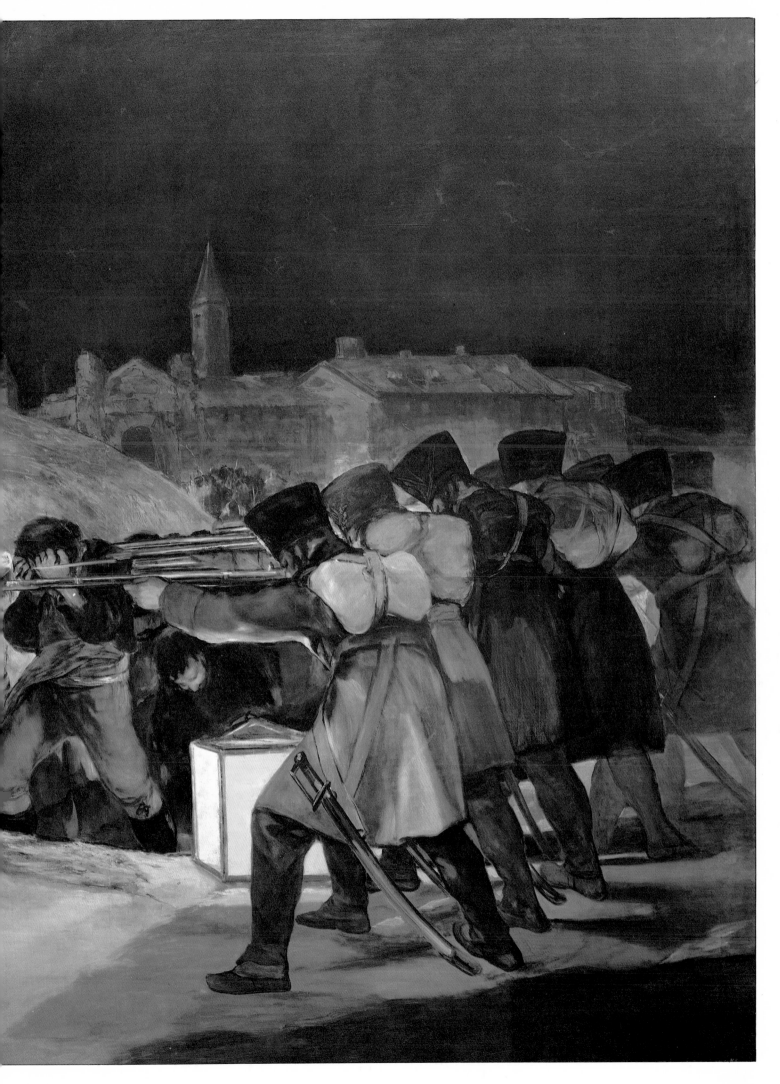

gether there are eight or nine dozen pieces of this work in various forms. In none, even when he is evidently holding someone up to scorn, is there the mordant satirical view of individuals one can find in many of his earlier works that gently ridicule high society. In all of them there is a great deal more cruelty, but the cruelty is among the people drawn or painted, not in the artist. For all their horror, the pictures he made against war reflect not superiority in the artist, but suffering, despair, pity that cannot be contained.

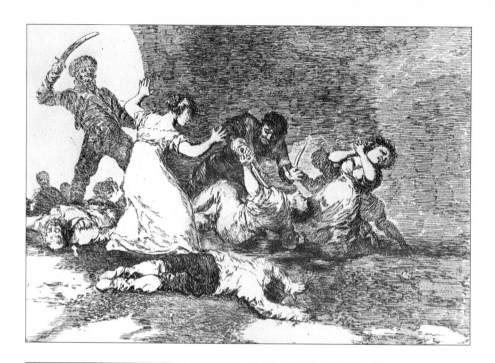

The 83 prints titled "The Disasters of War" were begun in 1810, four years before the two great May canvases. Goya supplied simple captions for them that are personal and that reveal him as being as skilled in language as any poet. Together the prints in the series form what is undoubtedly the greatest single book against war ever produced in any kind of language. It is a haunting book in the sense that, like the ultimate book of poetry Goethe later imagined, it is a book that is constantly in the making: one can assemble the pictures in different orders and they will convey meanings in a different way—ranging from pity to anger to heroism to profound prayer, to the terrible despair expressed in the one under which Goya wrote: "Nothing. It speaks for itself."

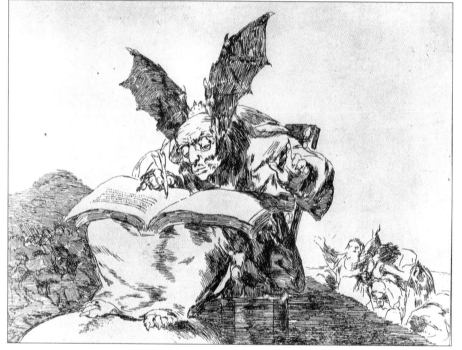

Throughout this incredible war Goya continued to paint and draw many other things, including a number of formal court portraits. In them, as in much of his earlier work, the historian of art can find new beginnings, the ultimate triumph of technique and color, fresh evidence for the argument that Goya had a unique power of putting philosophical questions in his art. But in the war pictures the artist himself seems to burst through the canvas or the plate, not in an egotistical way but in a terribly impersonal one. It is hard to avoid the feeling that the dying, the butchered, the raped, and even the monsters in these pictures are somehow seeing the artist, and, by looking at them, we see him, too. That reflective vision only deepens the total impression of horror in the work itself.

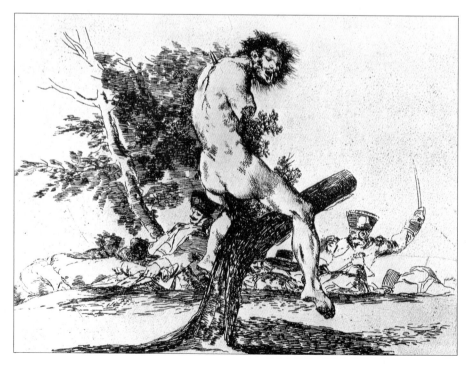

TOP
Infamoue provecho *(Infamous gain). Francisco Goya y Lucientes. Between 1810–1821. Etching, drypoint, burin, and burnisher.* (MFA).

CENTER
Contra el bien general *(Against the common good). Francisco Goya y Lucientes. Between 1810–1820. Etching, drypoint, burin, and burnisher.* (HSA).

BOTTOM
Esto es peor *(This is worse). Francisco Goya y Lucientes. Between 1810–1820. Etching, drypoint, burin, and burnisher.* (HSA).

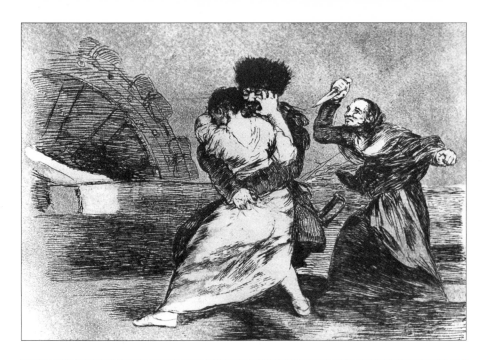

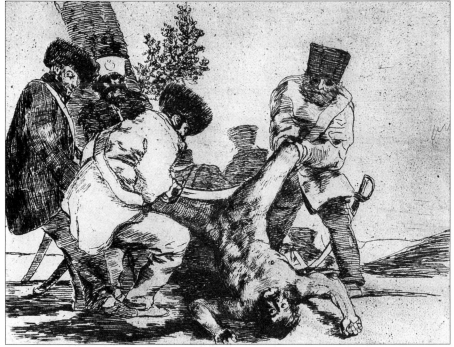

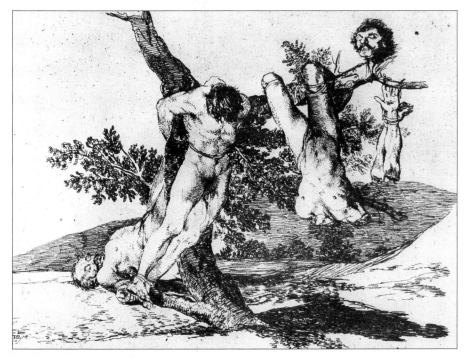

TOP
No quieren *(They do not want to). Francisco Goya
y Lucientes. Between 1810–1820. Etching, dry-
point, burin, and burnisher.* (HSA).

CENTER
Que hai que hacer mas? *(What more can one do?).
Francisco Goya y Lucientes. Between 1810–1820.
Etching, drypoint, burin, and burnisher.* (HSA).

BOTTOM
Grande hazana! Con muertos! *(Great deeds—
against the dead!). Francisco Goya y Lucientes.
Between 1810–1820. Etching, drypoint, burin,
and burnisher.* (HSA).

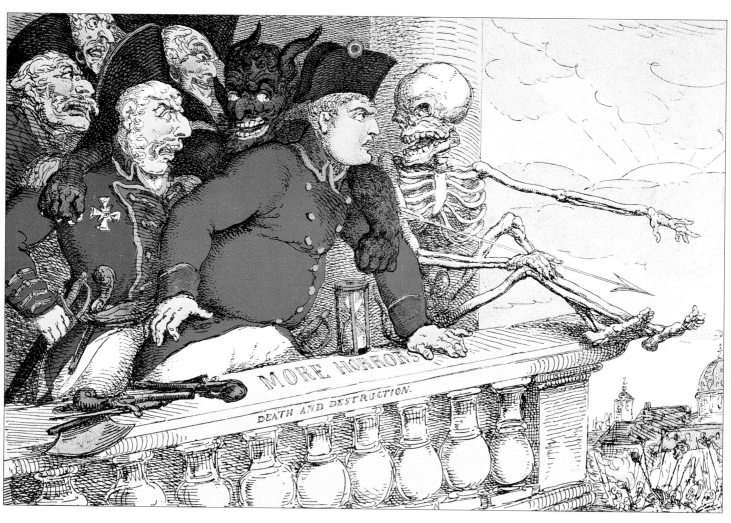

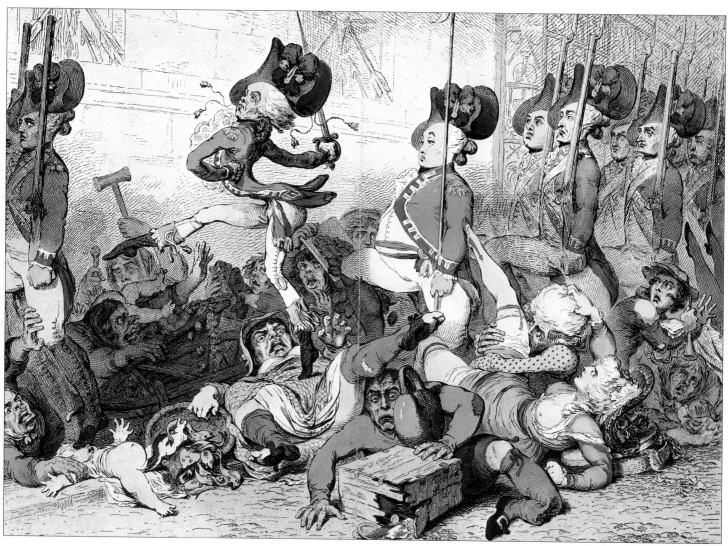

THE SPOILS SPOILED

The side that won in the Napoleonic wars was certainly seen as victorious by the national historians—especially of Austria and England—and even by Russian novelists. But in England some of the artists and cartoonists questioned the whole business even while victory was in sight. There was no time since the Glorious Revolution of 1688 when serious thinkers in England came under so much suspicion as at the time of Napoleon. One recalls that the government had Wordsworth and Coleridge under surveillance for a time at their seaside retreat, where they were discussing poetics, and for no better reason than that both had written sympathetically about the French revolution years before. The reaction of writers and artists should have been foreseen by the statesmen.

If Thomas Rowlandson could produce a picture of Napoleon and his generals being instructed by death to produce more mayhem and blood in the streets of Paris, a message the British government could hardly have resented, the plate contained a message about war itself that other artists were perfectly happy to exploit. By the first decade of the 19th century there was a fair tradition of mockery of English armies in England, after all. Contemporary accounts of Cromwell's army in the 17th century are not all laudatory. At the beginning of the 18th century the country's greatest wits had ridiculed the nation's greatest general, Marlborough, mercilessly. Novels of that era hardly make soldiers heroic. So it was not a surprise that in the age of the British triumph over Napoleon a cartoonist as skilled as

James Gillray, a natural rebel who worked during his most productive years for satirical publications, should have shown the British military not conquering a French emperor but marching imperiously and roughshod over British subjects, not in a line of suppression, but merely on their way to collect money.

George Cruikshank's triumphal monument to Napoleon, done in 1815, is a piece of nationalist propaganda on the face of it (the fortress across the sea in the background is England), but also the kind of indictment of tyranny and war that inspired many artists through the century who had no national goal to support.

But no one could speak with more authority among artists than William Blake, whose thought turned increasingly to war during the Napoleonic era. The great visionary, whose mystical epics had sustained a vision of the triumph of innocence and justice in England through the decades when Englishmen feared that what had happened to France in the revolution could happen on their island, turned somber in later years in a number of pictures on war, none more telling than the 1805 picture in which aged parents look on as a young woman kneels weeping over slain young men while the broken wall of their home is filled with corpses ravaged by a lion, and a giant vulture or eagle looms over them.

The great number of religious symbols Blake has brought together in this one picture makes it unique for its age: it would have been understood on sight by late Romans or in the middle ages or during the Thirty Years War.

OPPOSITE TOP
The Corsican and his lieutenants looking down from the balcony of the Tuilleries in Paris. *Caption: "Death: More cruelty, more dead, more mayhem." Thomas Rowlandson. 1815. Etching (hand colored). From* Der Weltkrieg in der Karikatur. (FDU).

OPPOSITE BOTTOM
The March to the Bank *or* The Pay-day Parade. *James Gillray. 1816. Etching (hand colored). From* Der Weltkrieg in der Karikatur. (FDU).

BOTTOM LEFT
Death's monument. *George Cruikshank. 1815. Etching. From* Der Weltkrieg in der Karikatur. (FDU).

BOTTOM RIGHT
War. *From a series in* The Consequences of War. *William Blake. 1805. Pen, pencil, and watercolor.* (FM).

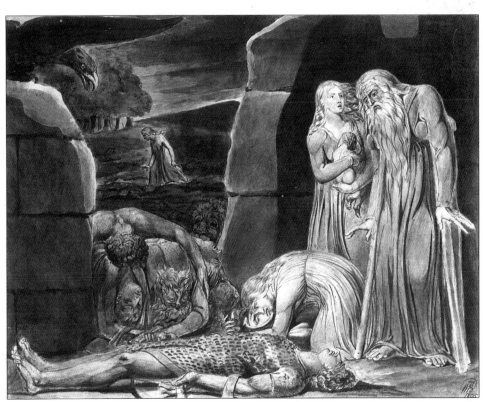

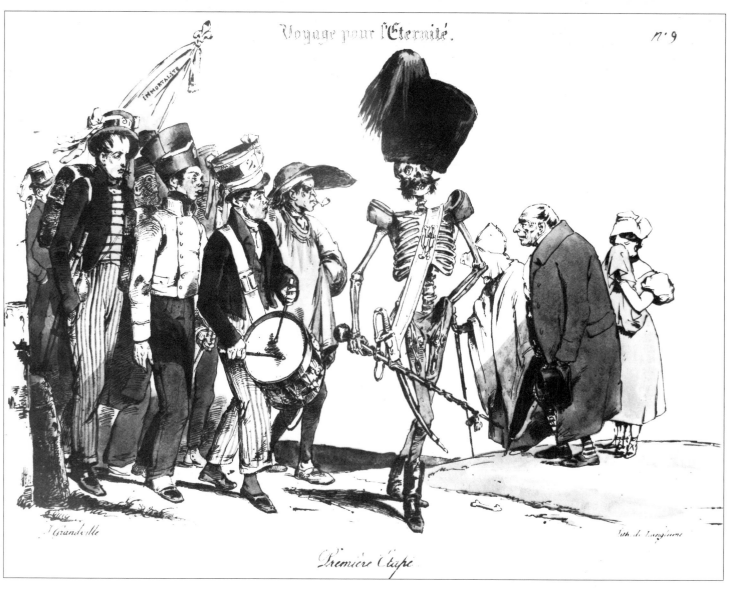

J. Grandville Lith. de Langlume

Première Étape.

ASHES TO ASHES

From Napoleon's fall until the rise and fall of Napoleon III 55 years later, France came back from defeat to establish a new empire and then rush into defeat again. It is not hard to understand why France in that era gave birth to almost every form of modern literature. A few of its artists, most notably Honoré Daumier, kept trying to remind people of the direction they were taking. But, in an age of growing industrialism, vastly ramified bureaucratic diplomacy, and increasingly complex international finance, it was hard for artists to pick a recognizable target.

Daumier was not alone. It is worth remembering that the great Grandville (his name was Jean Ignace Isidore Gerard), now known mostly as one of the greatest of all French book illustrators, used his skills powerfully in antiwar art, and, indeed, in antiestablishment art as a cartoonist for the rambunctious journal *Le Charivari*. His themes were largely traditional, like his version of the dance of death as the military drum major leading troops into eternity, but his precision and distortion were inspirations to French cartoonists for another 100 years.

Daumier was Daumier. After him all political cartoonists are analogues. He was bright, rebellious, splenetic, implacable; even his close friends admitted at times that they had met snakes with more charm. But in a nation that is supposed to love light, he made Frenchmen see—the truth behind modern definitions of peace, the falseness of disarmament conferences, the identity of the true war-makers in the persons of bankers and industrialists and inventors, and, above all, he made them see how they would look in the light of history.

He was only five years younger than Grandville, but lived through another generation after Grandville died at forty-four. Daumier was born when Napoleon was emperor and lived eight years after the Prussians had crushed Napoleon III in 1871. Although after he was sixty he began to paint and was recognized as one of the early impressionists, he spent his life as the first of the people we would recognize as modern cartoonists. And he had pretty much the philosophy of that breed: if you have to like something, don't be a cartoonist. He was still in his twenties when some of his lithographs for the irrev-

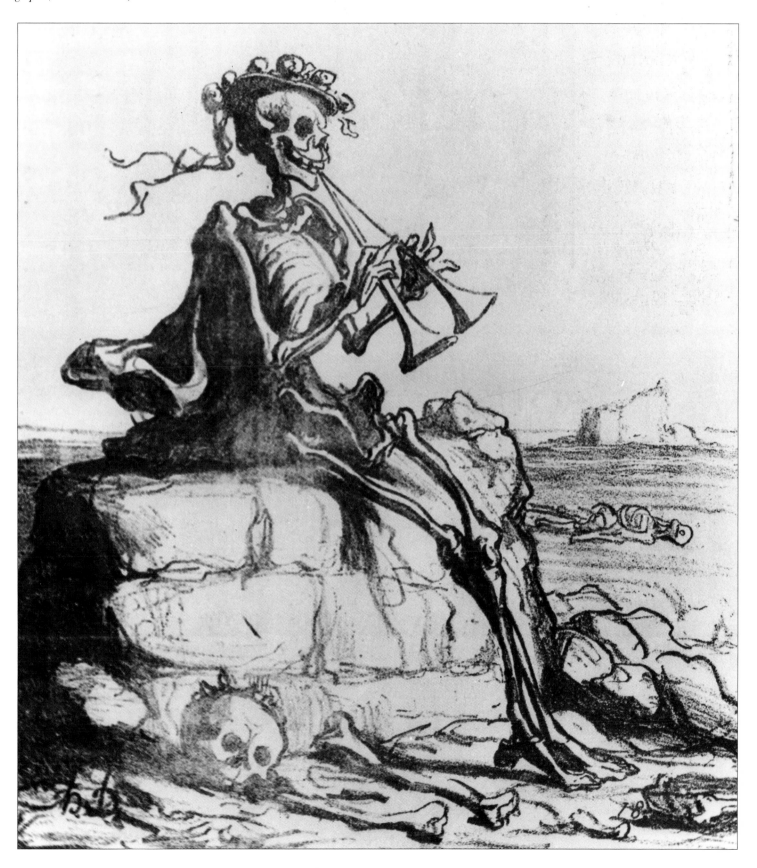

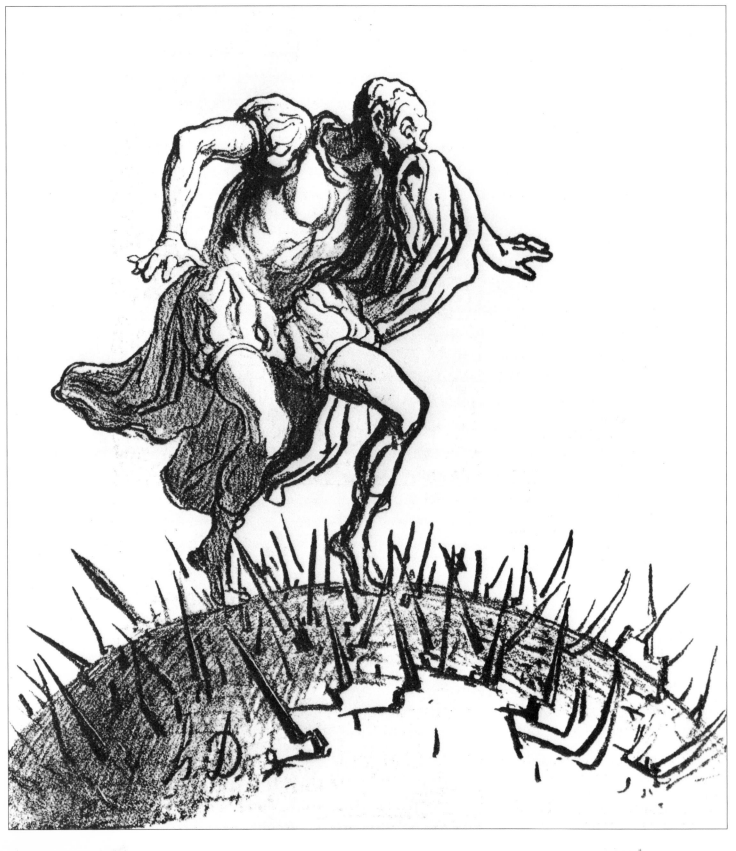

erent *La Caricature* not only got him indicted but the journal closed; however, he went on to work for the rest of his life for its successor, *Le Charivari*, producing for decades more than 100 lithographs a year lampooning French institutions, rulers, clergy, and the whole business of modern war technology.

Daumier was often in trouble with the law because so many of his cartoon characters were instantly recognizable as leading citizens of the day. Beyond that, he had a genius for translating accepted journalistic formulae into ridiculous visual images: one could make a book out of his sarcastic cartoons of "European equilibrium" being maintained on bayonet points or on the backs of people or by fraud. In hundreds of cartoons, ranging from lampoons of disarmament conferences to abusive images of peace or of France in female form, he made the French think that most often when the government talked about peace it meant war. He was also one of the first regular political cartoonists who exploited what was then the new cosmic vision of the planet as an object—most notably in the famous cartoon of Galileo trying to tiptoe across the globe, which is alive with the swordpoints of bayonets. His humor was lethal. Napoleon III gave the kaiser a statue of a maiden lying on a lion; a few years later, Daumier's cartoon had the maiden Peace draped over a German cannon.

In the end what gives Daumier's prints most of their emotional power, however, is his deeply imbedded love of France. After the defeat of 1871 he drew a shrouded woman with hands raised to her eyes, standing over a field of the dead, which he captioned: "Horrified by the heritage," and which, while it says little that is explicit to anyone 110 years later, has a force that can only be explained by its expression of the fierce patriotism of the artist. It is precisely that patriotism—resisting the official kind—that Daumier left to his successors as his best legacy.

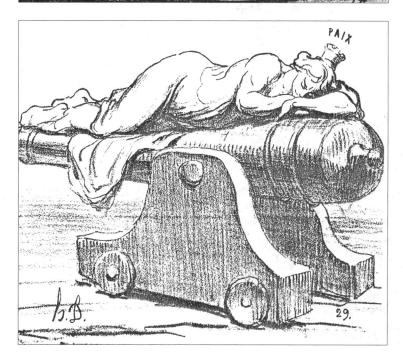

OPPOSITE
Galileo is startled by the change in the earth's surface. *Honoré Daumier. 1867. Lithograph. (Private collection).*

TOP
The Army Hierarchy. *Honoré Daumier. 1854. Lithograph. (Private collection).*

CENTER
Disarmament—"After you." *Honoré Daumier. 1868. Lithograph. (Private collection).*

BOTTOM
Peace embraces her lover. *Honoré Daumier. 1868. Lithograph. (Private collection).*

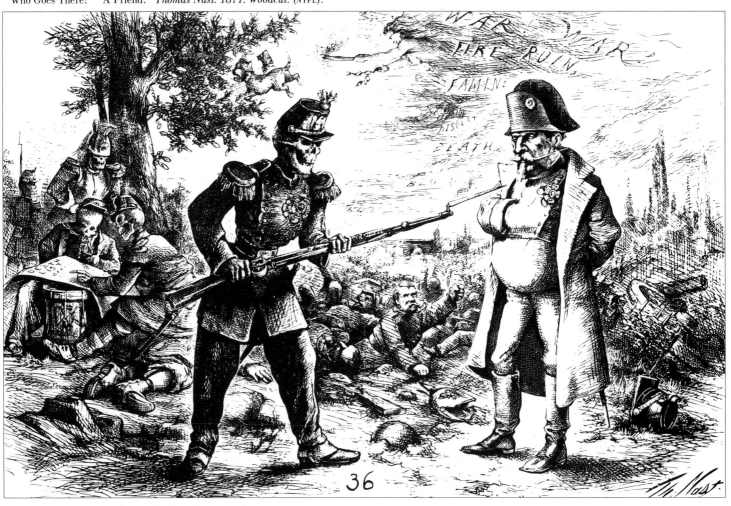

It has been six years. *André Gill. 1873. Woodcut from* L'Eclipse. (SCPC).

BLOODY DEGRADATION

The Franco-Prussian War of 1870–71 would have been pure Offenbach comic opera if the French had not turned to killing one another. Bismarck, the Iron Chancellor, had tricked Napoleon III into declaring war over a mere diplomatic insult, and the doddering emperor and his vastly superior French forces were not in the field more than a few weeks before emperor and army alike were taken prisoner.

The Prussians moved into Versailles, ringed Paris with troops, and then sat back and waited for Paris to destroy itself, Minor rebellions began in the city during the early winter and gradually grew in intensity through the first few bitter months of 1871. In effect the Prussians had been able to draw France together against the city until a "regular" French authority at Versailles under the great General Thiers was fighting the forces of the commune inside the city.

In what is known as "bloody week," the last of May when the city finally fell, about 20,000 people were killed. Shortly afterward, another 2,000 were summarily executed; 40,000 people were put on trial and 5,000 deported for life. More blood was shed in that May than during the entire Reign of Terror in the French Revolution.

Military Glory. *Thomas Nast. 1870. Wood engraving. From* Harper's Weekly, *November 12, 1870.* (NYPL).

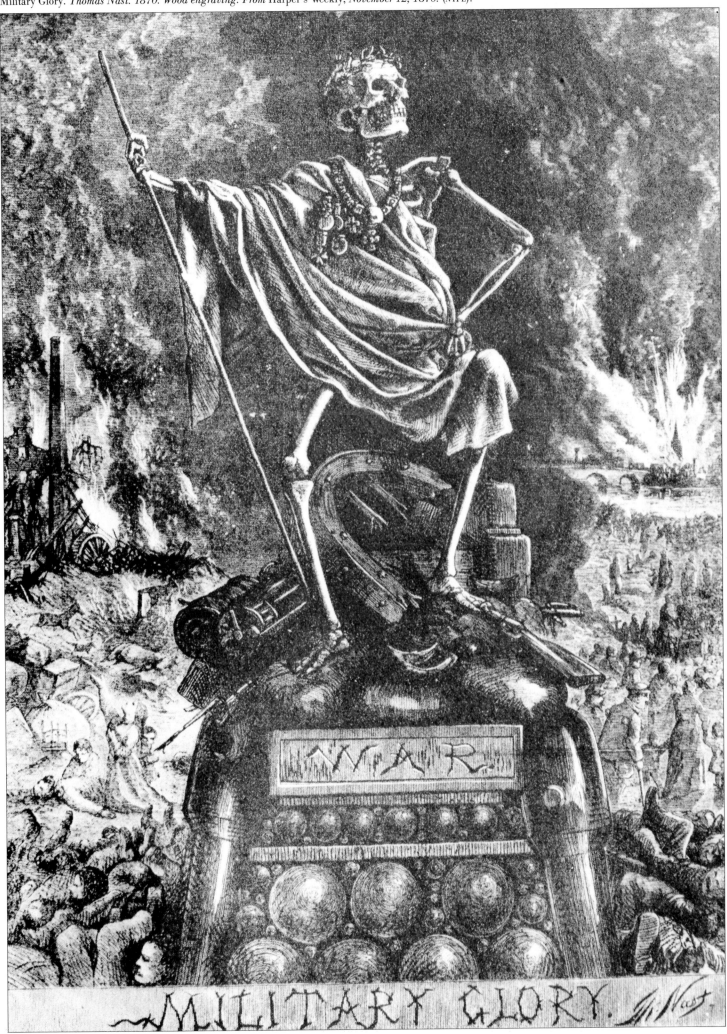

La Guerre. *Henri Rousseau. 1894. Oil on canvas. (Musée du Louvre, Paris).*

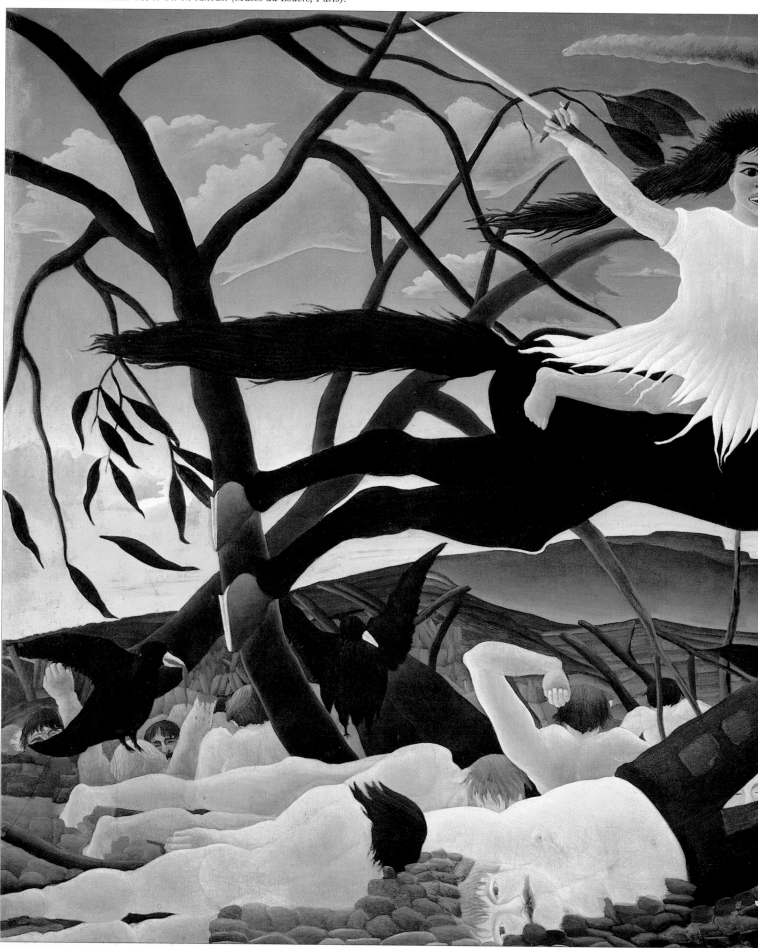

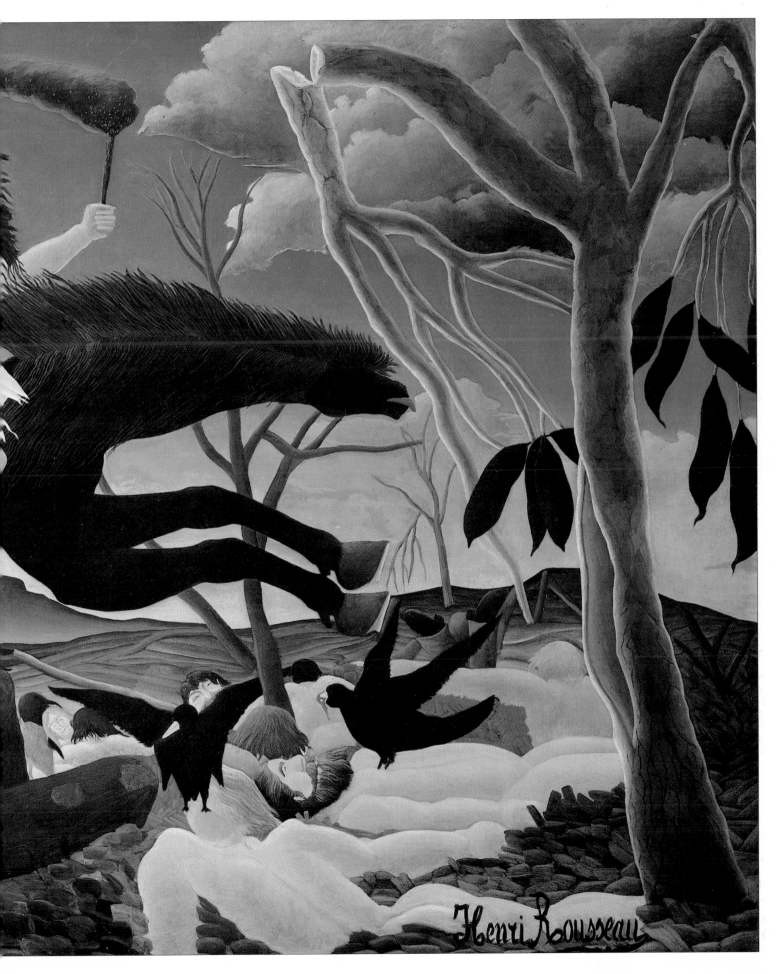

Henri Rousseau

BABY VIETNAM

The Spanish-American war was the first fought by the United States that aroused intense and bitter opposition since the Revolution. When it began, with the intention of seizing Cuba and some other Caribbean holdings of Spain, it was probably a popular war; certainly it was approved of in the press, even though it was a perfectly transparent effort by the United States to take its place among the world powers by establishing, if only on islands here and there, a world empire. In hindsight the silliness of pretending that such an empire would entitle Washington diplomats to talk to imperial representatives of Germany or England should have aborted the war before the first shot. And someone might have recalled that, at the outbreak of the previous war America fought to take Spanish territory, the Mexican-American war 50 years before, it was Abraham Lincoln who demanded that the administration show him one drop of American blood the Mexicans had spilled to cause the war.

But what turned the war sour and brought down the wrath of the press on Washington was the long war for the Philippines. It began as a simple diversion, an intervention into a situation where rebels out in the country were already threatening what was left of a government. And it went on for several years, with the commitment of increasing numbers of American troops—many of them members of National Guard units who were told they would serve six months and then return.

As the war dragged on past the turn of the century, protest came not only from the press and from popular organizations, but from many state governors who demanded the return of their National Guard troops. Further, there were press accounts of atrocities committed against Philippine natives by Americans. The cartoons of the time that had begun as ridicule eventually turned venomous. It is probable that the murder of President McKinley and the change of administration thus brought on while the war was in progress had as much to do with a change in public opinion, and with President Theodore Roosevelt's moves to end the war, as any evidence that came from the warfront itself or any change in American policy in the world.

TOP
Daddy, are you going to kill some other little girl's father?" *Anonymous. 1898. Watercolor. From* Life *magazine.* (SCPC).

BOTTOM
Uncle Sam Has a Touch of War Fever. *William H. Walker. 1899. Pen and ink. From* Life *magazine.* (FDU).

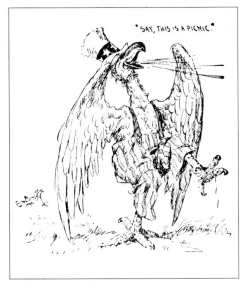

TOP
Say, This is a Picnic. *Charles Nelan. 1898. Pen and ink. From* Cartoons of Our War with Spain. (FDU).

BOTTOM
Must I Get Out? *Charles Nelan. 1898. Pen and ink. From* Cartoons of Our War with Spain. (FDU).

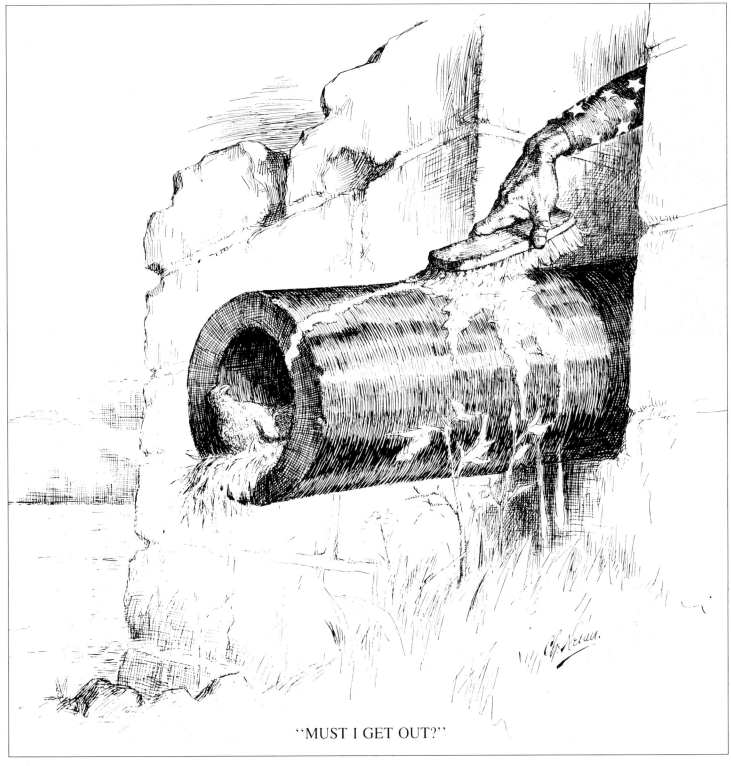

"MUST I GET OUT?"

DISTANT THUNDER

At the turn of the century the great powers of the day—Russia, Prussia, Austria, France, and England—were all in an arms race, and England was at war in South Africa against the Boers.

Many artists tried to remind people of the devastation of war and to caution them about the treachery of the peace talks that seemed to go on every year from the late 19th century until the beginning of World War I. It may be an indication of how widespread apprehension was: many artists who were not notably dedicated to antiwar movements produced works against war in the two decades preceding 1914.

Adolphe Willette, the Parisian cartoonist and painter, is not a bad example. In his long and productive life he made several series of drawings about particular wars—the Boer War, the English armed suppression of Ireland, and World War I —but he was immensely popular as a painter of Montmartre cafes and as a whimsical cartoonist and lithographer of Parisian life. His pictures are filled with attractive and sentimental coquettes and love scenes, and his hundreds of drawings of Poor Pierrot were so popular that they were gathered into several books that sold well for many years. There is no modern popular artist to compare him with, but the effectiveness of his antiwar art might be suggested if one were to imagine the impact in the late forties of harsh, brilliant, and savage presentations of war drawn by someone as popular as Norman Rockwell.

There is a striking volume of drawings published in 1907 that indicates how pervasive the suspicion of armed power was among artists in the West: *La Caricature de la Conference de la Paix*. It contains 233 prints and cartoons made by scores of artists from the major European countries.

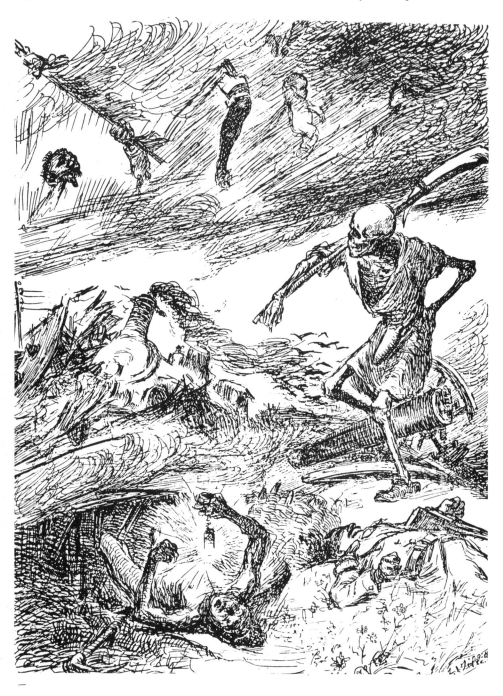

Peace or War! Forward, children. One way or another you will have to die! *Adolphe Willette. 1900. Pen and ink. From* Le Courrier Français. (FDU).

The occasion was the second international peace conference at The Hague that year. The first had been called in 1899 by Nicholas II, the czar of Russia, who said that if the nations met, revealed their armaments, and agreed to talk, war might be avoided. Between that first session and the second in 1907 the technology of war and the national arsenals had increased enormously, of course, and the spending of every large nation on arms was increasing every year. The fact that in between the two conferences Russia went to war with Japan and was wiped out in a few days did not give people much confidence in the process.

The caricature volume stripped the dignity and pretense off everyone involved, from its opening non-preface signed J. U. Venal et cie., in honor of the scorching Roman satirist Juvenal, and a sarcastic introductory letter signed by the delegate from Thule, Dr. Ari Stophane (whose letter contains a dialogue Aristophanes might have enjoyed), to its last cartoon of a medal given to all delegates with a legend proclaiming that the world wants to be fooled. It would be hard to think of an argument about war and peace that is not included in the 233 pictures in this little book, pictures done by the outstanding cartoonists and print artists of the day, from Walter Crane to Th. Th. Heine to Henriot to Louis Raemaekers.

Some of the cartoons are simple ridicule of the hypocrisy of the delegates and the nations they represent, but a striking number of them caution the world about the danger of a war that was certain to come, if only because every nation sending delegates to the second conference was busy arming itself more powerfully even while the conference went on.

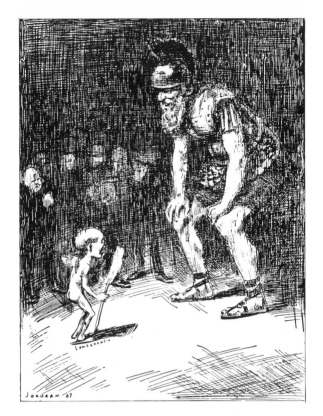

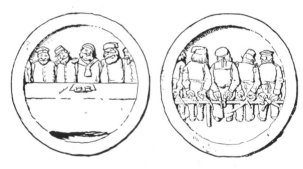

TOP RIGHT
At the beginning of the Peace Conference.
L. J. Jordaan. 1907. Pen and ink. From
La Caricature de la Conference de la Paix. (FDU).

NEXT
Frontispiece from La Caricature de la Conference de la Paix. *Anonymous. 1908. Pen and ink.* (FDU).

CENTER
Medal of the Peace Conference (front and back).
Anonymous. 1908. Pen and ink. From La Caricature de la Conference de la Paix. (FDU).

NEXT
No Witnesses. *Anonymous. 1908. Pen and ink. From* La Caricature de la Conference de la Paix. (FDU).

BOTTOM RIGHT
A Consequence of the Peace Conference. *Anonymous. 1908. Pen and ink. From* La Caricature de la Conference de la Paix. (FDU).

PATRIOTIC OBEDIENCE

The vast conscriptions of men needed to fight in World War I inspired many cartoonists who immediately saw the drafted soldier as someone who had to be perfectly integrated into the new technology; for most that meant they should be either brainless or already dead.

Expressions of the themes from two very different types of artist are the headless perfect soldier of Robert Minor and the mouldy skeleton of George Grosz. Minor was a Texan who had become the highest-paid cartoonist in the country, for

the *St. Louis Post-Dispatch*, while he was in his twenties. In his life he followed a fairly straight line from old-fashioned populist protest to socialism to anarchism to communism until he became a formidable spokesman and leader in the Communist Party in his later years. At the beginning of the war he went to Europe to see the conflict for himself and returned thinking that inevitably the populations of the warring nations would break out in open revolution when they understood the horrors of the war. It was in that period, and while he was contributing to *The Masses*

in New York, that he drew the famous headless soldier.

Grosz had a somewhat more intimate acquaintance with the reality of the war. He had worked closely with John Heartfield and his brother Wieland Herzfelde and undoubtedly shared some of their revolutionary zeal, but he enlisted in the infantry at the beginning of the war and was on active service twice (the second time in a mental hospital where the authorities used his earlier art as evidence he was a lunatic and unfit for service). He was not yet as famous a figure as he became in the

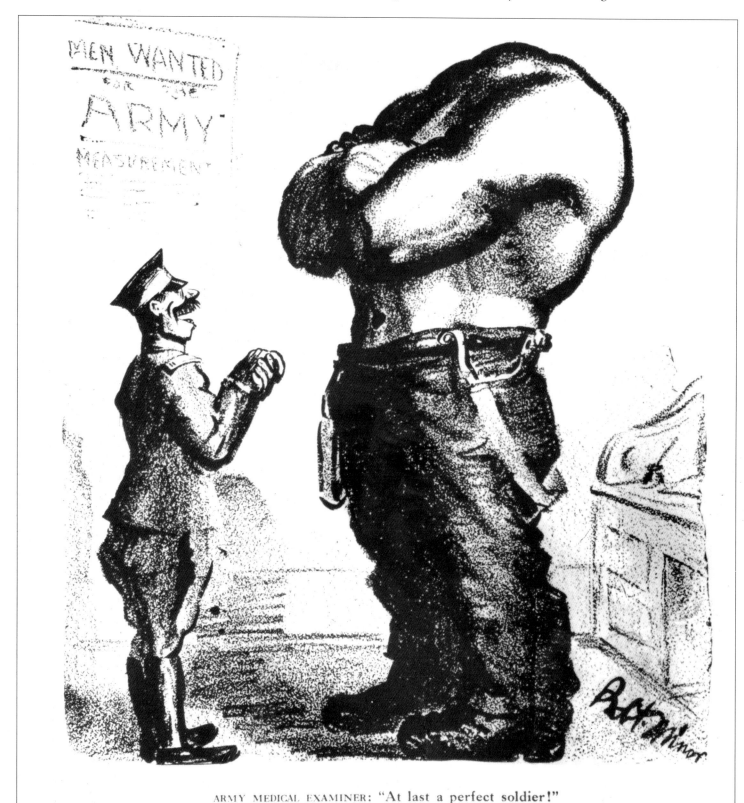

ARMY MEDICAL EXAMINER: "At last a perfect soldier!"

Weimar years when the government repeatedly prosecuted him for subversion and finally for blasphemy, but he had a large enough following to make officialdom nervous when he turned out many drawings ridiculing the military or expressing horror or outrage at the war, including the famous skeleton appearing for a physical examination before the military board and being pronounced fit by the doctor. What the doctor is actually saying is that there is nothing wrong with or missing from the recruit, or, as we would say: "A. OK."

OPPOSITE
Army Medical Examiner: "At Last a Perfect Soldier!" *Robert Minor. 1916. Crayon. Cartoon in* The Masses. *(Private Collection).*

BELOW
Fit for Active Service. *George Grosz. 1918. Pen and brush. From* Die Pliete. *(A. Conger Goodyear Fund,* MOMA*).*

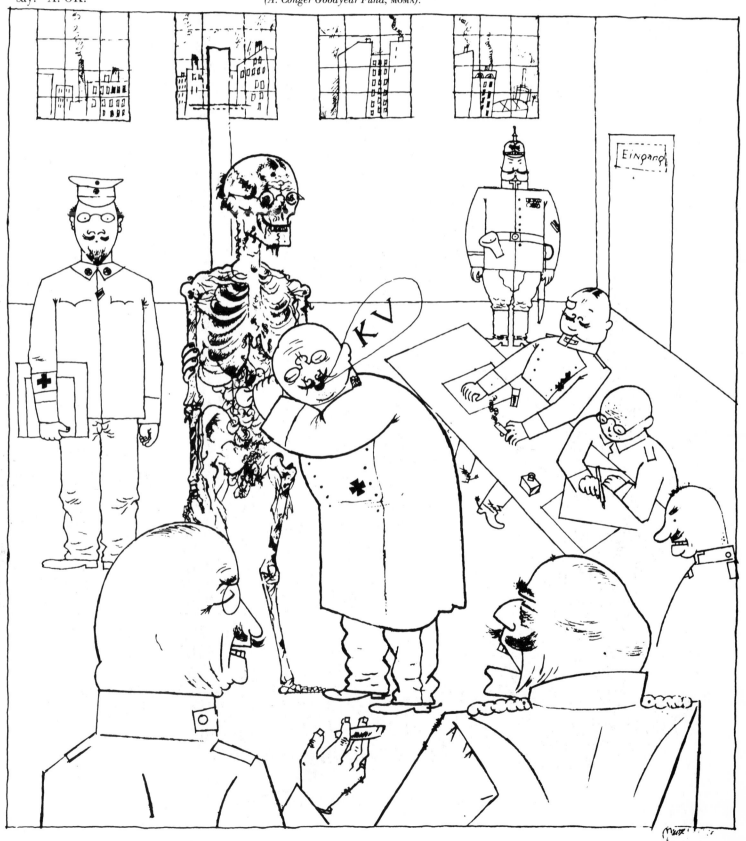

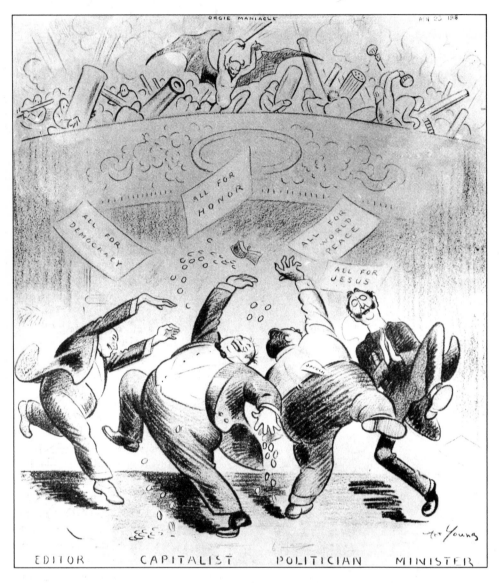

EDITOR CAPITALIST POLITICIAN MINISTER

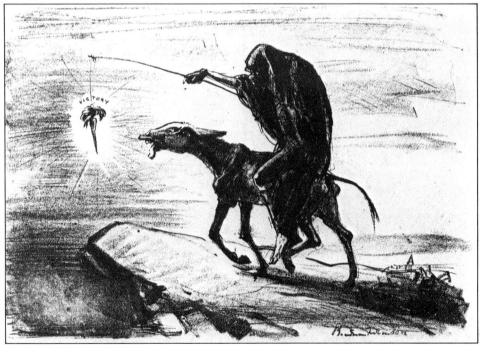

POLYGLOT PARTISANS

If the artists who contributed to it are an indication of its directions, *The Masses* under Max Eastman and Floyd Dell was hardly a party organ with a definite line. But, if its muddled mixture of socialism, anarchism, and Marxism looks confusing now, its standards in art do not. *The Masses* was willing to print good work and it benefited from contributions by an extraordinary number of cartoonists who turned to it after they had left better-paying positions.

Art Young is not a bad example. Arthur Henry Young came from Wisconsin and, early in his career, was a violent critic in the Chicago papers of the Haymarket Square rioters in 1886. By 1910 he had become a confirmed socialist and was one of the first of *The Masses* cartoonists. He was involved in the two libel suits brought against the magazine by the Associated Press, which *The Masses* had accused, in stories and in a Young cartoon, of poisoning the public wells against labor's rights. His antiwar cartoon, "Having Their Fling," is characteristic of his work and of his convictions; he firmly believed that the entire establishment was in the war business together.

Boardman Robinson's contributions to the methods of making editorial cartoons are famous. He was a Canadian educated in England who began cartooning in New York in 1907 and who was, from 1910 until 1914, the cartoonist for the *New York Tribune*. He resigned in 1914, in part because of his opposition to the war, which the paper supported, and contributed his antiwar drawings to a number of independent publications, including *The Masses*. In later years he became a famous book illustrator and muralist (there is some striking Robinson work on the walls of the Department of Justice in Washington). Among American cartoonists who opposed World War I, he produced perhaps the most striking examples of art; it is almost impossible to mistake a Robinson for anything else. But it is interesting that, in his defense of pacifists, he used the figure of Jesus Christ as a modern-day traitor to the warring state. A number of European artists played on that theme, and a few were imprisoned for doing it, but he is one of the few Americans who deliberately needled the Christian conscience that way.

Maurice Becker was himself a very committed pacifist—and he was committed to the penitentiary because of it during the war. He was born in Russia, but his family migrated to New York when he was three and he grew up on the Lower East Side. By 1914 he was selling car-

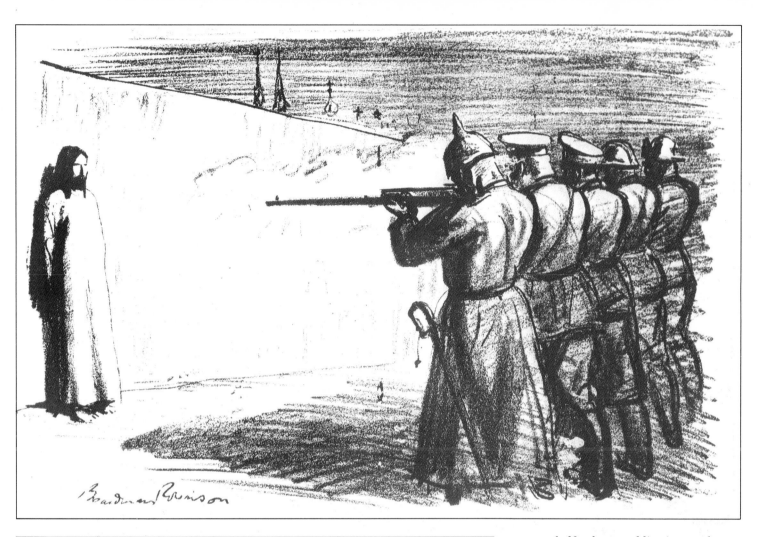

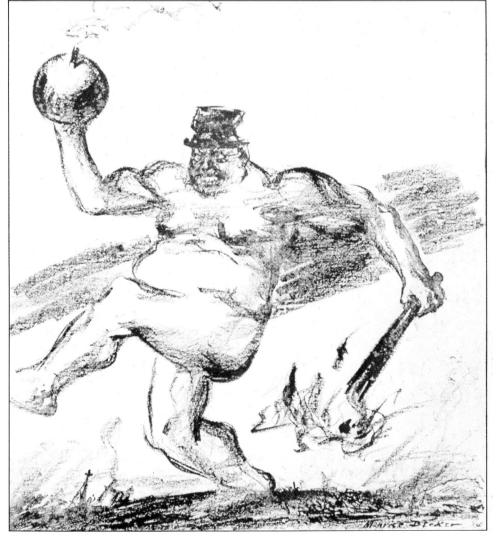

toons to half-a-dozen publications and working as an artist for the *New York Tribune,* drawing pictures of rich and powerful leaders of finance and industry. His acquaintance with their habits and looks he used with deadly effect in some of the cartoons he later did for *The Masses.* His September, 1914, cover for the magazine, shown here, is a wonderful example of the straightforward style he used to make simple statements (he was a master of many subtle styles). Becker was never as political a man as either Young or Robinson, but through a long life he remained personally convinced of the validity of socialism and of the necessity of pacifism; he refused even to support World War II in 1941 even though he was a Jew. He was convinced, he said, that all wars except internal revolutions were manipulations of powerful oppressors.

OPPOSITE TOP
Having Their Fling. *Art Young. 1917–1919. Pen and ink.* (FDU).

OPPOSITE BOTTOM
Victory, 1916. *Boardman Robinson. 1916. Crayon Cartoon in* The Masses. *(Ben Goldstein collection).*

TOP
The Deserter. *Boardman Robinson. July, 1916. Crayon. Cartoon in* The Masses. *(Private collection).*

BOTTOM
Whom the Gods Would Destroy They First Make Mad. *Maurice Becker. 1914. Crayon. Cartoon in* The Masses. *(Ben Goldstein collection).*

NAKED DEATH

First World War artists turned repeatedly to the ancient symbol of death—a skeleton—to reach the widest possible audience.

Jean Veber's drawing of the soldier at the trenches looking his enemy, death, in the face, is the most classical picture of the period. It is drawn directly from the old medieval and Renaissance traditions in which death appeared either as the companion of the soldier or as his adversary on the field.

Skeletons are everywhere in World War I antiwar art. The antiquity of the symbolism made the bones useful, but the skeleton had become much more familiar in the few preceding generations in a benign way, too, as the science of medical anatomy progressed.

Henry Glintenkamp's famous cartoon of death measuring the recruit for his coffin got Glintenkamp indicted in 1917 under the American espionage act. He fled to Mexico to avoid trial and left his editors at *The Masses* to fight the indictment on

their own.

In a war that left seven million men dead there was enough for artists to picture. The Dutch artist Louis Raemaekers returned many times to the theme. His widely reprinted etching of the grim reaper cutting down endless fields of men with a scythe is a modern classic. And his awesome robed skeleton drinking the good health of civilization from a huge chalice of blood was done in bright color in a deliberate, and successful, effort to shock anyone who saw it.

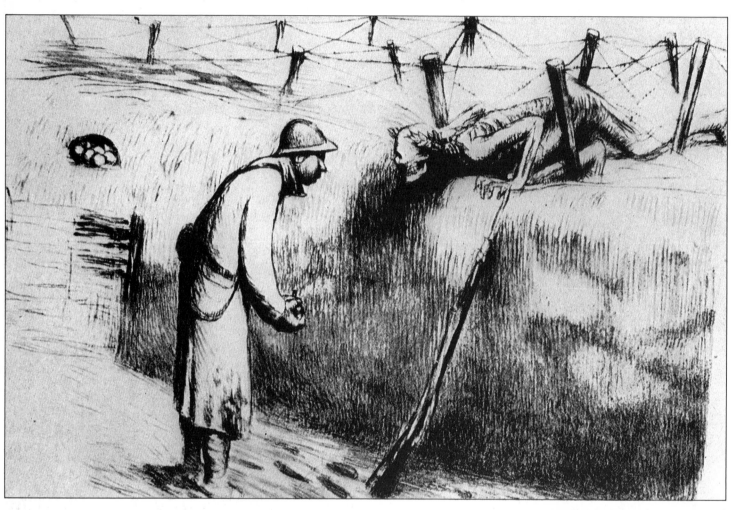

TOP
Face to Face. *Jean Veber. 1917. Pen and ink. From* Caricatures No. 31. (FDU).

BOTTOM LEFT
The Harvest. *Louis Raemaekers. 1914. Pen and brush. From* Cartoons Magazine, 1915. (Collection of Steven Heller).

BOTTOM RIGHT
A drawing on the subject of conscription. Henry Glintenkamp. 1917. Crayon. Cartoon in The Masses. *(Private collection).*

OPPOSITE
Cover of The Toppling of Civilization. *Louis Raemaekers. 1917. Brush and ink.* (SCPC).

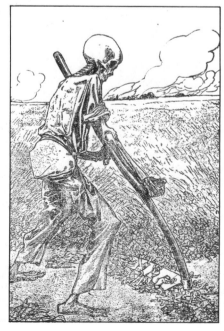

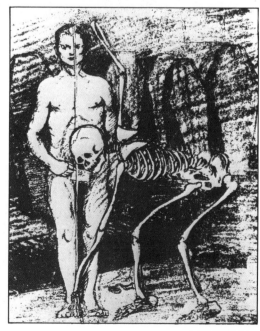

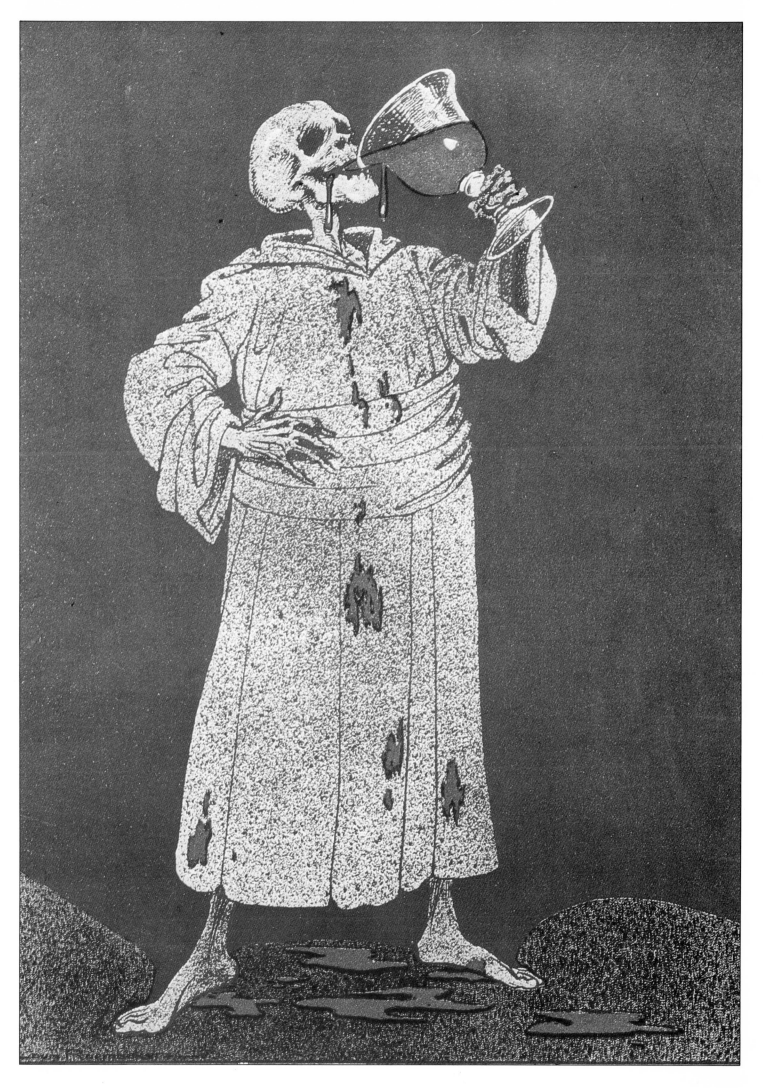

Attaque du Chemin des Dames. *Luc-Albert Moreau. 1917. Pen and ink.* (MDGM).

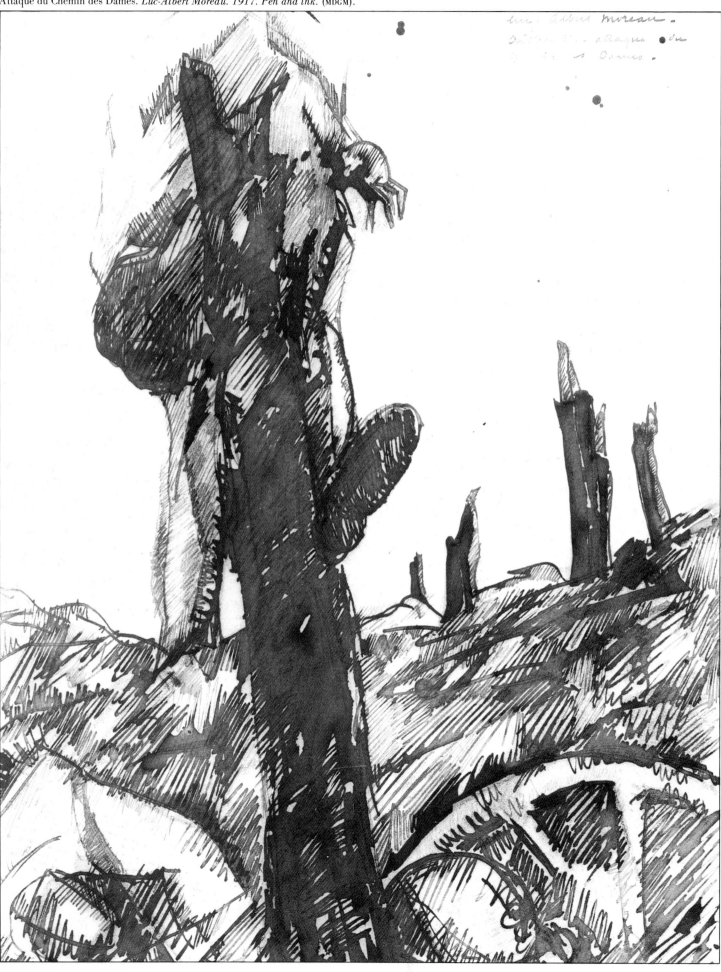

THE GOUGED EARTH

In the generation before the war the Impressionists and their followers had given art a new vision of landscape and its flora that was as profoundly popular as any new artistic vision since the Renaissance. It was so powerful that it gave rise to philosophical speculation about the reality of vision as well as to countless literary witticisms about the superiority of an artistic rendition to the real thing.

But the war brought into action an array of machines of unprecedented power: not only great vehicles that ground up the earth but massive artillery that cratered and shattered it. This aspect of the war was most telling on the painters of the time. Paul Nash, the lyrical artist of the English countryside, went to the Western Front as a government artist. His paintings—*We Are Making a New World* is the most famous—derive much of their power from his imposition on the actual chaos of the battlefield of a highly orderly structure of line and light.

Jacques Villon came closer in his pictures of the bloody fields to the actuality one sees in photographs of the devastated landscape. Some line artists produced drawings and etchings of a delicacy reminiscent of Callot to illustrate magazine stories about the war, but Luc-Albert Moreau, who was very popular in the magazines, used his pen mercilessly to emphasize the horror of the war. His large 1917 pen drawing of the *Attaque du Chemin des Dames* is not only a fearful picture of the battlefield with gouged earth, metal debris, a helmet, and a broken wheel, but he looked back to Goya's "Disasters" for inspiration and hung a mangled soldier's carcass on a blasted stump as part of nature to be seen in France at that time.

TOP
We are Making a New World. *Paul Nash. 1918. Oil on canvas.* (IWM).

BOTTOM
The Shellhole, Champagne, 1915. *Jacques Villon. 1915. Pen and ink.* (MDGM).

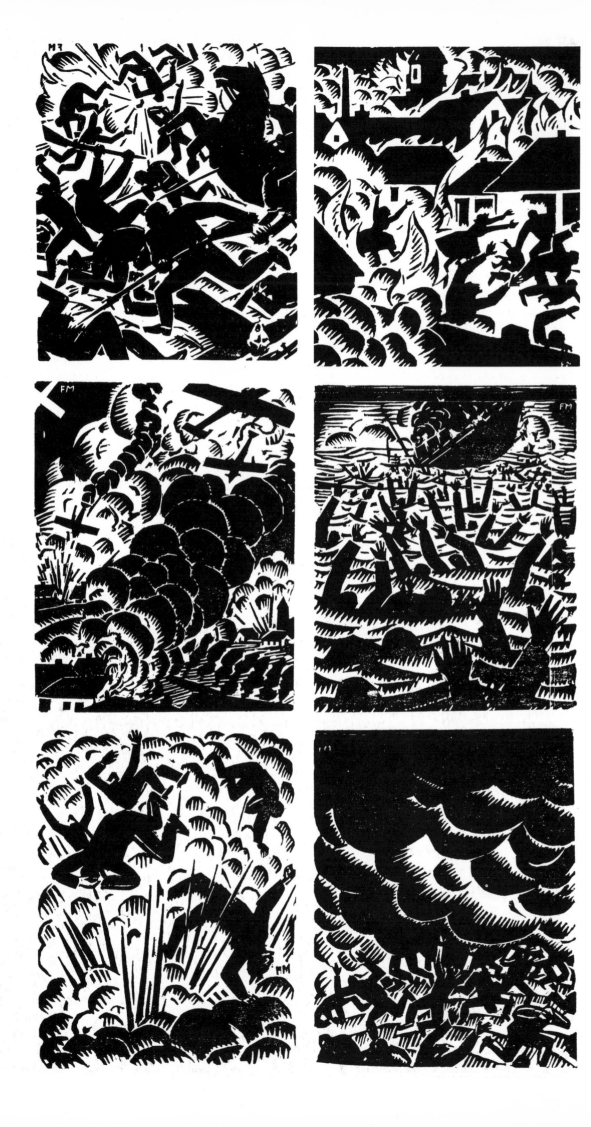

MASEREEL

Frans Masereel produced such an enormous amount of art against war, not only during two world wars but in the years between, that his name might enter the language as a synonym for outrage at inhumanity.

He was a native of Belgium who once said he had a very happy childhood, full of music, literature, travel, and especially, according to his friend Romain Rolland, sports of every kind imaginable. He was twenty-five when World War I began, and the war seems to have galvanized all his intellectual energies and artistic skills at once; he produced at least 800 prints and brush drawings depicting the violence of the war, but also his view of its suffering, its causes, and his animus against what we now call the military-industrial complex.

During the war, in Switzerland, he not only made great numbers of woodcuts for books, pamphlets, and periodicals but became one of the principals in the editorial staff of *La Feüille*, a left wing and pacifist newspaper that mixed art and politics with more energy and wit than any of its contemporaries. When he was seventy-eight, in an introduction to a volume of selected prints, he wrote in his heavy black pen: "What is more horrible than war, more idiotic, more criminal?" and he confessed his astonishment that anyone could remain indifferent to such a monstrosity.

In fact, in spite of the enormous energies he put into his work during the first war, it was really only in the twenties and thirties that he became an international figure in art. In part that delay may have been a result of his clearly inimitable style—inimitable only because the massive inking of his woodcuts echoes so much of antique art that anyone who produced anything vaguely similar would be accused of copying. But another factor is that many people initially found him a bit inaccessible. His imagination seemed to know no limits; there are very few repetitions in his hundreds of war scenes. But there is also a strong literary content to all of them—as dozens of prominent writers who provided commentaries for many of them discovered quite early. You could strip away the titles and any lines of comment Masereel or others supplied for his prints, put all the prints together into a huge volume, and read it like a book. He is also one of those artists whose vision grew enormously through the years—not only the artistic vision, but the political one. In his late work, especially that during World War II, you will find virtually every contested political and moral theme any writer or thinker has identified about the war, its aims, its morality.

Among the most striking images Masereel produced during World War I are a series of plates for Henri Gilbeaux's book, *Demain.* The human beings pictured on the title page as laborers with pick and shovel against a background of vast industrial structures are, in the book, blown up, drowned, bombed, burned, and shot in pictures of almost hopeless somberness. But he also had powerful ideas about the sources of such mayhem. The print from *Les Tablettes* simply captioned "January 1918" is characteristically powerful and, in spite of the apparent simplicity, loaded with artistic and literary allusions as well as political doctrines.

OPPOSITE
Illustrations from Demain. *Frans Masereel. 1915. Woodcuts. (Private collection).*

BELOW
Illustration from Les Tablettes. *Frans Masereel. 1918. Brush and ink. (Private collection).*

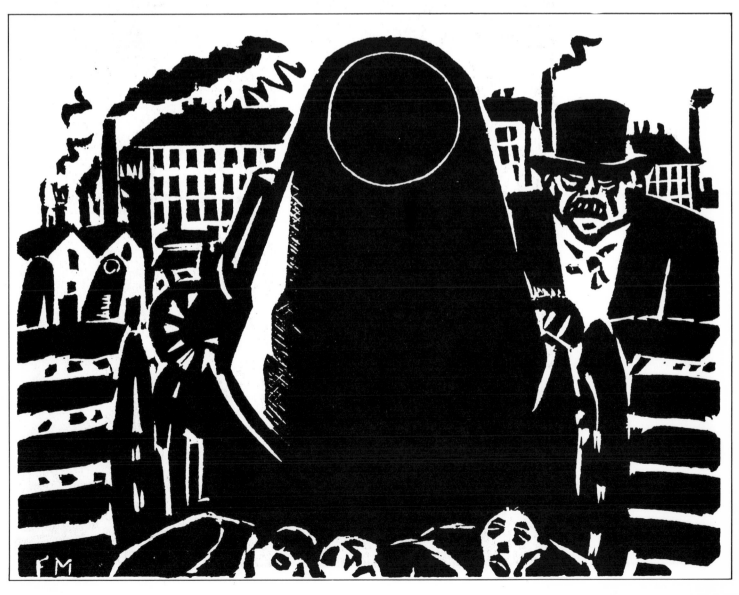

ARMAMENTS AND MEN

Or women, as the case may be. The armaments of World War I seem almost like toys to us nowadays, but their power and remoteness was awesome to people at the time. People had known the effectiveness of cannon and rifles in other wars. But in World War I a number of factors combined to make that power seem irresistible. The numbers of enormous weapons used were unprecedented; they were not used in some battles in contained areas, but everywhere. And, for the first time, machines simply replaced horses and men as carriers of both weapons and troops; airplanes were used in the war and on the ground tanks made their first appearance. It was immediately apparent that, no matter how heroic a resisting army might be, if it had not an enormous force of great machines at its disposal, it would be overrun. War could be created by men, but it could no longer be fought, won, or controlled by them.

The Dutchman George van Raemdonck tried a bit of ridicule in 1914, à la Callot, in his all-provident Bertha, picturing the great Krupp gun the manufacturers had named for the mother of the family as a woman whose skirt and bustle were decorated with skulls. The cannon she caresses, loaded from behind her back, is aimed by her as she gazes kindly through a lorgnette whose stem is a human leg bone. Jong's drawing of a great artillery shell pinning down Antwerp in the first Prussian assault concerns the same subject, but in a very different way.

An American cartoonist of the period tried a little gentler satire with his cosmic picture of Earth ringed by weapons (69 years later this picture seems oddly prophetic) while Saturn peers out from his own rings and calls the little planet a punk. But the ordinary man's image of the machines of war in that age is suggested by the L. J. Jordaan drawing of the huge robot armed with bomb and grenade, driven by vast wheels, simply walking right over the little human soldiers behind their barbed wire, armed with their little weapons. In Jordaan's case the message is clearly against the German war machine, but it is also against the war machine itself.

The Robot. *L. J. Jordaan. 1917? Pen and ink. From* De Groene, *an independent weekly for the Netherlands.* (WL).

WHO WINS?

The question was asked by hundreds of artists in different ways as the war ended its fourth year, and the best hope was that eventually it would simply end altogether because no one could go on with it.

The notion that survivors, even if they were heroes, could only get help from themselves was as common then as it is now. In the midst of the war, Georges Du-hamel in his magnificent *Vie des Martyrs* had observed that Paris seemed a city filled with men who had only one arm or one leg, an odd sight for the elegant old city of light. Perhaps no one—not even modern filmmakers—made the impression more enduring than the Hungarian artist Pal Sujan did in his poster for the 1917 exhibit of art in Bratislava about the miseries of the war, in his picture of the one-

armed veteran hoeing with his mechanical arm. And Reginald Marsh picked up the theme from poet Thomas Gray, that the paths of glory lead only to the grave, in his somber picture of the hero's caisson draped in a flag leading a march of statesmen to the cemetery.

ACROSS
The Path of Glory. *Reginald Marsh. 1921. Crayon. From* Disarm, *published by the League for Industrial Democracy.* (SCPC).

RIGHT
Untitled (from Les Croix de Bois*). André Dunoyer de Segonzac. 1921. Drypoint and etching. (Rosenwald Collection,* NGA).

OPPOSITE LEFT
Exodus. *Théophile-Alexandre Steinlen. 1917. Lithograph.* (SCPC).

OPPOSITE RIGHT
Pal Sujan. 1917. Poster for National Exhibition for War Relief, Pozsony, Hungary. Lithograph. (IWM).

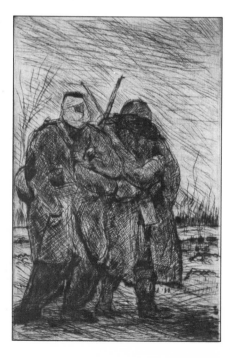

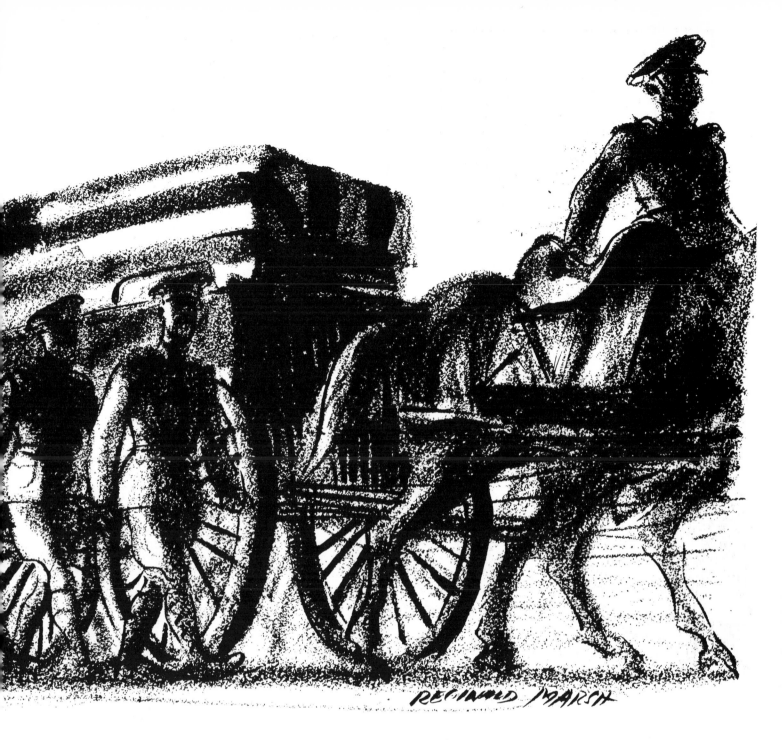

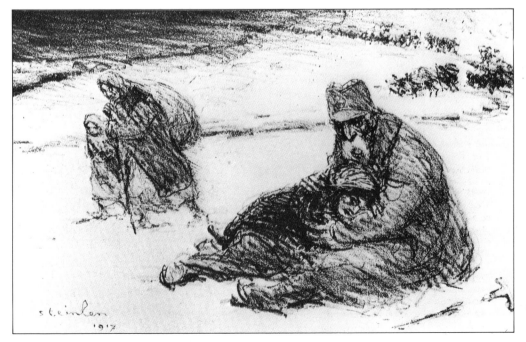

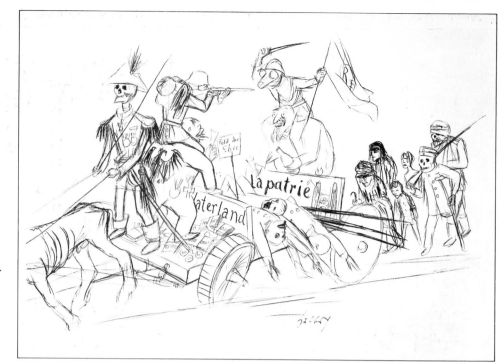

THE LOST

When the war finally ended there was simply nothing left of Germany or the Austrian empire. The impregnable Prussian monarchy had been whisked away in a little revolution in November, 1918, that any of the Prussian kings before then would have blown away in a single assault. A brief attempt at a socialist state was doomed from the beginning. In Austria the dual monarchy of the Hapsburgs, a family that had held power in Europe for 1,000 years and total power in Austria half that time, simply disappeared, and from contemporary accounts it is hard to find that anyone missed it much.

The bitterness the war left behind was lethal to hope. It is what gives the flavor not only to many of the conservative movements in the Weimar era, or, for that matter, to Adolf Hitler's *Mein Kampf*, but it also found expression in the work of many German artists who were against the war entirely. For a time German popular art about the war was an art of revulsion and of rather violent recrimination. Even attempts at humor, like Karl Hubbusch's drawing of death driving the last caravan, with Germany and France still menacing one another on the death wagon while the wretched survivors stump along behind (including death on a crutch), is merely bizarre. Gentle Max Beckmann produced a series of drawings in 1919 so macabre they challenge the most dreadful excesses of medieval flagellants. Even George Grosz's *Pimps of Death* is absolutely unrelieved by saving insight, hope, or humor. A modern unprintable expression about what to do to death is the obvious message of the whores with death's heads, and there is no relief from menace in this awful picture.

TOP
The caisson of war. *Karl Hubbuch. 1930–1931. Pen and ink.* (HK).

BOTTOM
The Last Ones. *Max Beckmann. 1919. Lithograph, printed in black. From* Die Holle. *(Larry Aldrich Fund,* MOMA*).*

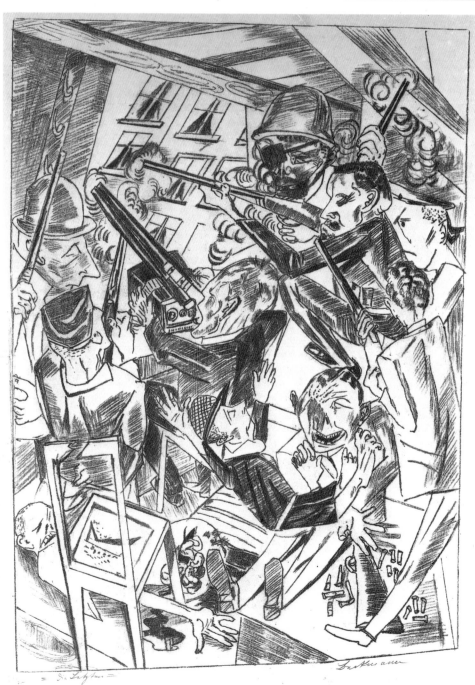

The Pimps of Death *(from the portfolio* Gott mit Uns). *George Grosz (signed Boff). 1919. Pen and ink. From* der Blutige Ernst. (KD).

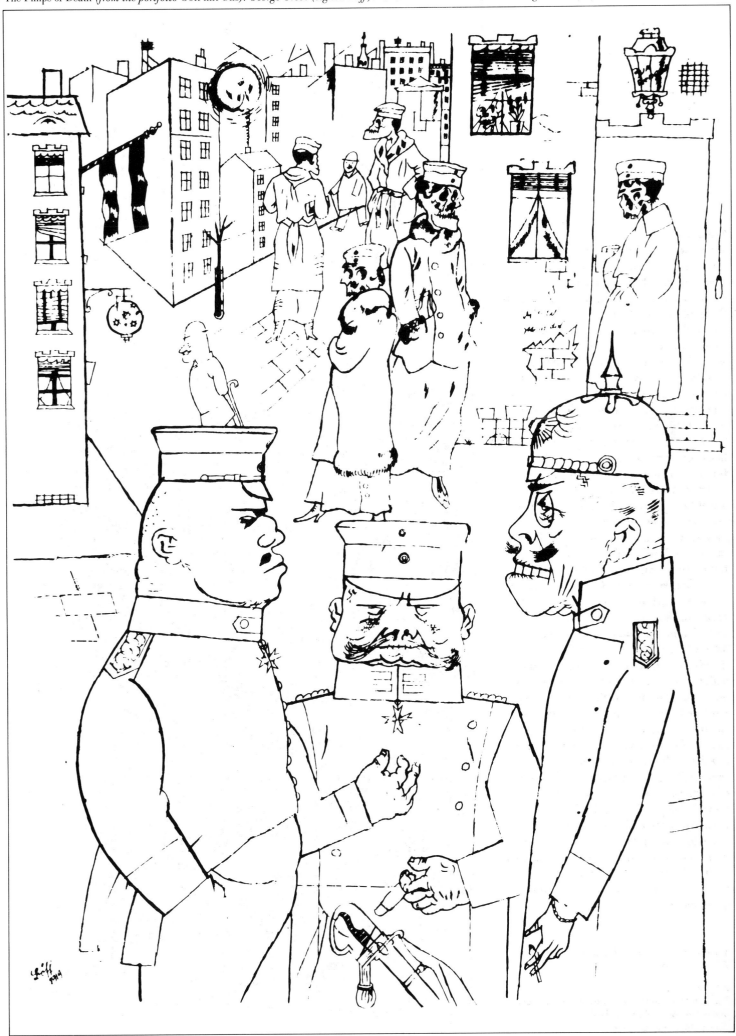

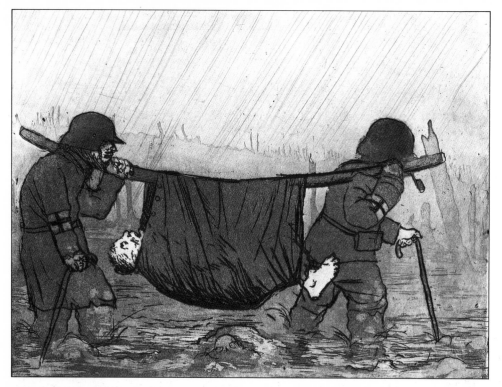

MAYHEM IN THE MEMORY

Otto Dix had not the bitterness of Grosz or the ferocity of Masereel, but he was hardly a tranquil Expressionist. In the years after the war he produced a number of etchings of battle, most of them gathered into two sets along with paintings that are in many ways more shocking than anything his colleagues did. Many of his pictures are didactic, a few are ironic and a few sentimental. But there is a calm exactness about all of them that produces an emotion in the viewer he finds it hard to ascribe entirely to the artist. If one compares his color pictures of troops in the gouged earth with the pen drawing of Luc-Albert Moreau on page 54, the comparison will reveal the effect immediately.

His best pictures of the war are recollections. The most famous one, a maggoty dead sentry, is by now a cliché, and his vision of all battle as the field of death may be more powerfully conveyed in his picture of one wounded man turning into a skeleton, who is lying across another whose steel helmet is cracked like a smashed skull.

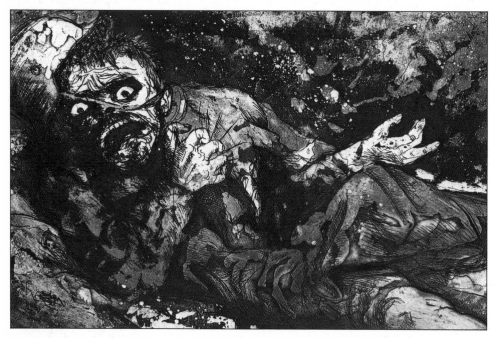

The air raid in broad daylight has one simple and terrifying message: there is no possibility of escape from a flying weapon. The wounded are borne off the field by the crippled. In one picture there is a hastily sketched skull in the ground under the slung hammock stretcher. In most of his war pictures, the faces of the dying or wounded are already becoming death masks, skulls looking out from beneath the skin. That theme becomes eerie when the soldiers wear gas masks in which the eye glasses seem to be merely dug-out sockets.

When Otto Dix recollected, the world may have been at peace but he was not, and there is nothing cathartic about his art; its effect is revulsion.

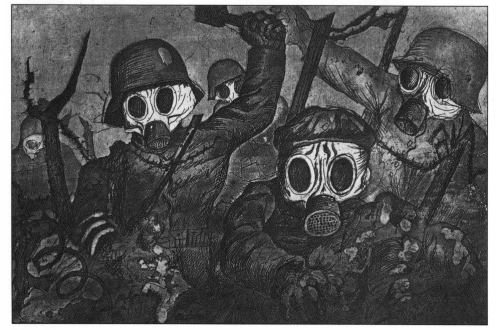

TOP LEFT
Stretcher in the forest. *Otto Dix. 1924. Etching and aquatint.* (HK).

CENTER LEFT
Wounded. *Otto Dix. 1924. Etching and aquatint.* (HK).

BOTTOM LEFT
Assault troops advancing into gas. *Otto Dix. 1924. Etching and aquatint.* (HK).

OPPOSITE
The Bombing of Lens. *Otto Dix. 1924. Etching and aquatint.* (*Gift of Abby Aldrich Rockefeller,* MOMA).

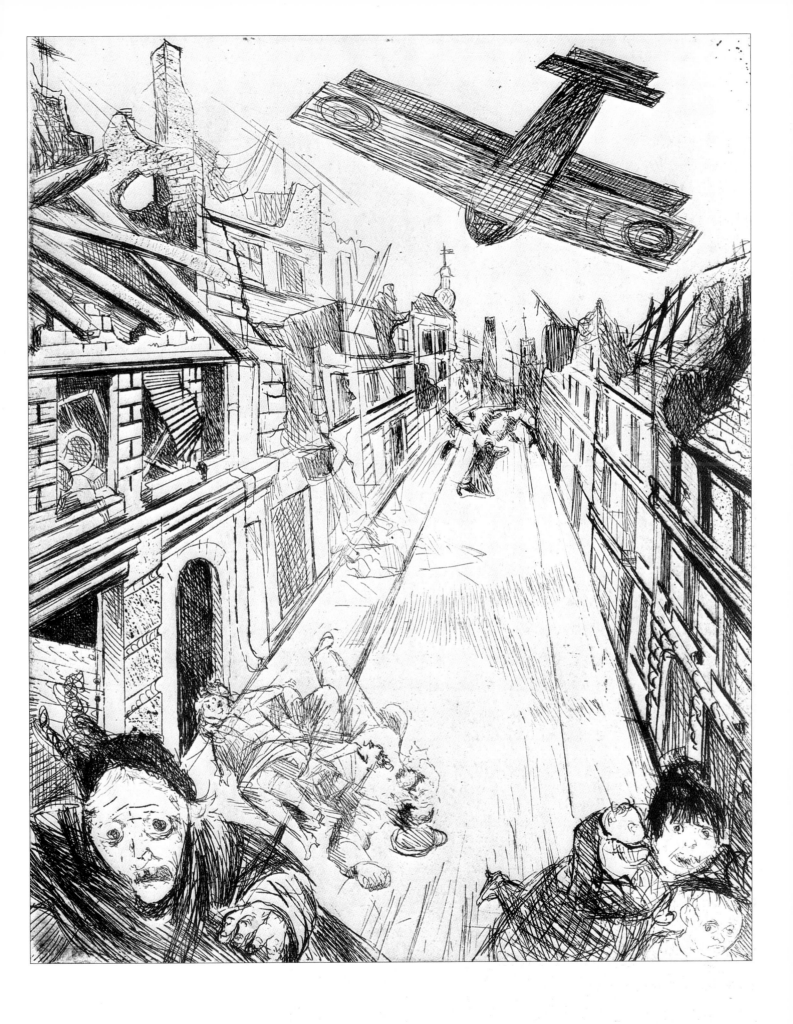

SOUL IN CHAINS

The fate of Georges Rouault's "Miserere et Guerre" series is an unnerving one, however appealing it may have been at the end to this very unmystical but deeply devout Catholic artist working in an unbelieving world.

He first conceived the idea during the first year of World War I when he was already in his forties, and he set to work on pictures clearly meant to stand in the line of Callot's and Goya's series on war. He made, then and in later years, about five dozen drawings for the series. After the war, the Paris art dealer Ambroise Vollard, who held a contract for all Rouault's work, suggested that the artist make paintings from the drawings, which Rouault did. Vollard then had the paintings transferred by a rough photographic process to 18 by 21 inch copper plates, apparently in the hope of helping Rouault turn them into etchings. Of course, to the artist the process was a disaster and he spent all his time in the years 1922–27 working on the plates so they would produce the prints he originally had in mind when he made the drawings. In 1927 the 58 plates Rouault finished were printed and the plates canceled. Vollard had intended the pictures to be printed with a religious text by Andre Saures, but the text was never written and Vollard died in 1939 when the next war was beginning.

It was only after that war, and after Rouault successfully sued Vollard's estate to establish his right to his own work, that "Miserere et Guerre" was finally released in the 450 copies Vollard had printed, with one-line captions Rouault added to them. Rouault survived another 11 years, long enough to see the book recognized as a triumph of his own art, a milestone of expressionism, and one of the greatest antiwar art books ever conceived.

The antiwar pictures in the volume are really only the second half of it, the first part being an artistic essay—or a couple of dozen of them—on the suffering of humanity seen in terms of the suffering of crucified Christ in a vision in which all history forward and backward converges on that crucifixion. Within that context the pictures of the sufferings of war take on the kind of overwhelming significance one sees immediately in late medieval pictures of the cruelties of war or in some of those from the Thirty Years War. It is not so much that Rouault lifts the suffering of mankind into the heavens as that he puts the man-God into every man and then exposes the cruel situation of man in war.

If no one of these pictures has the immediate thrust of those of Callot, it is because Rouault was struggling to create a new theology to support them. Altogether they form a text of almost bottomless grief that is somehow relieved by a hope beyond human hope. The famous picture of the skeleton wearing a military cap, captioned "Man is a wolf to man" (which comes from the Roman comedian Plautus), is clear to anyone. The picture of the soldier going to confession and saying "this will be the last time, father," while death stalks him, is much more complicated, and its meaning depends a lot on sharing Rouault's faith. The statement itself is ambiguous, since the soldier is clearly promising to sin no more while death makes certain he won't; but the real ambiguity is in the picture, since death is struggling not with the soldier but with the priest and what he represents, and it is not clear who will win.

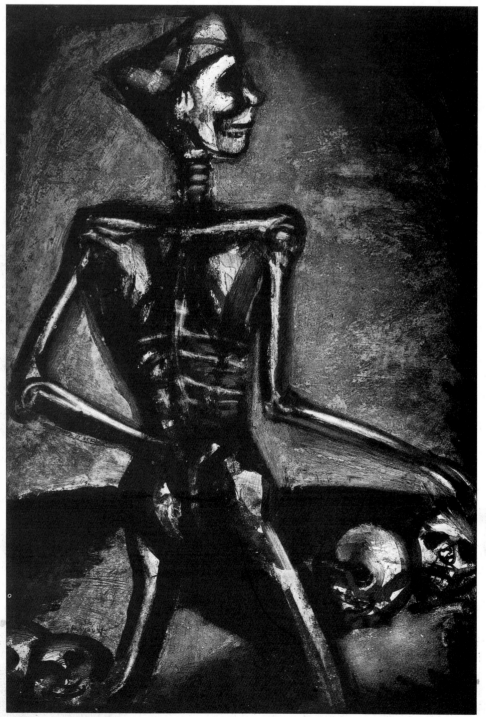

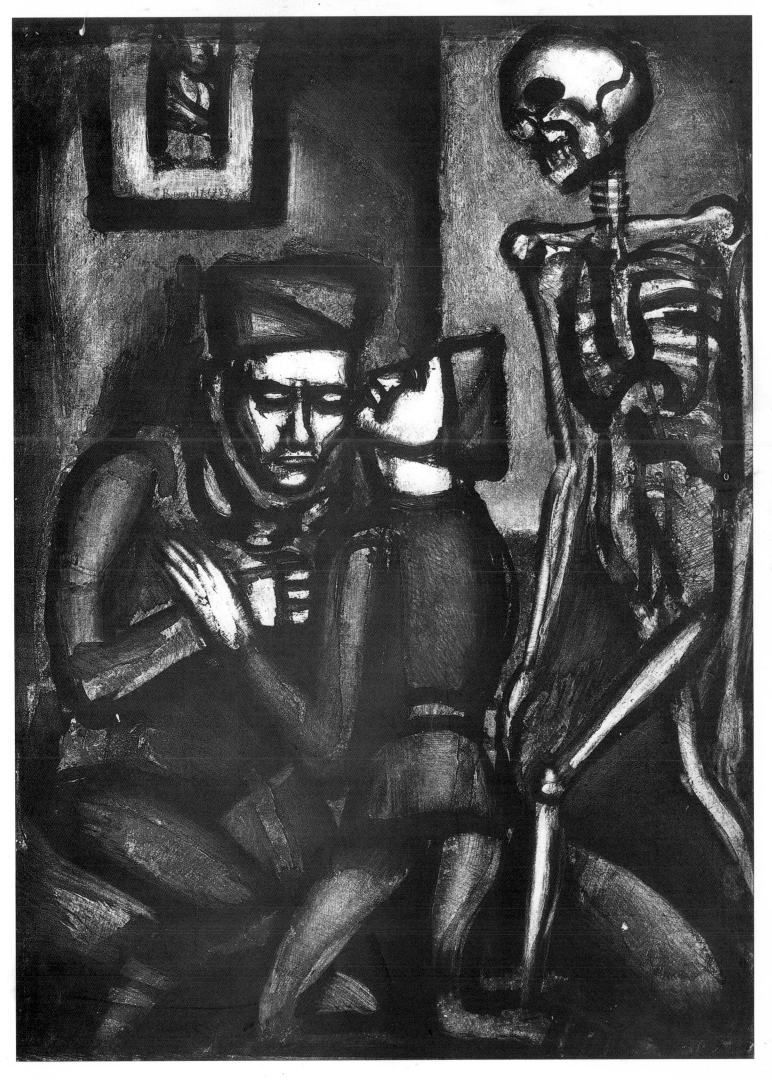

MOTHER COURAGE

If Käthe Kollwitz had created no art against war, her life would justify her as a heroine for peace; the considerable art is pure gift. When she was a child (she was born in 1867) Germany was filled with a sense of militant triumph, especially after 1871, and it was perhaps natural that in her home thoughts were often turned to the evils of war, for her parents were ardent social democrats. She was brought up not only on dreams of a better life for all people, but on the best German literature—Goethe, Schiller, Heine, the liberal philosophers—and on the Bible, taught to her by a grandfather who was a radical minister not attached to any established church. Classical themes run throughout her art and lift it out of the terrifying times she lived through in a ferocious country she loved.

Her feelings about war were given an intolerable impetus in the first year of World War I when one of her sons was killed in one of the first battles fought in the Low Countries, when Mrs. Kollwitz was already forty-seven years old. More than ten years later she completed two heroic statues, the Father and the Mother, and placed them at the entrance to the military cemetery in Flanders where her son was buried.

It was also in those years, after the first war, that she made the seven great woodcuts of the cycle on "War," which in many ways looked back on work she had done 16 years before, depicting the suffering of poor people in the Peasants War that broke out in 1525 during the Reformation. And it was in 1924 that Mrs. Kollwitz also produced what is perhaps the most famous antiwar picture of our time—the young man crying "War Never Again" as he raises his right hand in defiance.

The variety and inventiveness of her art in the next decade would be astonishing from an artist much younger who had no troubles, but she recorded also the depression and anxiety of Germany in those years. When the Nazis came to power they raided her home, searched the homes of her friends, threatened her until many friends asked her to leave. She refused, and not even Hitler's forces dared really suppress her: she was by far the most popular artist Germany had ever seen.

But she lived the end of her life in horror. When her first grandson was killed in battle in 1942 she drew the famous picture of the mother protecting her children, captioned: "Seed for the planting must not be ground." She was seventy-five and in the caption she was repeating an angry reply she had made in a newspaper in 1918 to a patriot poet who had asked one last effort by German youth to win the first war. The quotation is one every German would know immediately: it comes from Goethe.

The last years of Käthe Kollwitz's life must have been mere hell. She lost her home in bombings and was shuttled about from place to place till she landed on the estate of a nobleman near Dresden where she lived in two rooms till she died on April 22, 1945, in the last ruinous days of a war she hated, fought by a regime she hated that ruled a people she stubbornly believed could somehow find salvation in human decency.

TOP
The Survivors. *Käthe Kollwitz. 1923. Lithograph.* (GSE).

BOTTOM
Seed for the planting must not be ground. (Thou Shalt Not Grind the Seed Corn). *Käthe Kollwitz. 1942. Lithograph.* (GSE).

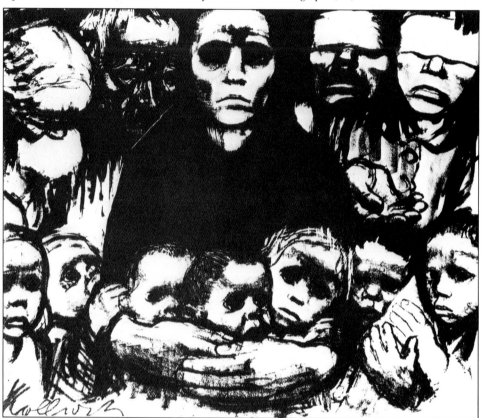

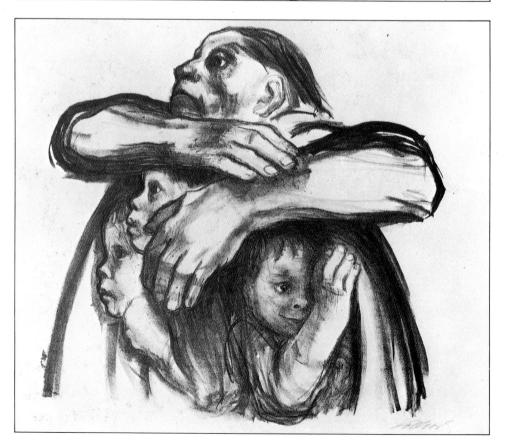

War Never Again! *Käthe Kollwitz. 1924. Lithograph (charcoal drawing).* <small>(GSE).</small>

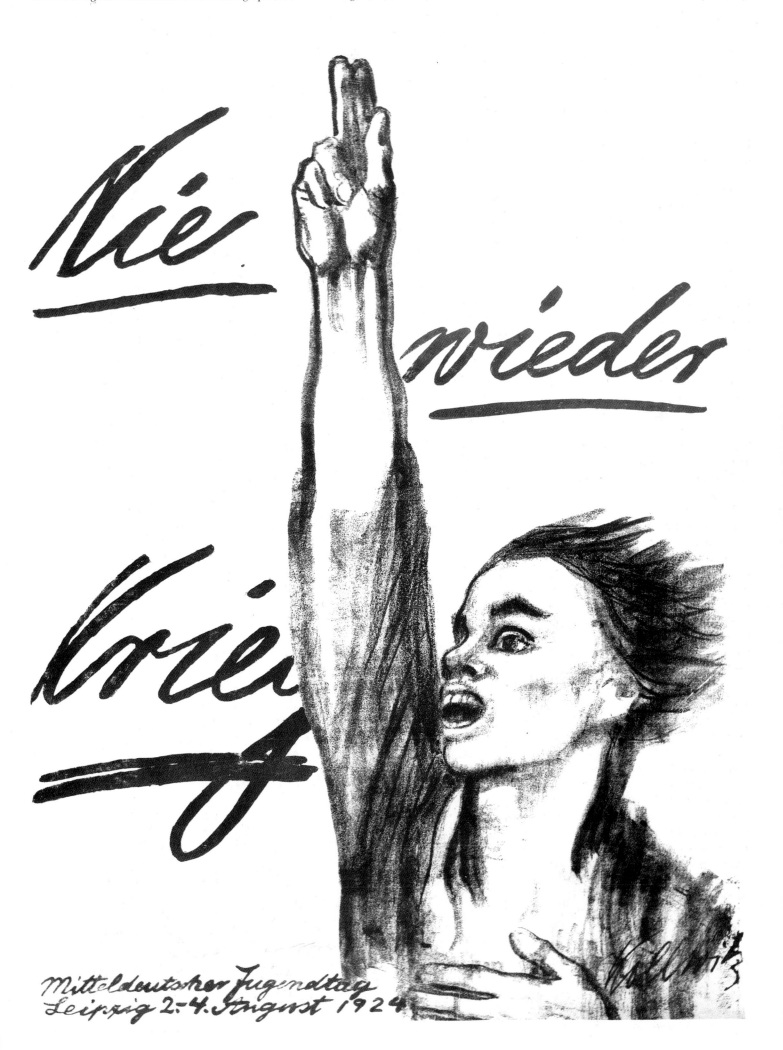

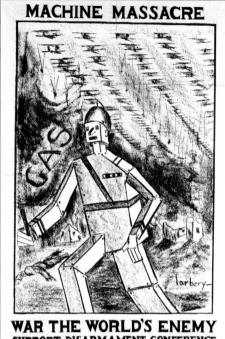

MACHINE MASSACRE

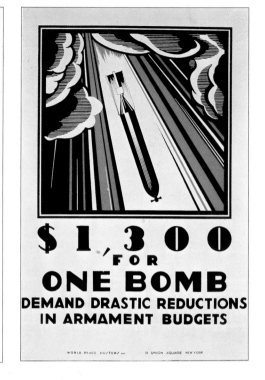

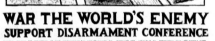
WAR THE WORLD'S ENEMY
SUPPORT DISARMAMENT CONFERENCE

$1,300
FOR
ONE BOMB
DEMAND DRASTIC REDUCTIONS
IN ARMAMENT BUDGETS

WALL ART

The 1920s and '30s were the years of the great development of color poster art in the service of all kinds of advertising and promotion, and the peace movements took advantage of the times, first in Germany and gradually throughout the Western world. Toward the end of the thirties a number of antiwar partisans also began to use the stage, films, and many kinds of literature in the United States to broadcast their messages. And before that, in the mid-thirties, the World Peaceways movement had taken to the airwaves with a half-hour show that was fairly good entertainment by the standards of the time (it would be sensationally good by the standards of our time), with music, drama, and even some comedy to promote antiwar sentiment.

But with rare exceptions these forms were too diffuse and subtle to be very lasting. The most effective means was still the most direct message, which was generally a vivid picture accompanied by a commonly understood slogan. Some, like "The Dead Cry Halt," were really transfigured editorial cartoons of an earlier era. Some, like the German poster announcing "War Never Again" and showing a worker breaking up a cannon with a sledge hammer, were designed to appeal to class emotions that were usually aroused in other campaigns—for wages, work rules, and political equality. One American poster that is meant to astonish the public by revealing that a bomb cost $1,300 is so pathetically poignant, in an age when one missile with its warheads and housing costs hundreds of millions, that one is tempted to reproduce the old banner and stick it up on highways all over the country as a kind of ironic comment on progress.

TOP LEFT
Machine Massacre. *Farbery. 1922. Poster for the National Council for Prevention of War (U.S.A.)* (SCPC).

TOP RIGHT
$1,300 for One Bomb. *Anonymous. 1931. Poster for World Peace Poster, Inc., New York City.* (SCPC).

BOTTOM
The Dead Cry Halt! *Anonymous. 1936. Poster for Women's International League for Peace and Freedom.* (SCPC).

OPPOSITE
Nie Wieder Krieg! *(War Never Again!). Heinz H. Halke. 1922. Poster for Druck Holzhauser Berlin.* (SCPC).

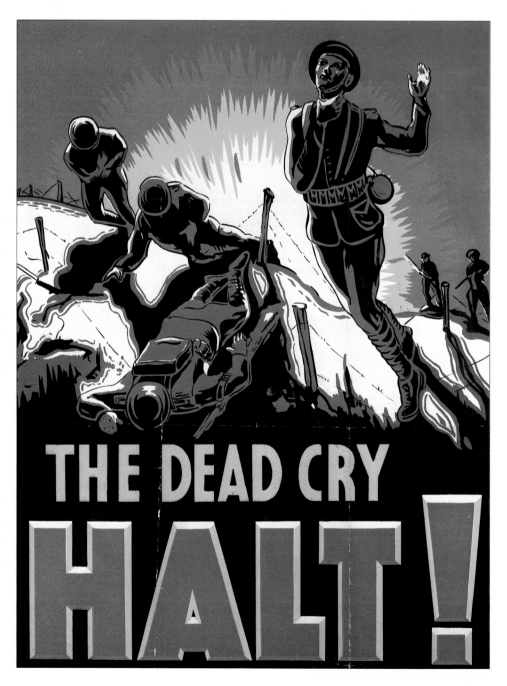

THE DEAD CRY
HALT!

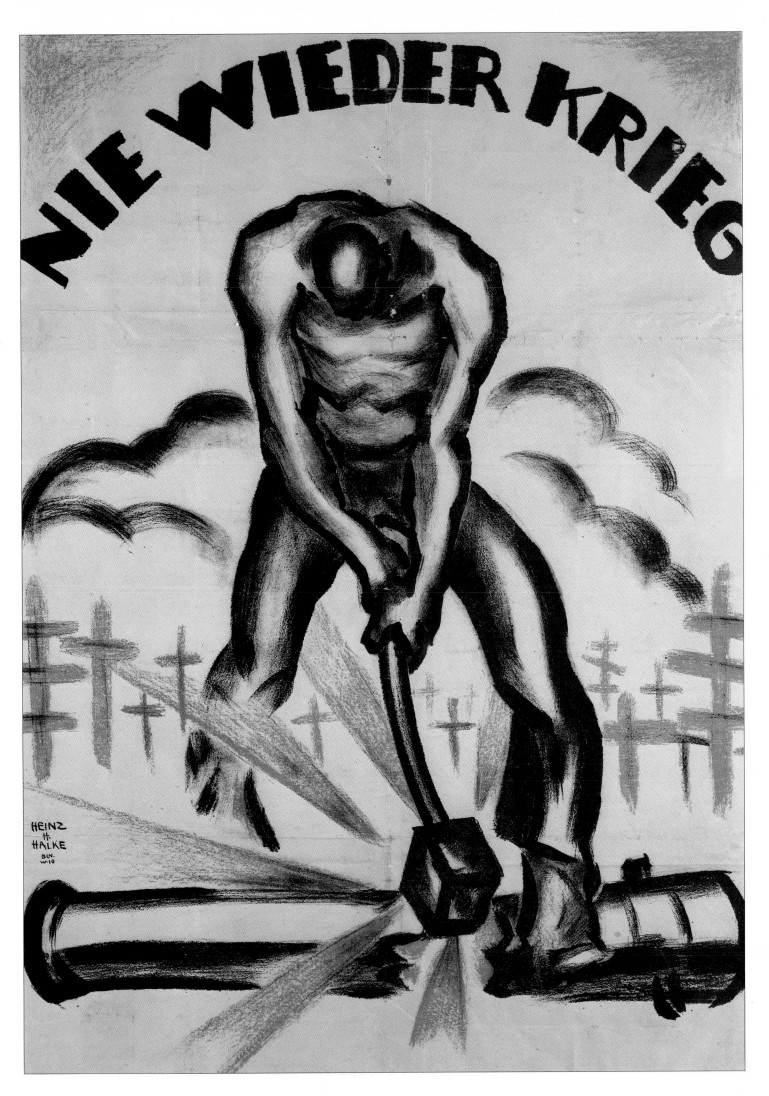

NIE WIEDER KRIEG

HEINZ H. HALKE BLN. W·10

CAESAR, WE WHO ARE ABOUT TO DIE, SALUTE YOU

Radical and liberal cartoonists in the United States kept up a steady fire against militarism during the twenties and thirties in very different kinds of publications. On the whole, they concentrated on the danger to American young people, working from memories of World War I in which the entire leadership of a generation was lost to England, France, Germany, and the Low Countries. In retrospect, there are historians who wish England had actually gone to war against Germany in 1936 when there was talk of war; it might have ended quickly. That is the kind of question that is painful to even the most resolute pacifists to this day.

In fact, in 1936 C. D. Batchelor of the *New York Daily News* drew a cartoon that won the Pulitzer Prize, on the classic theme of war as death the prostitute inviting European youth into her embrace. The theater placard outside her staircase advertised the Follies of 1936 starring Hitler, Mussolini, and an indecipherable third name.

Almost 10 years earlier Jacob Burck had published a series of drawings in *The Daily Worker* whose message was much the same. Burck, who later spent more than 40 years as the principal cartoonist for *The Chicago Sun-Times* and its predecessor paper, and who won a Pulitzer in 1941 for his poignant drawings of war, was much more radical in his own politics in the twenties and, in his style, much closer to his teachers, Boardman Robinson and Robert Minor. Their artistic influence never left him; it can be seen in cartoons he did in the late seventies, not long before he died.

His 1927 series for *The Daily Worker* insisted on one theme: if the dead are the great majority, many of them joined it at the command of leaders who not only did not care but actually invited nations to consider them the glorious dead; and he drove home the idea in pictures of government or military leaders looking at youth only as dispensable—as in the harsh picture of the military commander scooping the brains of the graduate out into a garbage can.

TOP
Move Over Buddy, There are More Coming! *Jacob Burck. Circa 1927. Crayon. Cartoon in* The Daily Worker. *(Private collection).*

CENTER
I Congratulate You, General! *Jacob Burck. Circa 1927. Crayon. Cartoon in* The Daily Worker. *(Private collection).*

BOTTOM
What D'Ya Need Them Things For! *Jacob Burck. Circa 1927. Crayon. Cartoon in* The Daily Worker. *(Private collection).*

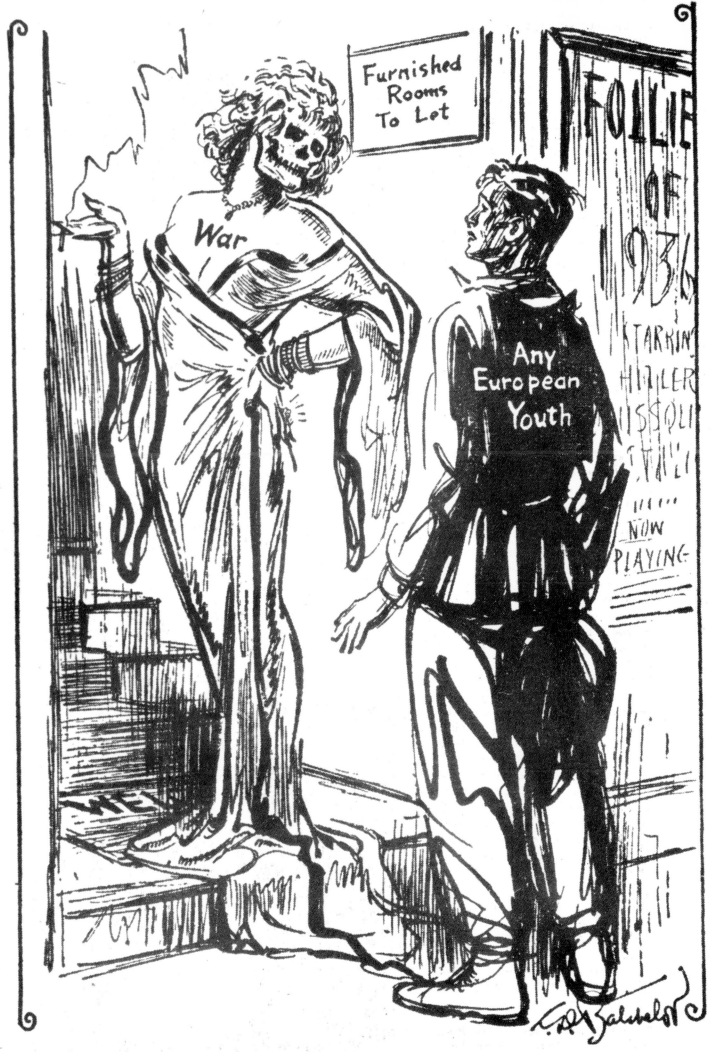

Come on in, I'll treat you right. I used to know your daddy. *C. D. Batchelor. Pen and ink. From the* New York Daily News, *April 25, 1936.* (NYPL).

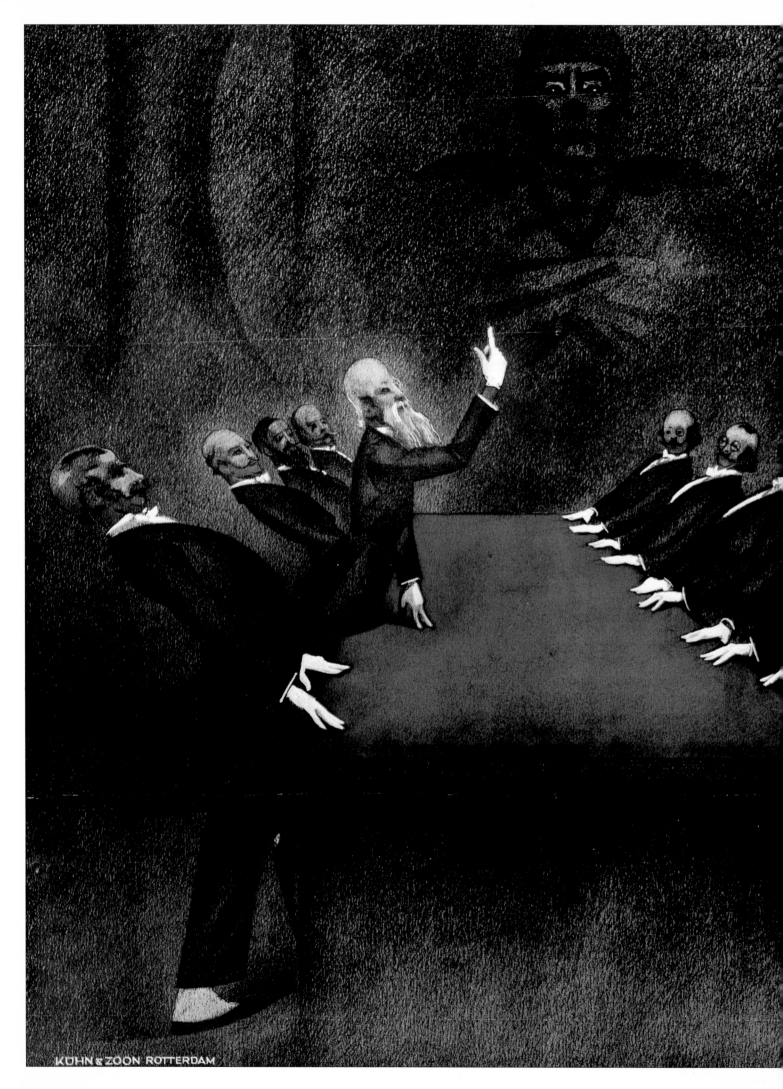

KÜHN & ZOON ROTTERDAM

PEACE, PEACE! AND THERE IS NO PEACE

Kurt Jooss's ballet *The Green Table* is as dramatic an expression of the despairing cry of the prophet as one could imagine. In the history of ballet it is important as the supreme example of a movement Jooss led to give a new form, look, purpose, and function primarily to male dancers. But it is also one of the greatest commentaries on war in the repertory of the performing arts, involving virtually every theme graphic artists of modern times have used in their work. It has the beauty of an awful nightmare and is reminiscent of many medieval visions of the triumph of darkness—like that in John Gower's terrifying 14th-century Latin poem in which the dreamer looking at beautiful flowers sees them turn into vengeful and murderous faces, only to be awakened by noise in the street that turns out to be, when he rises and looks down from his window, the shouts from a revolutionary mob of murderous faces looting and burning London. In that sense, the Jooss ballet appeals to emotions profoundly concealed in tales

and fairy tales known to every child; there lies its power, as much as in its stylized choreography and the jarring sound of the jazz piano that supplies its music.

It begins with war and ends with war, with the rage and triumph of the war god over soldiers, children, wives, mothers— and even over the statesmen who throughout the middle of the ballet, in a series of beautiful and grotesque scenes, try to negotiate disarmament and peace over a green table. Their efforts fail always because of motives they keep hidden from one another and reveal behind their backs to the audience.

If ever ballet had a political message it is in this work, what Elizabethans would have called "a dumb show," that speaks more clearly than most dramas.

OPPOSITE
The Warning. *After* The Green Table, *Ballet Jooss. 1933. Lithograph. Poster.* (SCPC).

BELOW
Photographs from performance of The Green Table, *Ballet Jooss. 1933.* (SCPC).

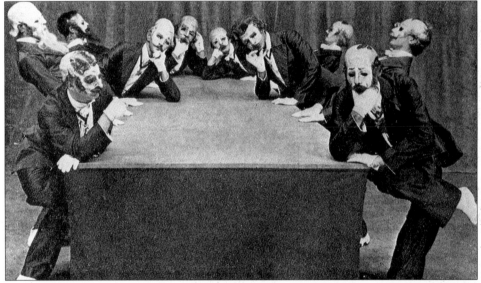

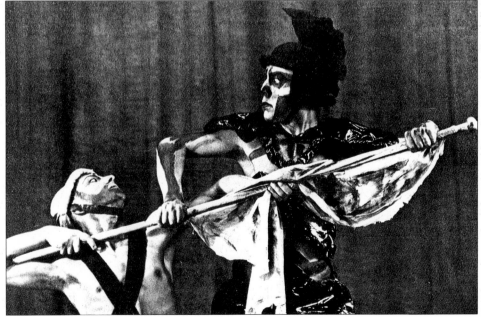

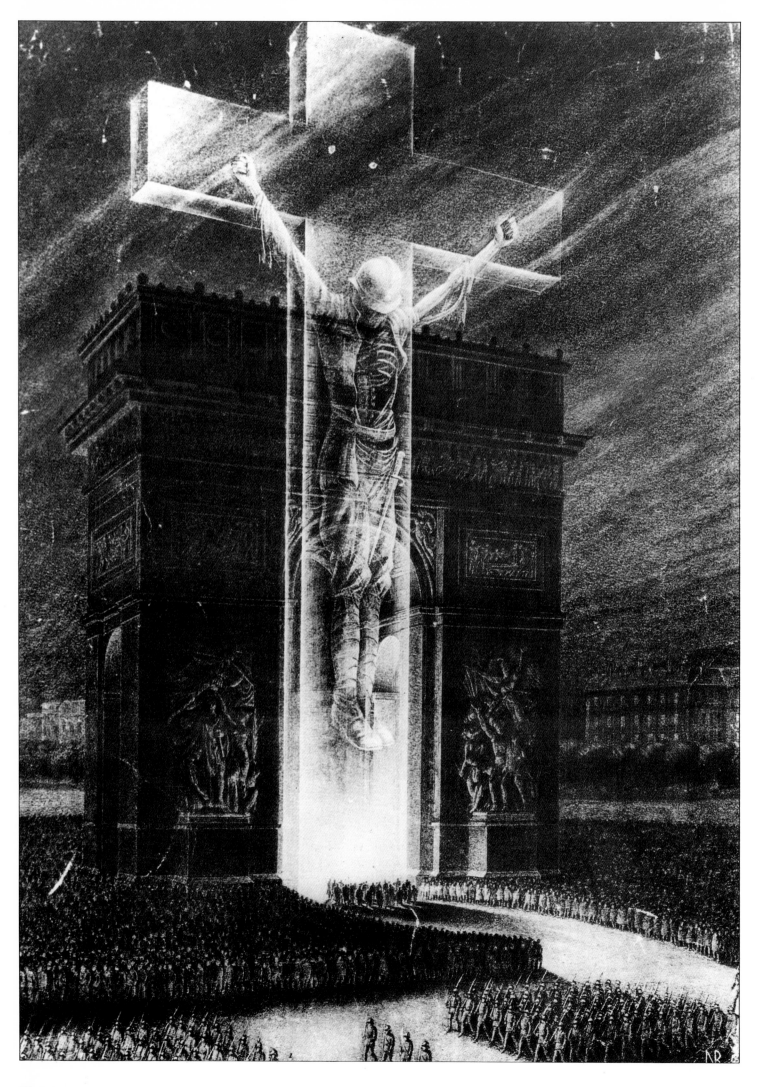

76

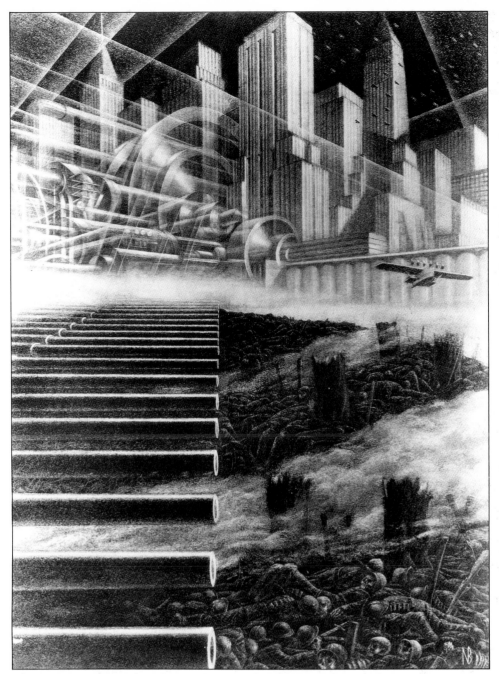

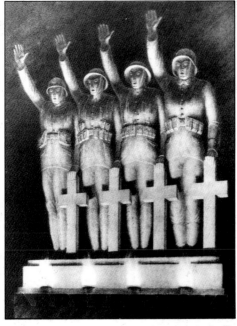

THE TOMBS CRY OUT

"All war is in fact fratricide," declared Giuseppe Motta, a former president of Switzerland who was the titular head of arms limitation and reduction talks that were held in Geneva in the early thirties. At the time such talks were not thought to be as important as several treaties limiting naval strength and armies that were negotiated by leading powers. The effectiveness of any of these activities was not an arguable proposition within a decade.

When the Geneva conference opened, the foreign minister of Poland arranged a showing of 12 remarkable pictures done by Bohdan Nowak, a Warsaw engineer and architect who had been so deeply moved by the works of Erich Maria Remarque in 1930 that he quit work and made the large sketches called *Vox Mortuum*—the voice of the dead.

They are clearly the drawings of an architect, in a monumental style that was very popular at the time not only with the public but with the designers of Rockefeller Center and the vast stadium displays of the European fascist parties. Nowak's message—each picture had a kind of sermon text in a few lines—was in a kind of Savonarola rhetoric, meant to be both somber and threatening, denouncing inhumanity, selfishness, blood lust.

Indeed, in the event, they are prophetic—the unknown soldier as the gigantic martyr hanging crucified over an enormous military parade of the kind Hitler loved to stage in his heyday; the dead standing in the raised arm salute behind the crosses over their own graves, palms out, demanding a halt to killing; and the great dream of the industrial city floating over a field of dead soldiers lying under an endless row of cannon barrels and an airplane (the text says the nations rearm because they are slaves of their own technologies, greedy for all they can get).

BELOW
The Moral of Geneva. *John Heartfield. 1932. Photomontage. Reproduced from* Arbeiter
Illustre Zietung. (ADK).

OPPOSITE
Blind power. *Rudolf Schlichter. 1937.
Oil on canvas.* (BG).

POWER LIVES

The ingrained bitterness of German resisters became starkly visionary in many forms in the thirties. John Heartfield, who had changed his name from Helmut Herzfelde during World War I as a protest, is generally credited, perhaps along with George Grosz, with inventing photomontage in 1916. He adopted the method from soldiers on the front who clipped and pasted pictures to send home secret messages about the bloodletting in the war. When police fired into a demonstration in front of the League of Nations building in Geneva in 1932, leaving 15 dead, Heartfield used the technique to create a symbol he himself used with enormous effect twice in later years and which many others have copied. His commitment to communist values is clear in the slogan "Where money thrives, freedom cannot survive," but the power of the picture is in the bayoneted dove raised in front of the palace of the League, on which the League's white cross flag has been supplanted by the Nazis' swastika.

Five years later Rudolf Schlichter painted *Blind Power.* The Nazis had already prohibited him from exhibiting any of his work, which was only seen after World War II in German museums. It is hard to imagine how they could have allowed such a painting to be seen by Germans at the time, since its central figure is not only a superb example of the kind of physical strength the Nazis favored in the human type they preferred, but its armor is made up of living creatures of hell common in medieval German art and literature, and it carries not only the weapon of war but builders' tools—all of them instruments Nazi propaganda joined together as the tools of triumph of the great race.

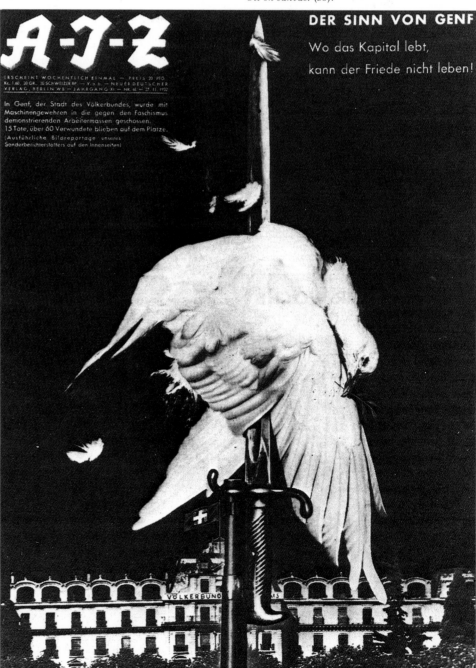

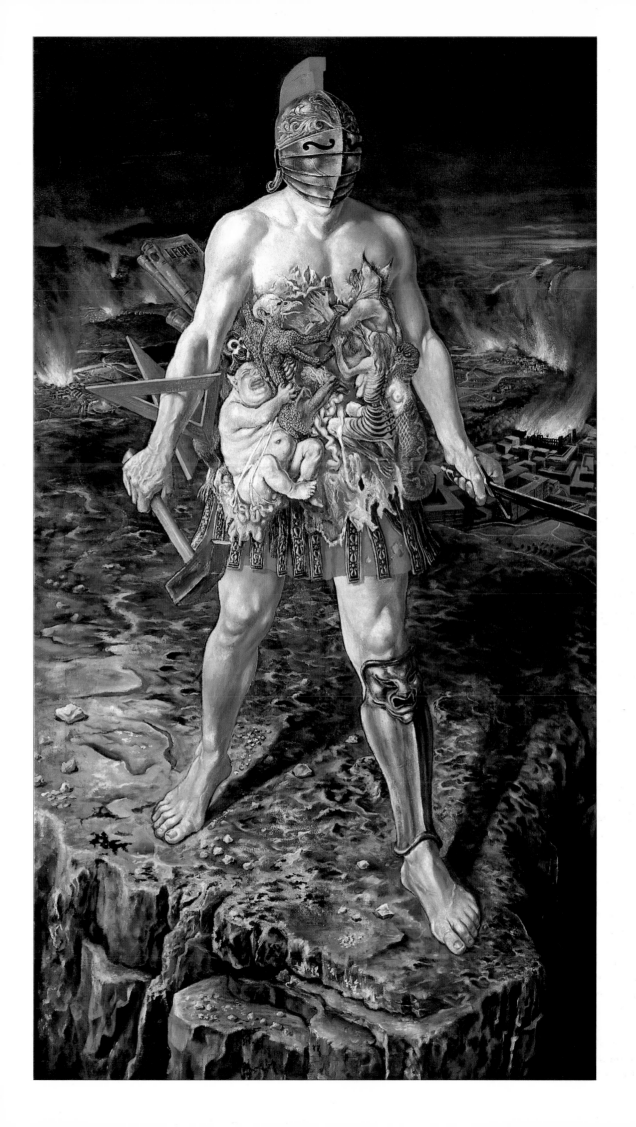

ABOVE
And now after a brief intermission. *A. Paul Weber. 1934. Lithograph. (Jeff Rund collection).*

OPPOSITE TOP
The Drummer. *A. Paul Weber. 1936. Lithograph. (Jeff Rund collection).*

OPPOSITE BOTTOM LEFT
The Artist Looks at Modern Warfare. *Gyula Zilzer. Circa 1932. Brush and ink. From* Gaz. (SCPC).

OPPOSITE BOTTOM RIGHT
Joy Riders. *Benjamin Kopman. 1938. Lithograph.* (FDU).

DRUMROLLS

It is one thing for historians to look back at the period between the two world wars and say that, after the first, the second was inevitable. But it is uncanny that so many artists sensed that at the time.

That there was a kind of grim exhilaration in war was an idea many tried to use to expose the lunacy of it—or, in some cases, as in the *Joy Riders* by the American painter Benjamin Kopman—the hard reality.

The old idea that the blood stirs at the sound of the martial drum was used with great and simple effect by the Hungarian Gyula Zilzer in a book of drawings for which Romain Rolland wrote a powerful introduction. The drummer in his gas mask is a frenzied demon over Paris, and people at the time could have heard the drumming of the airplane engines on their lethal mission.

But in Andreas Paul Weber grim humor found an unexampled genius. Weber, who was in the army in both world wars, was a relentless ridiculer of destructive excesses, particularly in war, an autodidact in art of whom Ernst Niekisch once said his work was not the result of deduction but of a human instinct that was always exactly right, a totally realistic visionary.

Weber was a master critic of blind bureaucracy that became an instrument of human suffering, not only in his depictions of the Nazi state and its apparatus but in some famous parodies or reconstructions of celebrated paintings by the great masters from Dürer to El Greco.

It is the unstudied or instinctive spirit of his work that sometimes makes it seem improbably exuberant, considering what it means. In Weber's work the death rattle always has a little laughter in it.

Death as the looney drummer announcing his own act into a radio microphone is effective precisely because it is so unexpected. Anyone who listened to radio in that age was accustomed to hearing music interrupted for a few announcements and then resumed after the announcer said the intermission had come to an end. In this case the music was a little different. Hitler's architect Albert Speer wrote in his memoirs that state control of broadcasting and loudspeakers was in many ways the regime's most powerful weapon. Weber's suggestion about who was speaking, unseen but only heard by the millions, is stunning.

He gave the military drummer a more formal look in another lithograph—headless, bemedaled, marching with his drum in perfect military step. But he is a legless veteran and he is marching on an unraveling tightrope.

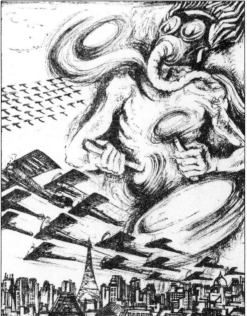

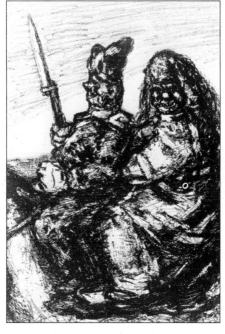

FUTURE SHOCK

The vision of future war that Gyula Zilzer saw in the gas god and airplanes over Paris was one shared by Arthur Young, who in the same year drew for the League of Industrial Democracy a picture of the crushing effect of the new technology: an immense tank and plane simply demolishing a city and its people.

The *Scholastic Magazine*'s Armistice Day cover a few years later picked up a much older theme—war as the reaper, cocking his ear to hear the fields grow, for, as everyone at that time knew, in the month before harvest you could hear the corn grow in a field.

Daniel Fitzpatrick, who followed Robert Minor as a cartoonist for the *St. Louis Post Dispatch* and who was to win a Pulitzer Prize for his work, worried often in the thirties about the armed world then being created. The consistency of his concern is remarkable, as one can see in three

cartoons on this page that were drawn over seven years. Behind them all is the notion that the power of nations was an intolerable burden and that the balance of power spoke only in the language of power and built a civilization that teetered on the shifting and thrusting foundations of power.

BOTTOM LEFT
Cover for Scholastic: The American High School Weekly (Armistice Day Number, Vol. 27). Artist unknown. 1935. (SCPC).

TOP RIGHT
Sinking a Continent. *Daniel R. Fitzpatrick. 1931. Crayon. Cartoon in the* St. Louis Post-Dispatch. (SCPC).

CENTER
Fellow Diplomats—. *Daniel R. Fitzpatrick. 1938. Crayon. Cartoon in the* St. Louis Post-Dispatch. (FDU).

BOTTOM RIGHT
This is the House that Diplomacy Built. *Daniel R. Fitzpatrick. 1935. Crayon. Cartoon in the* St. Louis Post-Dispatch. (FDU).

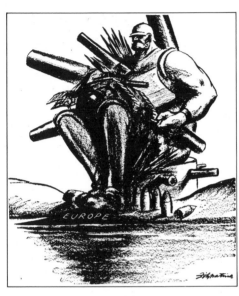

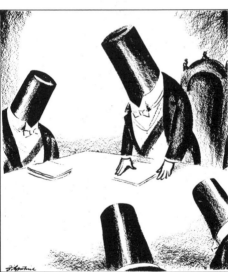

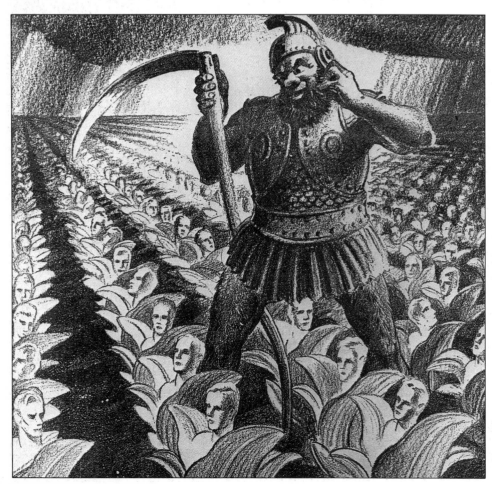

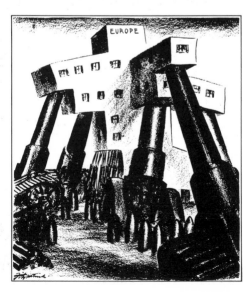

Future War. *Art Young. 1932. Pen and ink. From* Disarm, *published by the League for Industrial Democracy, New York.* (SCPC).

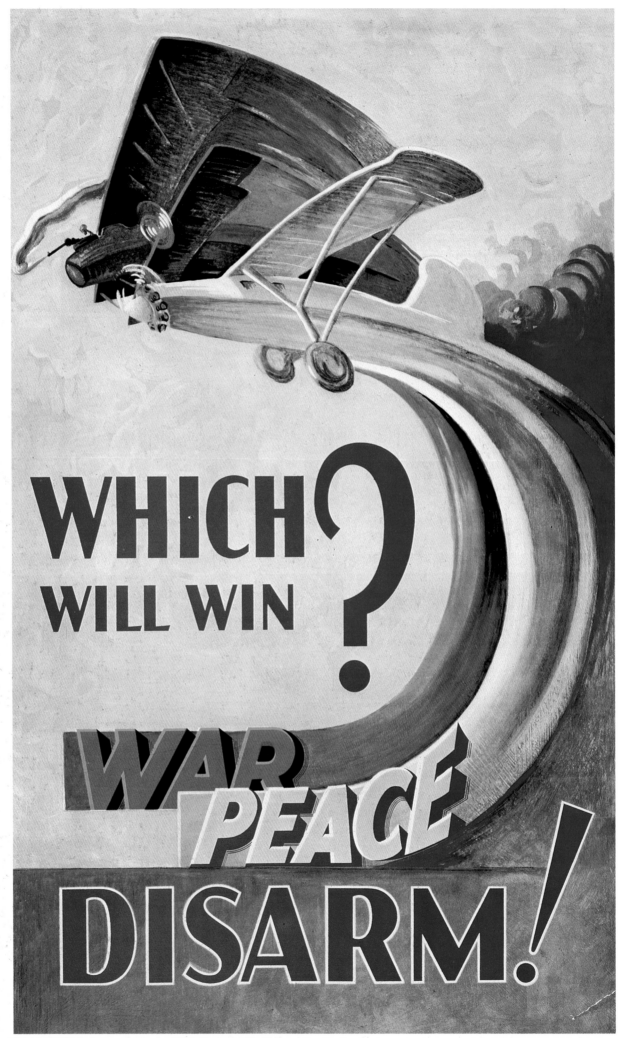

Which Will Win? *Artist unknown. c. 1931. Poster for World Peace Posters, Inc.* (HIA).

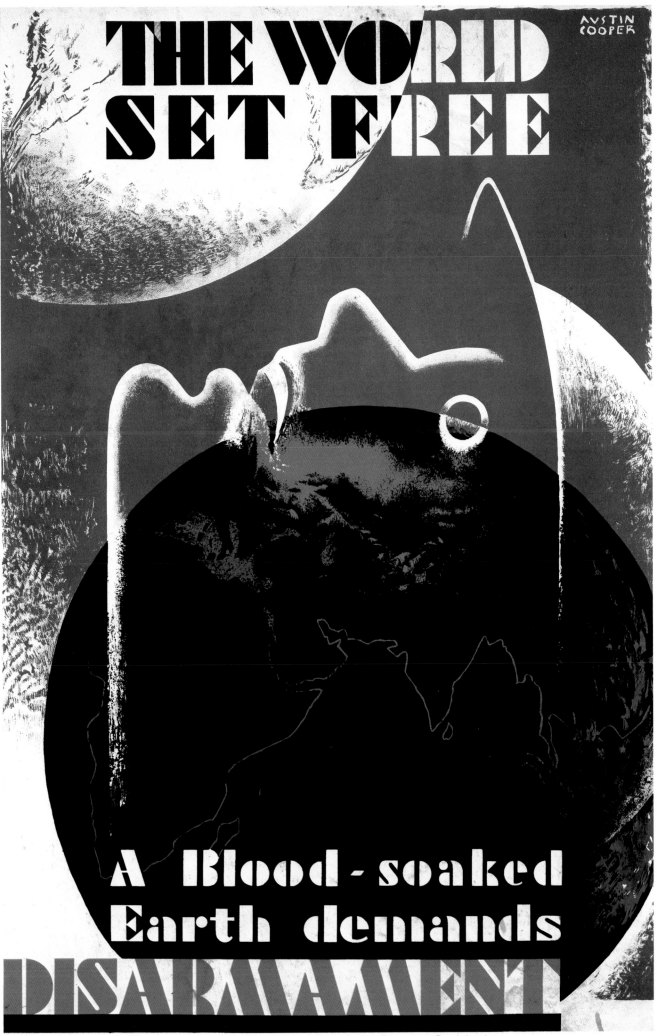

The World Set Free: A Blood-Soaked Earth Demands Disarmament. *Austin Cooper. Circa 1935. Poster* (SCPC).

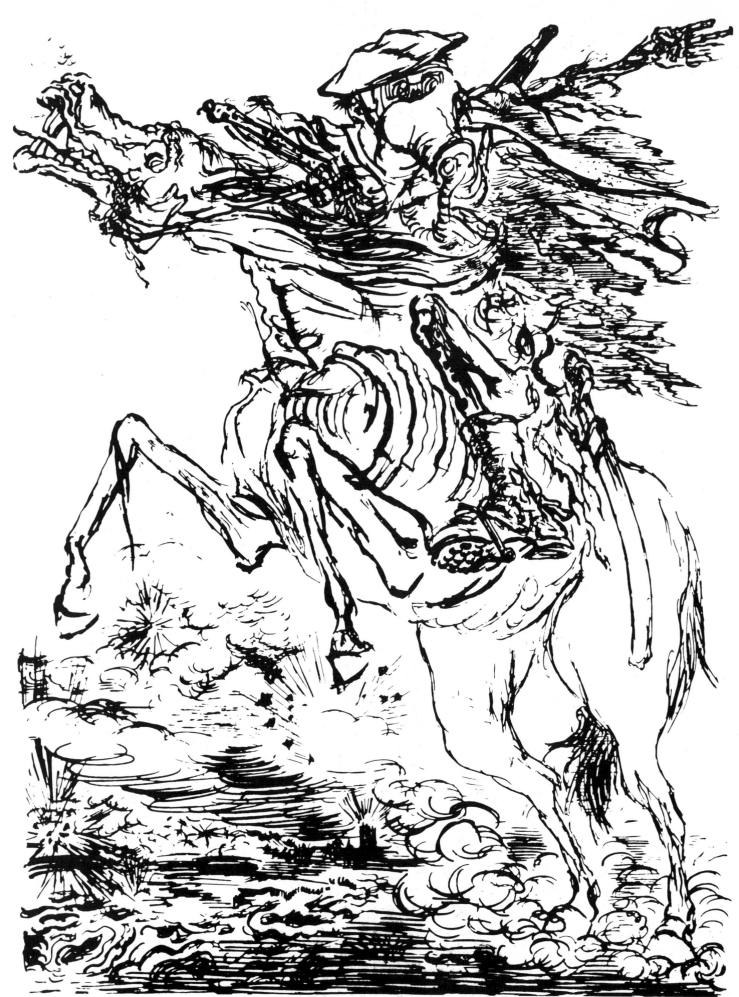

The Riders of the Apocalypse (I Was Always Present). *George Grosz. 1936. Pen and ink.*

BIZARRE MASKS

For many people in the 1930s the newer war technology had no personal meaning. Tanks and airplanes were things seen in exhibits or films, but the reality was known to relatively few who had not been soldiers in World War I.

The most commonly feared war technology, remembered well and written about a great deal, was poison gas. It seems a little odd, in an age of nuclear weapons, to think of that rather simple form of chemical warfare as such a pervasive personal menace; but at the time, one ought to recall, respiratory diseases, including simple pneumonia, were the great killers of mankind. The prospect of gas was more effective as a threat than air pollution is to us; people thought of it the way we think of massive radiation.

George Grosz characteristically called on classical themes and dressed up his apocalyptic horseman in full military gear, making the gas mask the most prominent feature. Abe Birnbaum, a cartoonist who appeared in many magazines, painted a family portrait in 1937 that the World Peaceways organization in New York used in its advertising. The ad copy ran:

"In the front row are Papa and Mama, in the Gas-Masks for Grown-ups. Back of them is son Jimmy, in the latest Youth's Model Gas-Mask. Then there are little Sally and Tommy in their Gas-Masks for Tots. And finally, Buster, in the special Gas-Mask that man, in his great humanity, recently designed for dogs."

In Philip Evergood's retreating army, masks are useless. The troops are skeletons, and so are the onlookers except for the woman and her children. It is simple and effective, this message: war is death and life is something else.

TOP
Family Portrait. *Abe Birnbaum. 1938. Oil on canvas photographed in frame. From an advertisement for World Peaceways, Inc.* (NYPL).

BOTTOM
Orderly Retreat. *Philip Evergood. 1944. Oil on canvas. (Carleton College collection).*

Guernica. *Pablo Picasso. 1937. Oil on canvas.* (MDP)

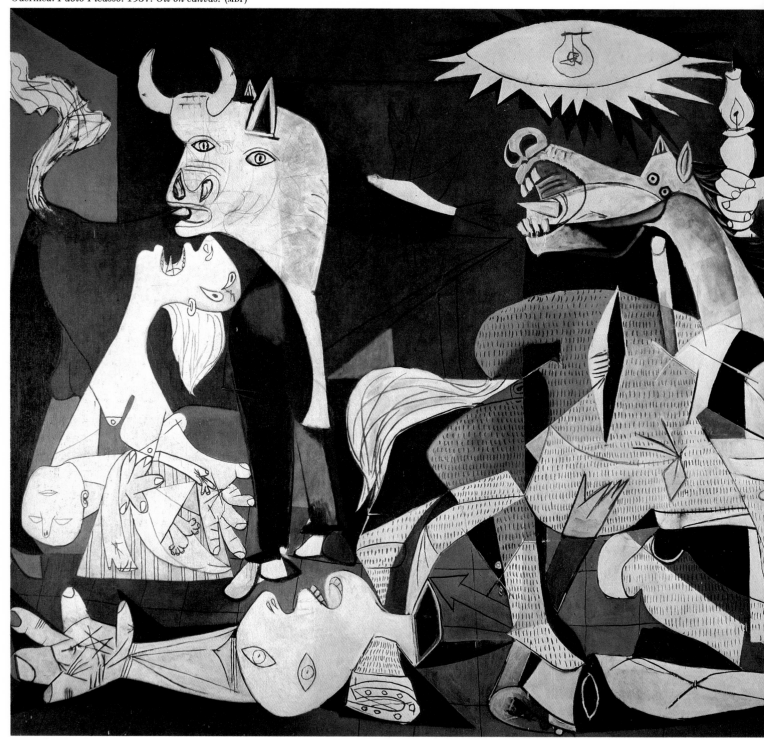

BLITZKRIEG

On April 26, 1937, the Basque town of Guernica became the first target of an all-out aerial bombing attack, the prototype of Coventry, Dresden, Hiroshima. The attack was carried out by German planes (Heinkel and Junker bombers and Heinkel fighters) commissioned by General Francisco Franco in his battle against the Spanish Republican government. They dropped bombs of 1,000 pounds and smaller weights right across the town of 10,000 people, and press reports said the fighter planes machine-gunned down people who tried to flee into neighborhood fields.

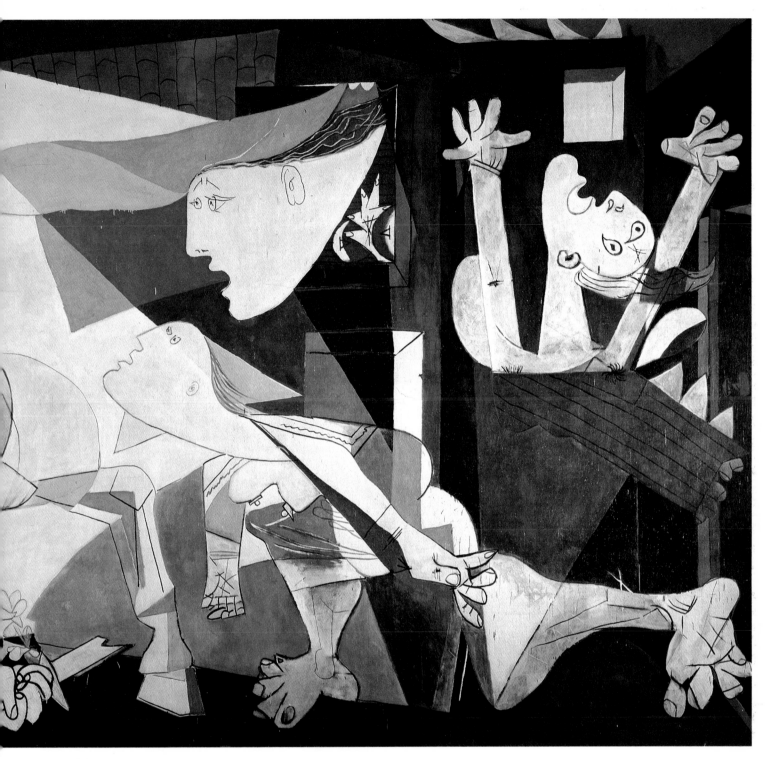

Pablo Picasso was under contract to the Republic's government to provide a large painting for the Spanish pavilion at the Paris world's fair that year, and the bombing gave him a subject. In June the immense painting *Guernica* was installed in the pavilion where it immediately became the object of terrific political controversy, left-wingers maintaining its abstractions said too little and the right saying it was a libel. In the world of art critics it was controversial since it incorporated all kinds of themes Picasso had been working on—and some known sketches—and it has been fought over ever since.

In part the controversy helps explain why it is the most famous painting done in this century, and Picasso consigned it for four decades to The Museum of Modern Art as a kind of political hostage, an act that increased its notoriety considerably. There is to this day a raging argument over whether the painting is in fact a statement against war or whether Picasso meant it that way. Without intending to demean the partisans in these arguments, it ought to be said that, however the artist intended it, or however he painted it, or whatever he thought its purpose was, almost everyone has taken it as the most massive artistic statement against war in our time. A definition has come from its viewers that makes any definition given by its critics or even its maker a bit irrelevant in popular history. In that sense, it is a peculiar triumph of modern art; its voices all come from the outside. The fragmented but immensely wide and deep symbolism it contains may have made the interpretation of it as an antiwar statement inevitable.

In any case, it is the only piece of antiwar art known that has been used as a weapon against a government and a dictator and that has been the object of international negotiations by the kinds of statesmen who usually negotiate over war and peace.

WHY?

World War II just never made it as myth. The first World War—or what we choose to call the first, from 1914 to 1918—produced not only many poets and writers who found their stories in the war, but ideas and images of war and society that direct our thinking even now. That sort of birth did not happen in the war of 20 years later. It is as though the second war ended a world already ended a generation earlier in the imagination, while the first was seen as the dropping away of a chasm between an ancient and naturally developed world and one that was all contrivance, like some kind of sport.

One problem is that, in a sense, World War II has never ended, leaving one with the impression that what is happening is a birth and not a death. It may be a terrible birth, but the continuation of conflicts that were essential to that war is confusing because it is a fact but not one that can be reduced to an object in the mind. It still moves inside us.

Also, it is hard to say when it began. Most Europeans would say it started in September, 1939, and most Americans would say in December, 1941. But, for Chinese, did it begin with the civil war started by Mao or the Japanese invasion of Manchuria? When did it begin for the Finns? With the Russian invasion? When for people in the old French empire of Southeast Asia—perhaps in the 18th century? Residents of the Ruhr, Alsace, and Austria would give different dates, and an Ethiopian would give one different from all those. What about Spaniards? The ordinary man of the world, the whole world, might be forgiven for thinking of World War II as a kind of vacuum cleaner that sucked up a continuing lot of little wars into a mighty maw.

In the histories we read now of that war a common theme is lost—one that was common in the thirties in the United States and one that deserves some attention: that the world was at war and was just waiting for the Americans to take it all over. Modern historians don't like grand theories of that kind, but if one is looking at the history of antiwar art, one has to be aware of them, at least. For the antiwar art of the thirties seems to be a response to continuing armed conflict, with an exception. That the exception was Germany ought to make one think along different lines.

The second World War was also a trap for consciences. In England many intellectuals who were annoyed that Hitler had not been put down forcibly by England in 1936 opposed war plans three years later when it was clear the British government

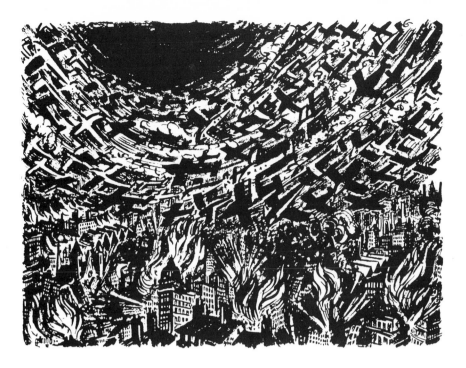

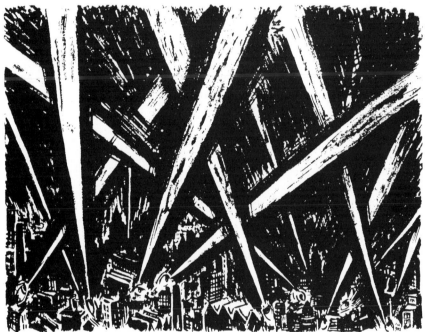

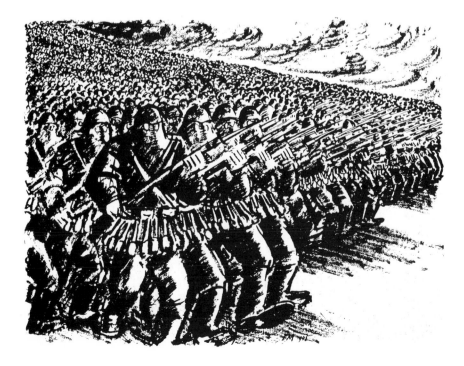

intended to bomb cities. The America First group in the United States, isolationist and most right wing, was in common cause with many left-wing groups including those that wanted only to avert German aggression against the Soviet Union.

Furthermore, after the break-up of the old world order, most countries were legally suspicious of emigrés. Germans in France and England were suspect for their opposition to the Nazis. In Russia the radical and left-wing Germans who had fled Hitler were commonly put in camps and the intellectuals were murdered. Russian emigrés who left their country after the 1917 revolutions were suspect everywhere. In Southeast Asia the Chinese were segregated and watched. In England large numbers of immigrants were interned as enemy aliens, and in the United States citizens were interned as the war began.

Intellectual leaders and artists were no better than governments. In France were the artists more vigilant than the socialists or the Vichyites? When there was fear that the Nazis would take Max Jacob away did not Picasso himself say that "Max is an angel who will fly over the wall?" Did American artists or filmmakers do anything to defend Charlie Chaplin when, ridiculing Hitler and trying to rally American resistance, he was denounced as a Jewish sympathizer with communists? And it was the FBI, not artists of the film community, who came to defend Marlene Dietrich when the Nazis in Germany said she ought to be killed for becoming an American citizen.

The fact is that there was not much opposition to that war among artists. Even the few dedicated pacifists among them were silent. Some American cartoonists continued as late as the winter of 1941 to depict a war to the finish as monstrous, but, on the whole, there was silence.

If, by the time the war ended, artists were responding to the mere fact of nuclear bombs, there is still somethng to be found out about the silence in between. It is no disgrace to artists that art does not always rise above the times, but it is worth remembering.

It is said by historians that 55 million people died between September, 1939, and August, 1945, not in the course of nature, but in the course of the war. The two atomic bombs used in the war killed about 175,000 people, which would be about three-hundredths of a percent of the total. One ought to look ahead, but it is worthwhile to look a bit behind, too.

Frans Masereel. Illustrations from The Apocalypse. *1953. Brush and ink. (Private collection).*

DEFIANCE

As the Nazis clamped down on Central and Western Europe there may have been a good deal of underground opposition, but overt protest, especially in countries neighboring Germany, was rare and brief.

In Denmark Harald Engman the painter seems to have held up the flag alone among the artists. In the thirties he had painted many satirical works concerned with official corruption, prostitution, unemployment, and the condition of the poor. Slowly he turned to the satirizing of totalitarianism as fascist governments gained control of more and more countries in Europe, and finally he turned to overt ridicule of the Nazis. His work has that kind of obsessive bitterness that comes from someone who was obviously fascinated by the very people he lampooned; the style and appearance of the Nazis were not lost on him, and Danish critics have wondered whether, had the Germans known how to treat him properly, he might not have shown them in a favorable light.

If their speculation has any validity, one has to conclude that the Germans did not know how to win Engman over. In 1940 he had an exhibit in Copenhagen of paintings ferociously attacking the Nazis, which was closed down by them in April. He fled to the north of the country, went underground, and painted pictures that he later showed on a street in Copenhagen as an exhibit of underground paintings.

Engman finally fled to Sweden, where he worked on many anti-Nazi publications as well as for the newspapers during the war.

Much of his work is patently directed against one side in a growing war, but much of it simply rises above any dispute and becomes a protest against not only force but war itself. He is not one of the more easily recognized antiwar artists of Europe, but, then, he was never recognized as belonging to any school and there were Danes who denied he was very Danish. From the outset he resisted identification with any school of art. Beyond that, in his youth he was a sailor who had traveled to other European countries and had lived in New York—in Chinatown where he learned the language and a love of Chinese culture that stayed with him throughout life. He was essentially a loner on the cultural scene, if one thinks of culture as high culture. On the more ordinary level of common culture his work says he was anything but a loner. It is his capacity for immediate identification that gives his art a peculiar power that is far greater than its style would warrant.

BOTTOM LEFT
Adam and Eve after the Fall. *Harald Engman. 1942. Oil on canvas. From* Den Forbudte Maler. (WL).

BOTTOM RIGHT
Destruction Advancing (*From* Death's Trumpet). *Harald Engman. 1941. Oil on canvas. From* Den Forbudte Maler. (WL).

OPPOSITE
Den Gode Jord: Nutids-Gobelin. *Harald Engman. 1943. Oil on canvas. From* Den Forbudte Maler. (WL).

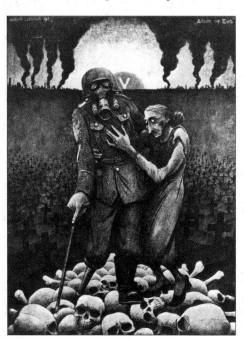

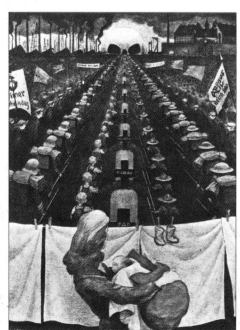

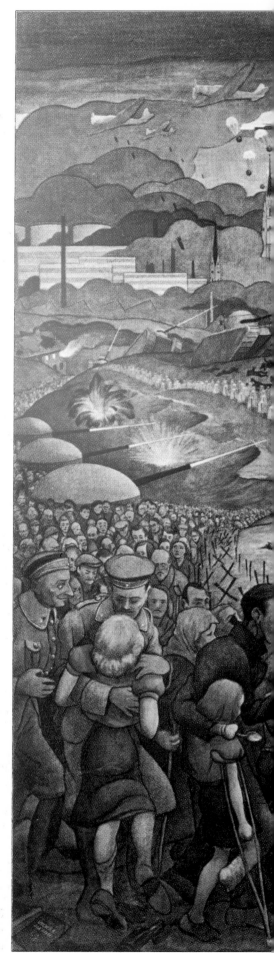

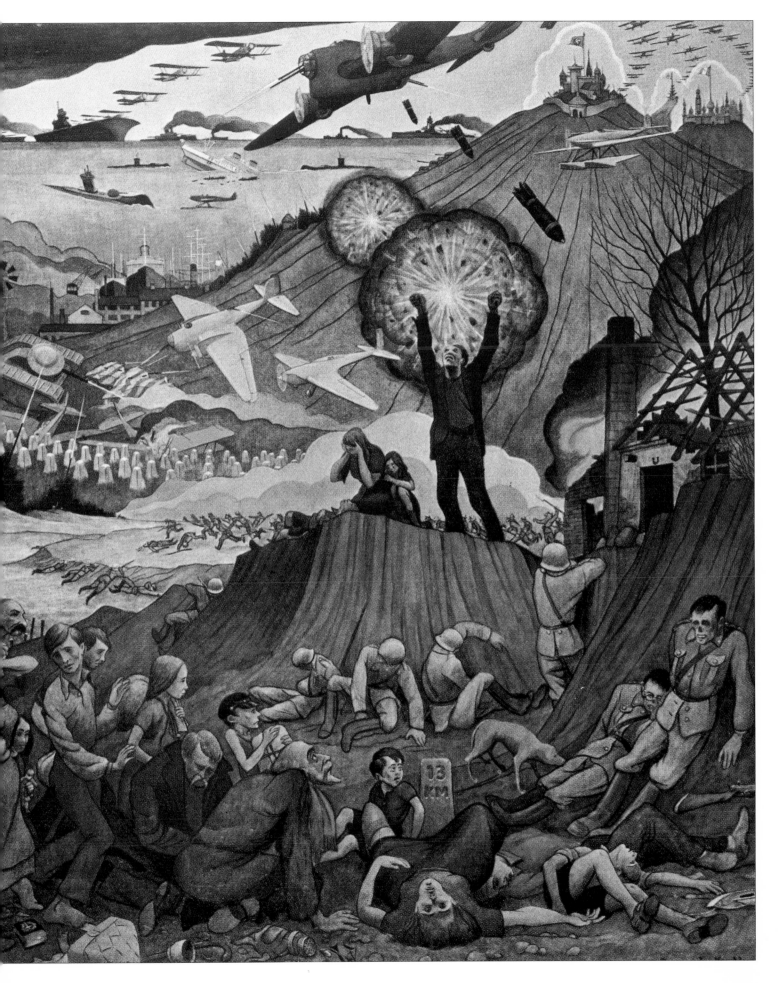

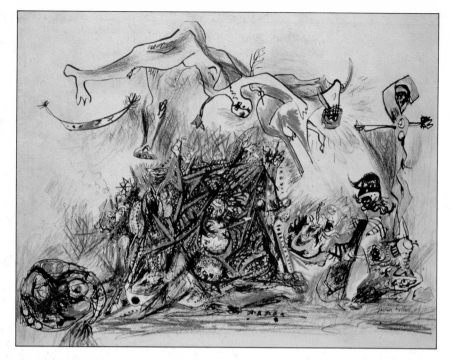

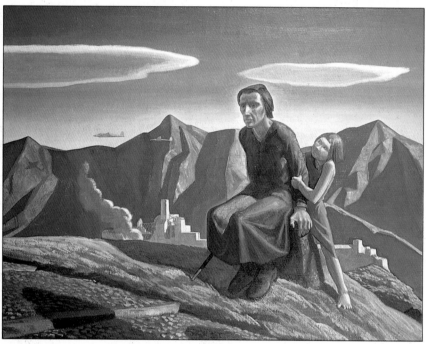

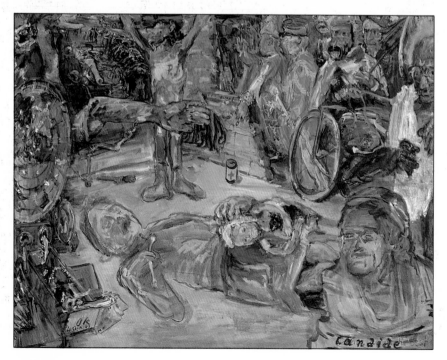

NOTHING COMES FROM NOTHING

To the artist, during and immediately after the war, except for propaganda there was little to depict but the effect of war. There was a tremendous outpouring of official art, of course, much of it quite ingenious in arousing passions in favor of the war effort. Artists who opposed war of any kind had enough inspiration.

Jackson Pollock's drawing titled *War* was done either during the war years or immediately after (it was left to his wife who gave it later to The Metropolitan Museum in New York); it shows a woman and a cow being blown out of a pile of bones and debris in which there is, among the rest of it, a shot dove.

Oskar Kokoschka's 1943 painting has an ironic title: *What Are We Fighting For?* The answer is clear enough in the painting, from the negative point of view—not for the interests of ordinary people.

Rockwell Kent's 1942 painting titled *Bombs Away* is a good deal more ambiguous, as one might expect. The bombing by the airplane is not in dispute. But the message of the mother and child is. It is a haunting painting and clearly antiwar in its sentiment, but one would not want to rush to define its content in terms of ordinary antiwar expression.

There is never that problem with George Grosz. If there was a World War II, obviously there was a Peace II after it, and his 1946 painting is a definition of peace that contains more definition of war than its opposite. The bitterness of the canvas is simply appalling; if there is war, peace is only what is left.

TOP
War 1947. *Jackson Pollock. Pen and ink and colored pencil on paper. (Gift of Lee Krasner Pollock in memory of Jackson Pollock, 1982,* MET).

CENTER
Bombs Away. *Rockwell Kent. 1942. Oil on canvas. (Private collection, Los Angeles, courtesy of The Rockwell Kent Legacies).*

BOTTOM
What are we fighting for? *Oskar Kokoschka. 1943. Oil on canvas. (Kunsthaus Zurich, courtesy of* COSMOPRESS, *Geneva, and* ADAGP, *Paris).*

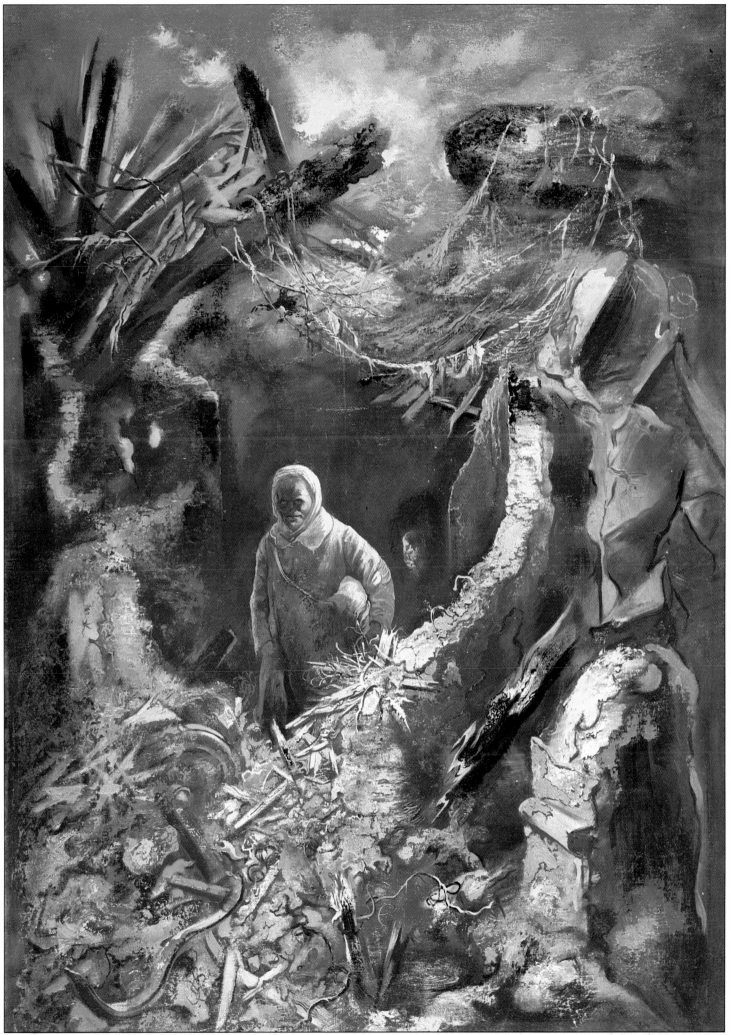

Peace II. *George Grosz. 1946. Oil on canvas.* (WMAA).

A HANDFUL OF HELL

The movement to ban atomic weapons was begun by many of the scientists at Los Alamos and Chicago who were working on the first bombs long before they were tested or used in 1945. By the time artists had conceived of images of the bomb that were immediately recognizable and could convey a strong appeal, there was a large intellectual constituency for that kind of appeal. There was also a large body of reporting about the effects of the first bombs used and about the possibilities of larger bombs and the prospects of much greater use of them in future wars.

The atomic bomb had one aspect that was unusually fit for art—the mushroom cloud. There were newsreels of that cloud and press photographs shortly after the bomb was first used, and unusually gory accounts of how effective the first bombs were. And it was clear at once that it was

no ordinary cloud, but a column of fire that rose so rapidly miles into the air that it ballooned out in response to atmospheric pressures. In a sense it created its own caricature more effectively than any weapon man has ever invented.

Within a few years the numbers of artistic representations of the nuclear explosion were legion, and they appeared in countless media. Furthermore, the mere fact of the bomb gave rise immediately to antiwar movements of a kind not known before—and they appeared first in the country that used the bomb.

Robert Osborn created a classic in 1946 in his drawing of the mushroom cloud as death's head, which he included in his book of drawings. *War is No Damned Good.* The title also indicates that the bomb had tended to clear the mind of distractions. At least no one could mistake the message of the art.

Among the thousands of antiwar drawings, paintings, and posters that appeared in the early years after World War II, which used the nuclear weapon as a symbol, the poster made for the Swiss Peace Movement in 1952 by Hans Erni is probably the best known. By the time he made the picture there was more reason for worry, of course. Russia had detonated an atomic bomb in 1949 and there had been a good deal of talk of possible use of atomic weapons in the Korean war that began in 1950. Erni's poster simply bypasses all notions of destruction of cities or even of nations and turns the earth itself into a skull with an atomic plume rising from its broken forehead. It is the kind of prototype in art that is frustrating in one sense since it tends to occupy the places of all its possible progeny. In street language one would say Erni's inspired poster is a mean mother.

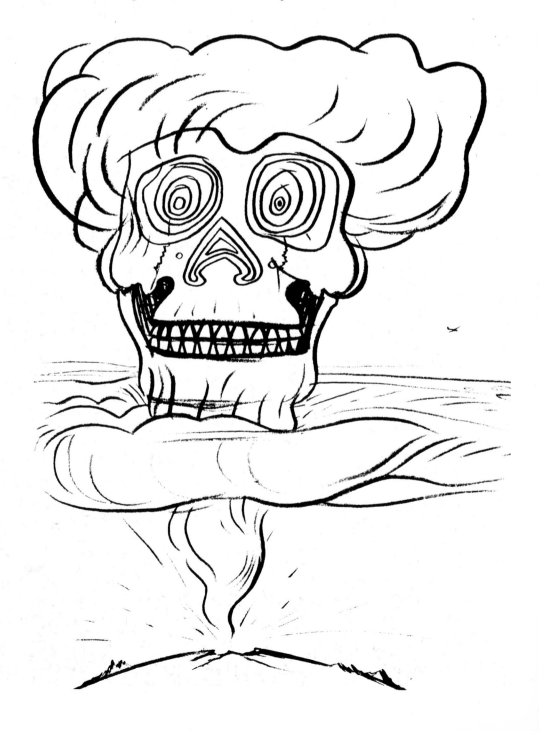

RIGHT
Atom Bomb. *Robert Osborn. 1946. Crayon. (The Swann Collection of Caricature and Cartoon).*

OPPOSITE
Atom War, No. *Hans Erni. 1954. Offset lithograph. Poster. (Courtesy of the artist).*

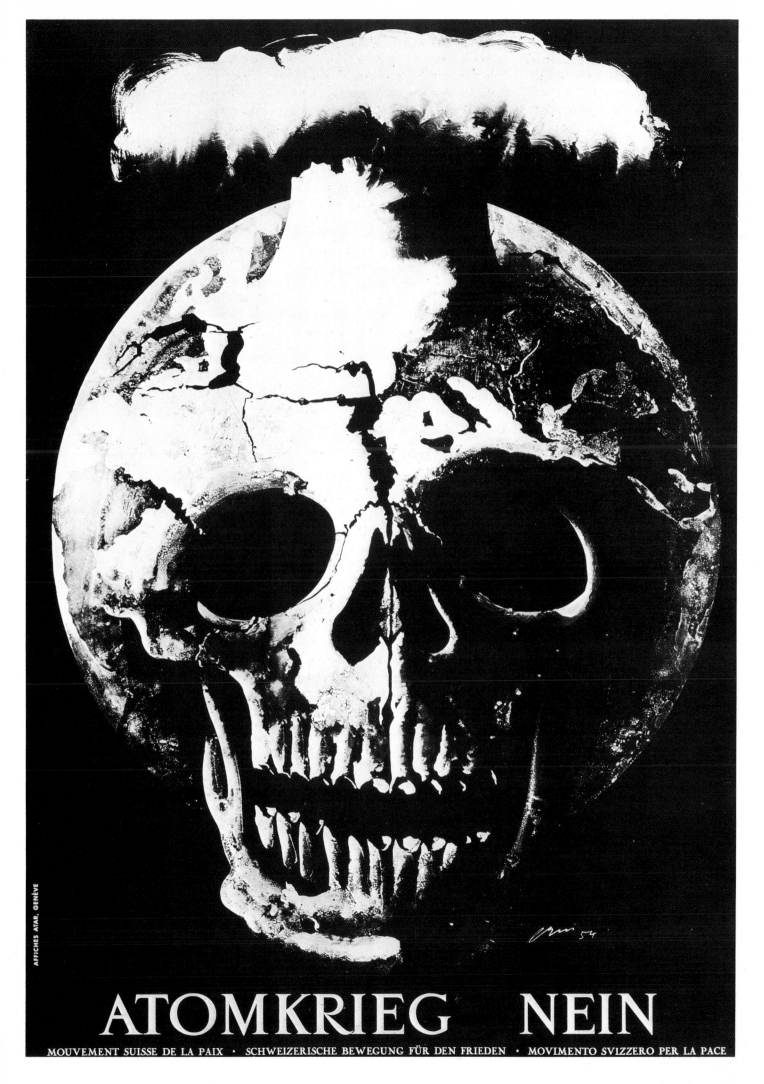

ATOMKRIEG NEIN

MOUVEMENT SUISSE DE LA PAIX · SCHWEIZERISCHE BEWEGUNG FÜR DEN FRIEDEN · MOVIMENTO SVIZZERO PER LA PACE

SOCIALIST ATOMIC REALISM

Strictly speaking there is no allowable art in the Soviet Bloc countries that can be fairly called antiwar art. If it were permitted, would there be any? It is doubtful. The various uprisings in Hungary, Czechoslovakia, and Poland suggest that people who oppose the regime might think war is justifiable in one form. Considering their experiences in World War II, one would have thought the people of Russia, Poland, Hungary, Rumania, and Czechoslovakia would have some reason to oppose war altogether. But expression of any such interest is another matter altogether.

There is a great deal of art in those countries that was meant to inspire fear of nuclear war or to promote disarmament. Most of it is poster art and, since posters need some form of approval from government to remain up on a wall, they do not contradict government purposes. But quite a number are striking not only for the artistic skill in them, but for the evident passion of the artist. A picture of flowers growing where missiles have been scrapped tells at least as clear a story to any population as Tadeusz Trepkowski's famous bomb poster of 1952 tells to a population that knew the effect of bombs that were much less lethal than those the great powers now have.

Most often the antiwar posters one sees from the Eastern bloc now will carry some kind of slogan that suggests the real threat is from the West, and many of them try to drum up patriotism, but the images speak for themselves—eloquently.

TOP
No More Nuclear Blackmail. *Boris Angeluschev. 1965. Bulgarian Poster.* (FDU).

BOTTOM
Disarm! *Radi Angelov. 1960. Bulgarian Poster.* (FDU).

OPPOSITE
Nie! *(Never!). Tadeusz Trepkowski. 1952. Poster.*

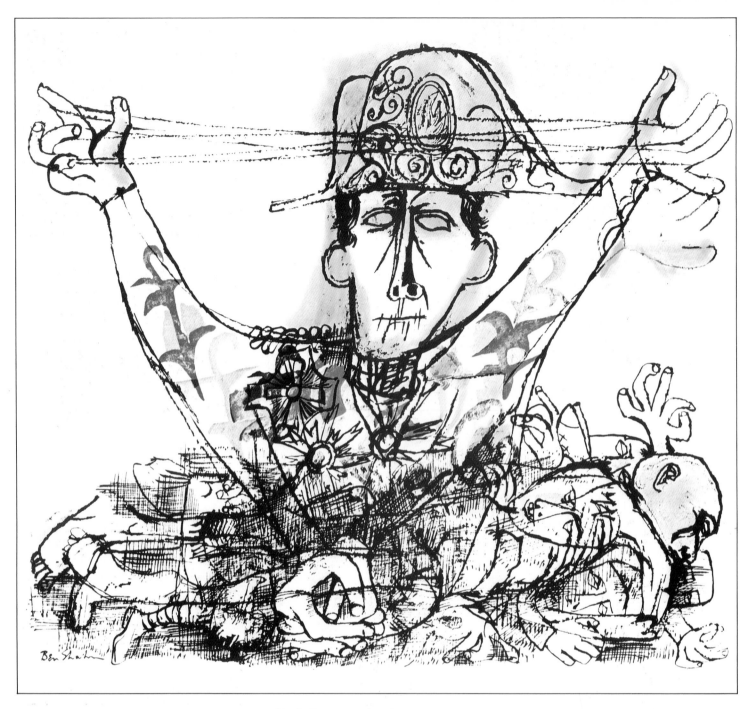

PARADISE LOST

For many artists the message that finally came out of the last world war and the weapons race that started even before the fighting stopped is that the world cannot be perfected as a home for humanity. After the long reign of the ideas of the Enlightenment, that is a fairly drastic change of mind. In a secular age its consequences are unpredictable.

The problems that come of trying to find justification in history are now normally thrown at Marxists of various kinds, but the French novelists of the 19th century were masters at dissecting this kind of absurdity long before there were any Marxists to tease. The problem lies not in doctrine but in events, as Ben Shahn suggests in his unaccustomedly bitter tribute to Goya, a picture in which it is a Spanish fascist, not a French Napoleonic soldier, who manipulates suffering humanity.

H. C. Westerman's war god is possibly even more desperate—a jerry-built machine that is not even a machine but an object that might be made by someone who has forgotten what a machine is and recalls only the fear and reverence mankind has for it.

The opposite view within this despairing world view is that there is hope for humanity in some form. Bronislaw Linke's *Niobe's Face*, from a series known as "The Stones Cry," is an odd and old-fashioned evocation of the view that, though it cannot be understood, there is a salvation in suffering. Oddly, it derives much of its strength from a deliberate appeal to history, the actual history of suffering depicted and the mythical history people have habitually cloaked in legends. In this case it is the legend of Niobe whose children were all killed; the gods felt such pity that they turned her into stone both

as a lesson and to stop the suffering, but the transformation they worked could not stop her tears, which continued forever to pour from the stone.

Among those somber artists of the fifties who tried to make some sense of the events in terms of fate, Leonard Baskin was at once absolutely traditional and totally radical. Baskin had said that "our age is a landscape of death." His graphics and sculpture, he said, showed "injured and brutalized man, naked and alone." He once said his idea of the hero is someone who is "spent and bewildered, frail and human," but he concluded that "man is collectively redemptible." Except for the socketless hipbone, a knee cap, and a hand, his hydrogen man appears to be boneless, nothing but veins, arteries and shreds. But he also appears spookily alive. He is the first of the great survivors, in current art, of the war yet to come.

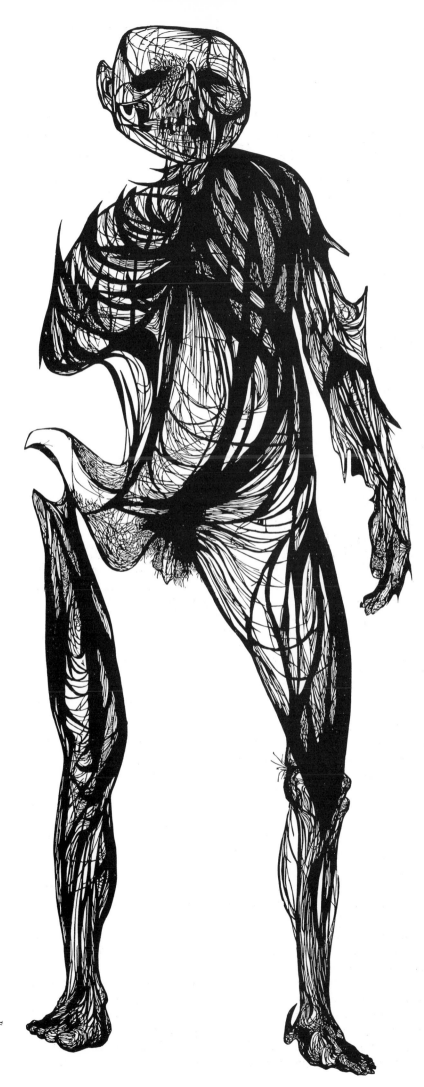

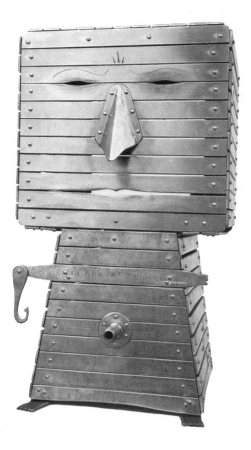

OPPOSITE
Albertina. *Ben Shahn. 1962. Watercolor and gouache. (© Estate of Ben Shahn, 1983).*

LEFT
Hydrogen Man. *Leonard Baskin. 1954. Woodcut.* (KG).

ABOVE
Evil New War God. *H. C. Westerman. 1958. Brass, partly chrome peeled. (Howard and Jean Lipman collection,* AFG).

BELOW
Niobe's Face, *from the cycle "The Stones Cry." Bronislaw Wojciech Linke. 1956. Watercolor, pen and ink, gouache, rubbing on paper.* (MNW).

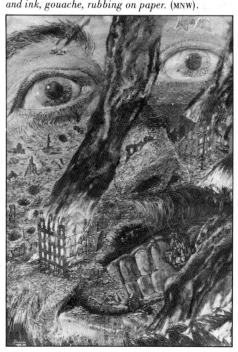

101

BLASTED WERE THE PEACEMAKERS

Camelot was a fine place, but it was the
bastion of a kingdom of warriors who ran
hot or cold as the occasion required. And
they may have been right, and good.

People outside the bastion were not
always in tune with the inner music of the
place and they often suffered opprobrium
for marching to their own drummers.
Many young people now will not remem-
ber how widely suspect the National Com-
mittee for a Sane Nuclear Policy was for
20 years. If SANE were only ridiculed as
a den of dreamers there was no harm, but
there were insistent questions about the
purposes and even the loyalties of its lead-
ers that are chilling even in memory.

Ben Shahn's grim black humor poster
for SANE is now seen by art students as a
fine example of his ability to fill anything
at all—from letters of the alphabet to mere
blobs—with passion and meaning. In this
case he filled the blob with humor that
made the poster especially outrageous to
cold warriors. They understood that its
arousing of people's risibility was effective;
and that is why they were angry with it.

Picasso's fate was even more ironic.
The fact is that anyone would have a hard
time proving Picasso cared a whit for any
cause except the very old and not easily
articulated cause of the absolute freedom
of every Spaniard. Political identities were
attached to him throughout his life. When
he drew a number of doves of peace in the
sixties they were attacked with hot tar.
His 1961 poster for the Congrès Na-
tional—the peace movement's May 1962
meeting in France—was widely de-
nounced as art unwittingly done in service
of Soviet propaganda. Characteristically
Picasso did not worry about its use. In his
usual annoying way he insisted that art
had its own language that is understood
by everyone.

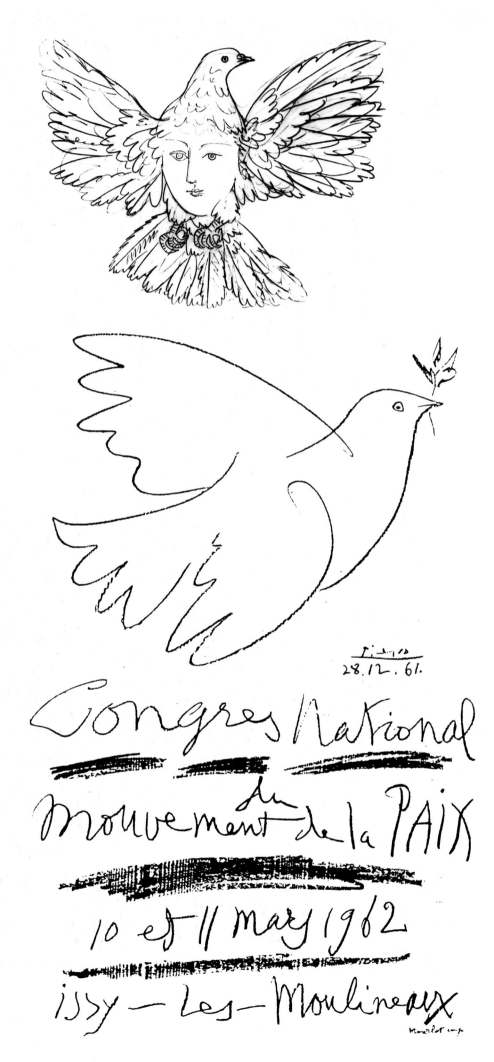

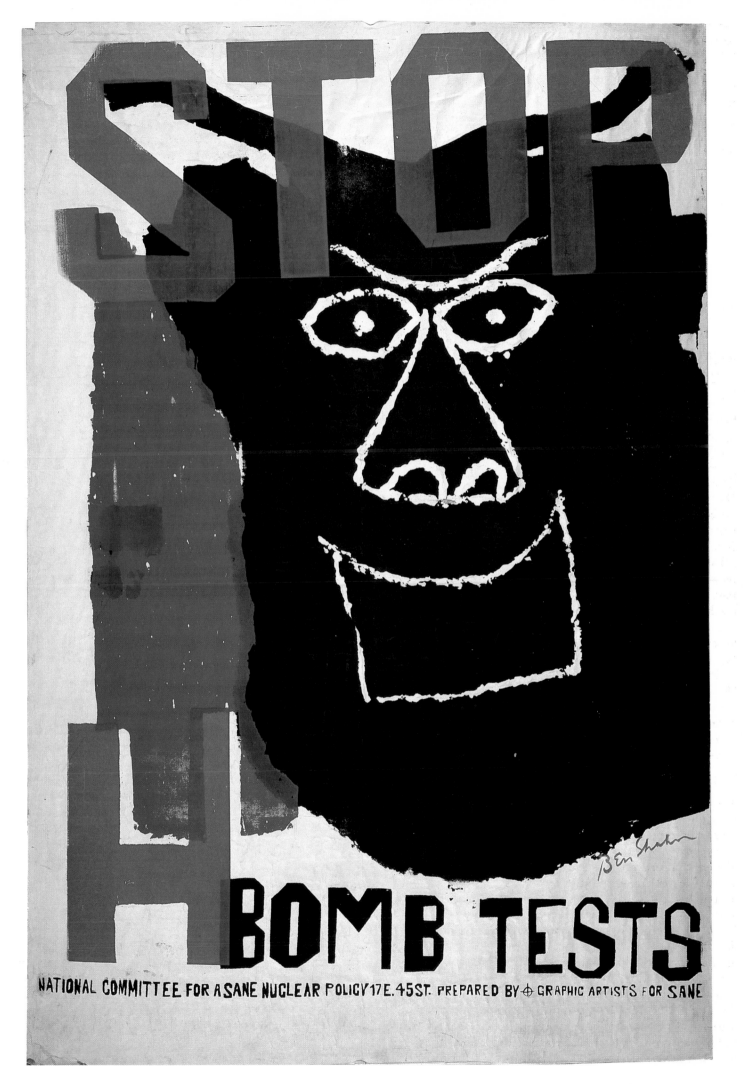

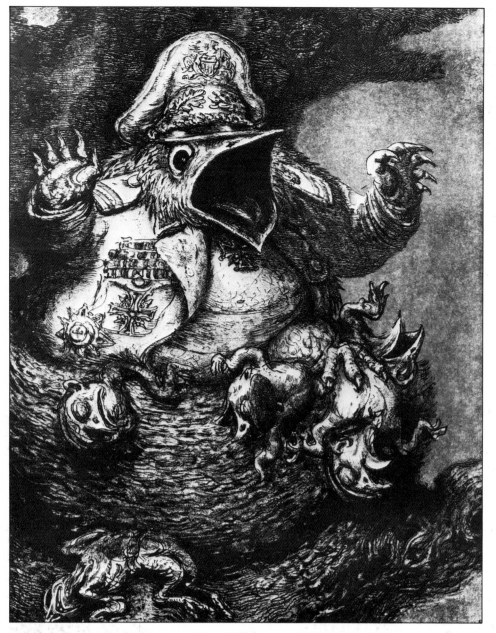

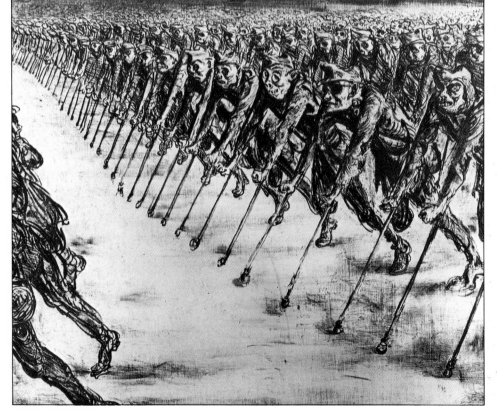

DEATH PREMIER CRU CLASSE

Between the time of the Cuban missile crisis and the massive culmination of the American war effort in Vietnam in 1968, it is remarkable that war did not spread over larger parts of the globe than it did. Inside the United States in those years the great expression was a movement against the war in Vietnam and it is hard for an American to realize the depth of fear among people elsewhere. The antiwar movement in this country carried with it a kind of exhilaration and sense of triumph, and a great deal of violence. One did not have to step outside this country for very long between 1965 and 1970 to feel the apprehension among many in Europe or Latin America who feared that such an energetic outburst as the war on the one hand and its opposition on the other would inevitably escalate. It was a fear exacerbated by the continuing hostility of the United States and Russia and growing conflicts between Russia and China. If one goes back now and reads through newspapers of that era from France, Italy, Germany, and Japan, one is struck by a sense of terror perhaps not felt by Americans at the time.

Whatever it appeared to be on television, to most of the world the Vietnam war was bombs; the United States dropped more tonnage in that conflict than in World War II. Shigeo Fukuda's *No More* poster, in which the mass of missile-driven bombs is interrupted only to allow enough light to reveal a death's head, says enough.

To A. Paul Weber, who had seen two wars with the eyes of a soldier, the world was taking the route of its history. His 1963 parade of maimed one-legged soldiers is grim humor at its best (or worst, as the case may be). But his chick war hawk is a stroke of wild genius. The next hell-raiser is born from the egg of the past in a nest of the dead of the past. That the legend for it comes from the language of wine merchants—a sound natural vintage—gives it an ironic tone of well-being implying a good old-fashioned notion of breeding that gives a sharp edge to its offense. It is the artist's way of saying class will tell.

TOP
Die gesunde, naturliche Auslese. *(A sound, natural vintage). A. Paul Weber. 1972. Lithograph. (Jeff Rund collection).*

BOTTOM
The parade. *A. Paul Weber. 1963. Lithograph. (Jeff Rund collection).*

OPPOSITE
"No more." *Shigeo Fukuda. 1968. Silkscreen. Poster. (Courtesy of the artist).*

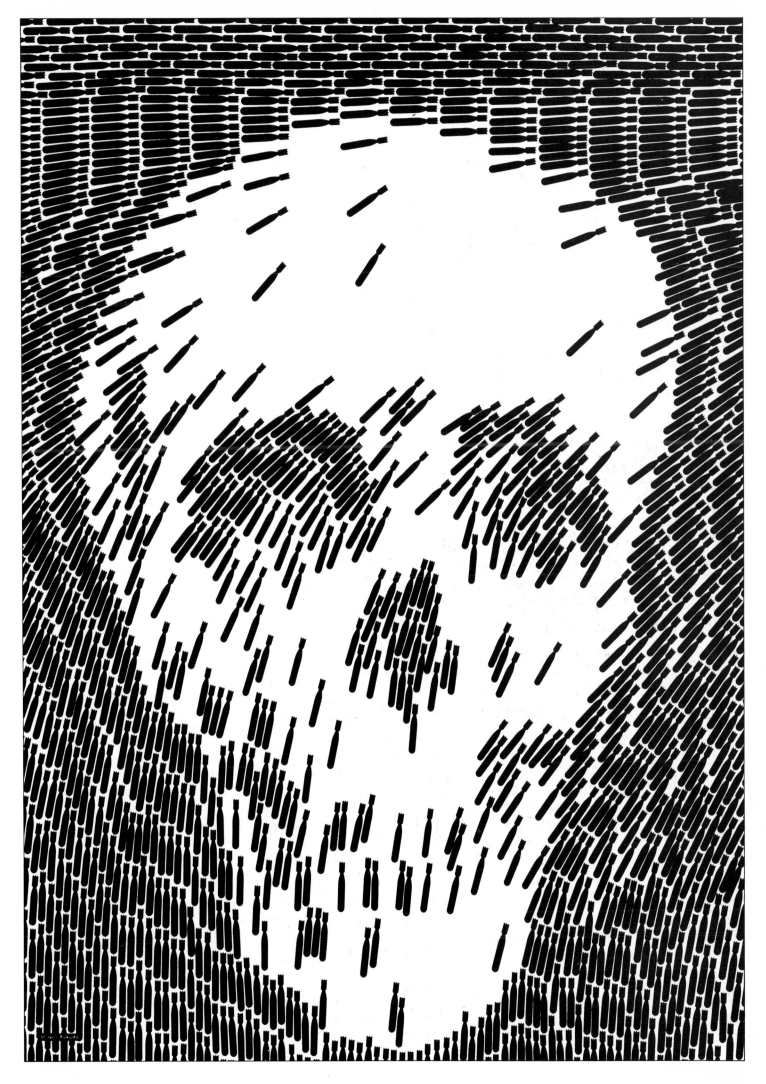

SUBLIMINAL SUBVERSION

No matter what their message, films present a difficult problem. People's perceptions change from generation to generation and the intention of a dramatist, or a filmmaker, can be lost in time. The dramatist has an advantage; if a tradition grows up around his text, it can be endlessly reinterpreted. If there is not a tradition, there is always the text. Some films have the advantage of a novel behind them, or a play in which the message is clear enough in words. But a filmscript is an unusually self-contained document and some very famous films were made without even that much underpinning—antiwar films and others. The performance, in film, is the document. Furthermore, any film has thousands of images, so that one comes away with an impression that is one's own; it may reflect the intention of the director or the writer, but inevitably it will never reflect it entirely. There is no art that is so dependent on the passions of its viewers at the moment.

There must be hundreds of films in many languages that express a revulsion against war. The number that are likely always to be taken that way is rather small, and even among those there will be reasons for disagreement. But there are some about which there is no disagreement. They all depend on a long tradition of classic methods, whether it is the ridicule of human pretensions in *Duck Soup*, or the kind of dreadful sense of futility like that that arises from an ancient play in *Paths of Glory* or *All Quiet on the Western Front*, or the thrilling horror in the way the best-laid plans of men go awry in a film that is probably much more memorable as an antiwar statement than the book it was taken from—*Dr. Strangelove*.

In the case of *Duck Soup*, well, the Marx Brothers were the Marx Brothers and it is unlikely anyone would doubt what they were up to. Remarque's novel made *All Quiet* a document of a message long understood, and Stanley Kubrick surely succeeded in making his film *Dr. Strangelove* as metaphysical as he said he wanted it to be—the absolutely terrifying absurdity of the life we live. Among the films, *Paths of Glory*, which was taken from a novel, is most clearly a statement against war that was meant to influence the public. When the play, from which the film was made, appeared on Broadway in 1935, Sidney Howard, who created the play, said clearly and as often as he could get interviewers to listen that he meant it as a warning against war in a year when Europe was arming itself to the teeth for the next war.

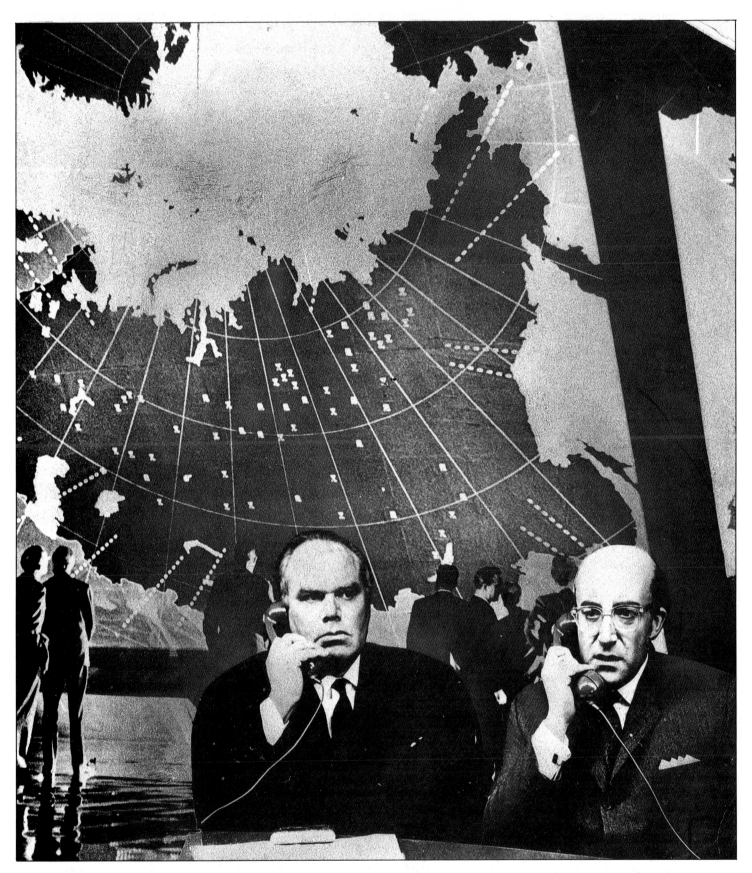

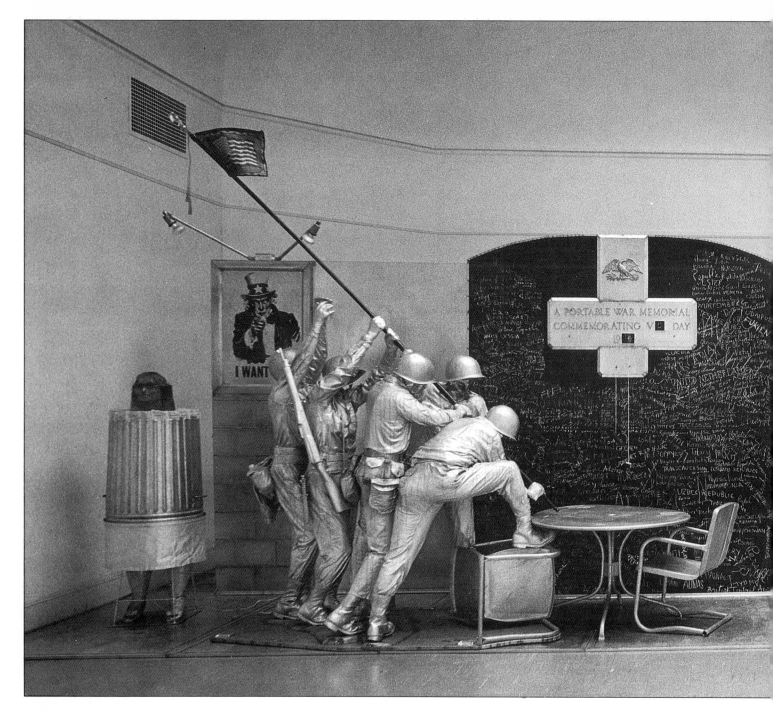

TAKE A WAR HOME TO DINNER

For most people the Vietnam war appeared on nightly news broadcasts at dinner time. If the government were more united and more paranoid at the time, it might have investigated the effect of that message coming every day at the end of a work day. The electronic media brought it home so effectively, in fact, that an artist had to be very inventive to make a different statement; and many were inventive. They turned to the apparatus of everyday life outside the television set. Many of the most effective antiwar pieces in the Vietnam era were deliberately inanimate—in contrast to the TV pictures.

Robert Andrew Parker's soldier's Sunday dinner, for instance, is literally made up of familiar apparatus. He was in the habit of wandering through junkyards and in them he found a discarded surgeon's manual. Given the hazards of a soldier's occupation, his familiarity with the apparatus in the manual is apparent.

Duane Hanson's soldiers were effective in their day—and are now—simply because they vividly raise right on the floor of an art gallery the question Hamlet went crazy over: how could a living subject—"I"—in a moment become a mere object, and precisely how and why did such a transformation happen?

Edward Kienholz's portable war memorial is at once more comic and more sinister than the others, in that it turns around the old warning that there is no refuge. The Iwo Jima Marines raising the flag in triumph over a television set can be taken along to any drive-in. Kienholz has thoughtfully left the particular victory (V–blank day) replaceable like the price signs on a hamburger stand, and one can fill in one's own year as well. Final art for final triumph, for what it's worth.

ABOVE
The Portable War Memorial. *Edward Kienholz. 1968. Sculpture mixed media. (Collection of Museum Ludwig, Köln, courtesy Nancy Kienholz).*

RIGHT
Vietnam Scene. *Duane Hanson. 1969. Fiberglass and mixed media.* (OKH).

FAR RIGHT
Sunday Dinner for a Soldier. *Robert Andrew Parker. 1968. Mixed media. (Collection of the artist).*

108

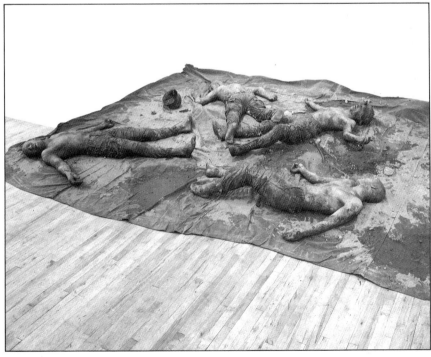

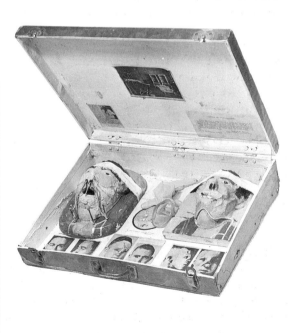

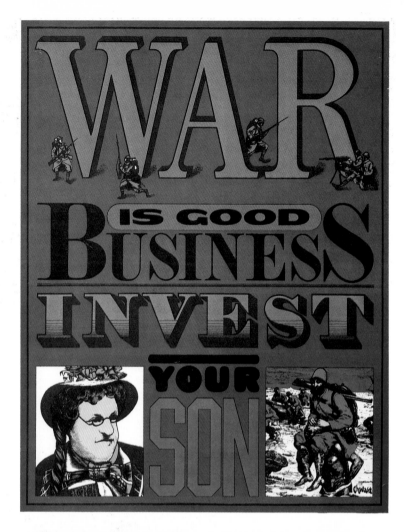

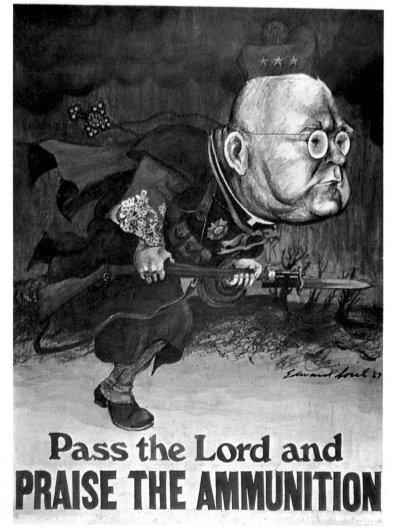

SMART WEAPONS

There was so much artistic protest against the war in Vietnam that choosing examples is not easy. Part of the problem is the volume and part is the particular views of many artists who supported different antiwar movements. Some statements are simply too narrow to be effective antiwar art outside those political movements. But the war did give rise to an extraordinary outpouring of art against war of any kind, and to art that questioned the aims, rationality, and morality of war. It was certainly the first war the United States fought in which there were uncountably more artistic statements against the war than in support of the government.

The subject matter of art was already greatly expanded. And, because there was so much political division in the country, there were many more contradictions to exploit, such as support of the war by clergymen, the morality and legality of the draft, and the irresistible anomaly of seeing confused men fighting with weapons whose technology in many cases made the machines smarter than their employers. Also, the entire customary rhetoric not only of government but of business and many other sectors of society came under scrutiny.

Seymour Chwast's *War is Good Business* is as much a philosophical examination of old assumptions as it is a lampoon on patriotic conduct that is not very enlightened. The essential question it raises is quite simple, inviting a comparison between human costs in a war and the profit figures of war industries, but it has many other implications.

Edward Sorel's picture of the late Cardinal Spellman, with a caption taken from the old song about praising the Lord and passing the ammunition is a variation on a theme he seems to have enjoyed. The cardinal was the overall Catholic chaplain for the military for many years and he threw himself into his pastoral work in the early Vietnam years with an enthusiasm that might fairly be described as not altogether religious.

In another picture, a tree full of hawks with familiar faces, Sorel had made fine use of the cardinal's title as well.

The unprecedented firepower used in the war made it inevitable that artists would return to some of the World War I themes and show the landscape after battle. Chas. B. Slackman naturally put the idea to use with great effect in the context of a highly stylized old Chinese landscape drawing. And Alan Cober's version of the smart bombs being used by mindless strategists is a classic in this large category of lampoons.

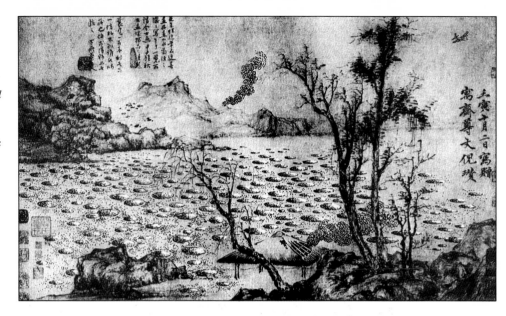

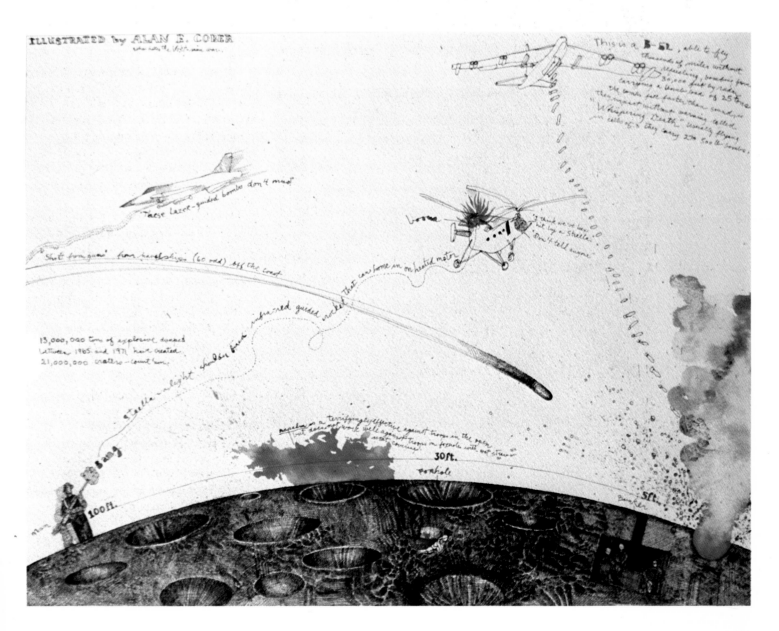

PASS THE AMMUNITION

Sometimes the mere lunacy of war and weapons policies is best exposed by simply exposing it. It takes a while for people to realize that a grand plan is totally mad. When the first wave of large ballistic missiles was made and installed a generation ago, for instance, there was opposition, but it was deadly serious. For the past four or five years, as administrations have fought over various plans to base the MX missiles, columnists, commentators, and artists alike have had fun with it. Russell Baker in his *New York Times* column once suggested putting the missiles on New York subway trains; since no one ever knows where the trains are anyway, the Russians would be hopelessly baffled by the system and the missiles would be invulnerable because they would be untargetable. Lou Myers' cartoon gives a little different idea that also encompasses some of the debate over these missiles.

Bill Charmatz' duet is a neat package of comment on the friendly embraces of adversaries with a murderous intent.

But in the world of grim laughter Tomi Ungerer may be the master. The soldier carrying his coffin and speared through by his burial cross is sardonic, but the mad machine-gunner firing heads from his barrel has to be one of the funniest horrifying pictures ever done.

ACROSS AND OPPOSITE BOTTOM RIGHT
Untitled. Tomi Ungerer. 1964. Pen and ink. From The Underground Sketchbook of Tomi Ungerer.

BELOW
Untitled. Roland Topor. 1971. Pen and ink. (Courtesy John Locke Studio).

BOTTOM RIGHT
Duet. *Bill Charmatz. 1983. Brush and ink. (Collection of the artist).*

OPPOSITE BOTTOM LEFT
Untitled. Lou Myers. 1981. Pen and ink. Cartoon published in New Yorker. *(Courtesy of* New Yorker *magazine)*

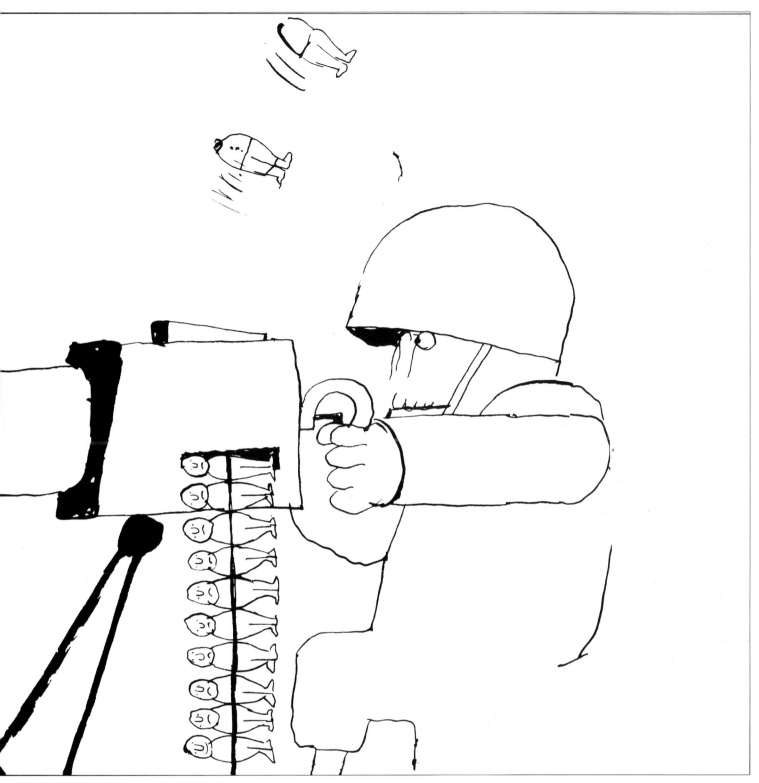

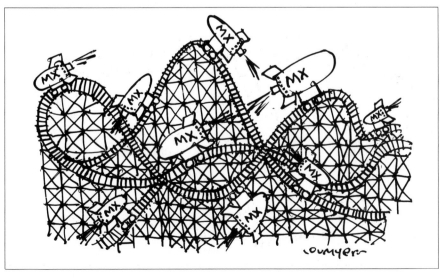

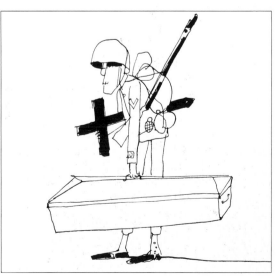

BLINDED MINDS

Most antiwar art expresses outrage, ridicule, remorse, anger, or some other emotional reaction. There are examples in which the emotion is diffused or refracted in so many ways that the overall impression is numbness and hurt without the urge to strike out against what produced it. Some of these hark back to classical themes, like Robert Morris's *Memorial*, a crater with a backdrop of fiery smoke. It has the finality of the Roman judgment about the civil wars, that "they created a desert and called it peace," and it is almost as adamantine as that stony remark.

Jurgen Waller's negotiators might suggest exasperation and even a bit of humor, but the real effect is simply resignation. His calling the affair a game plan is indicative of his intention, but there is also a suggestion that there is no way out. One has to remember that, at the time it was done, the negotiations over Vietnam in Paris were beginning, with their endless arguments about the shape of the table, makeup of delegations, and who was to be called the aggressor. But in the picture the words contradict the symbols and the peace dove is reduced to a kind of carrier pigeon in a way that makes the heart sink.

Benny Andrews' *War Baby* from that period is unusual in that it uses the soldier to express the sorrow of the event, not a wounded or burned soldier but a healthy one—in a sense. The dead child has withered limbs and is in fact totally distorted, but the soldier's face is even more distorted. His face is all metal, revealing anguish and bewilderment, but no suggestion that the soldier really understands the point of his having killed the child.

There is none of the ferocity here of napalmed victims or dead soldiers lying in heaps. The frozen aspect of the picture makes it an appalling statement. It has not the resonance or classical allusion of a Kollwitz, but Mrs. Kollwitz would have understood it with great sympathy.

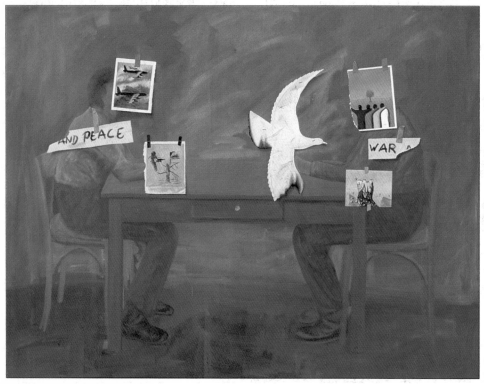

TOP
Crater with Smoke *from "War Memorials." Robert Morris. 1970. From a series of five lithographs.* (CG).

BOTTOM
The strategy of the game. *Jurgen Waller. 1981. Oil on canvas. (Collection of Luc Lepere, Syke).*

OPPOSITE
War Baby. *Benny Andrews. 1968. Oil and collage. (Collection of the artist).*

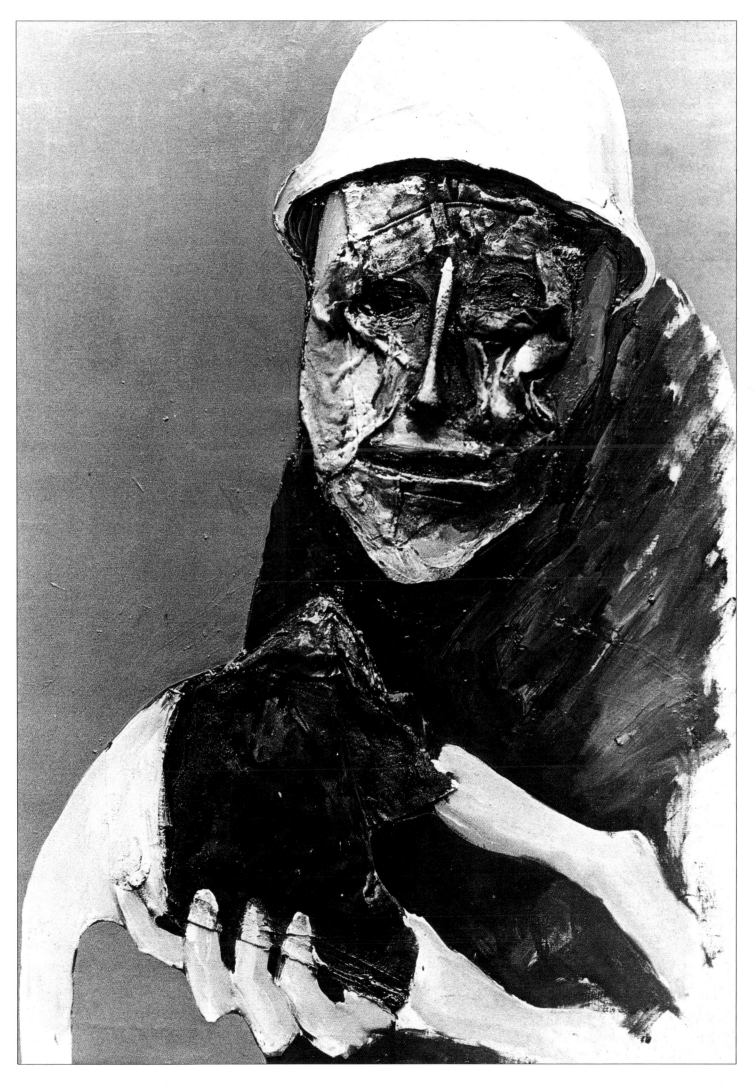

Victims. *Michael Biddle. 1973. Etching.*
(Collection of the artist).

Vietnam! *Antonio Frasconi. 1967. Woodcut
printed by the artist from the original blocks.
(Collection of the artist).*

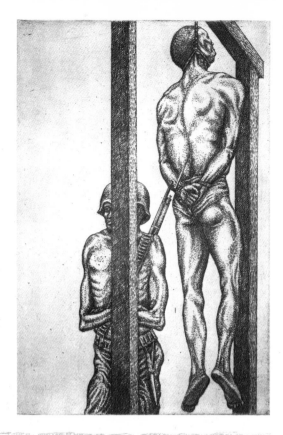

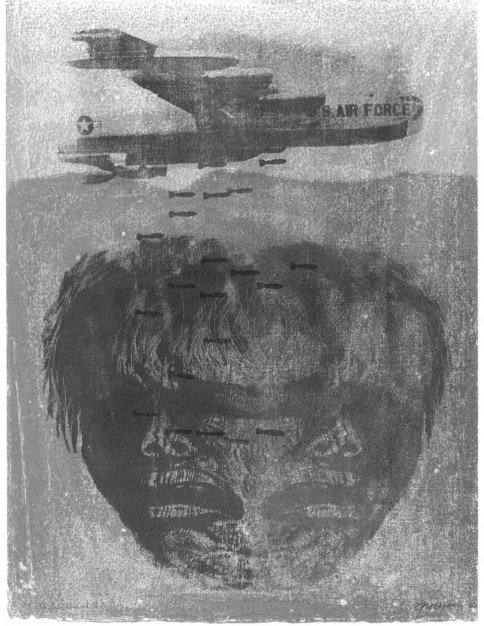

VISIONS OF THE INFERNO

The medical science of treating burns advanced rapidly in World War I, even more in World War II, and spectacularly in Vietnam. Modern war has not done away with personal barbarities by individual soldiers, as Michael Biddle's etching of victims suggests. But increasingly death comes by disintegration, from large shells or automatic weapons, and by firestorm. Antonio Frasconi's suggestion of the pit is a precise and correct evocation of the experience.

What horrified many people, however, was the widespread use of napalm throughout the war. Napalm is a kind of thickened gasoline. The thickeners now used are polystyrenes—stuff familiar to us in modern paddings and fabrics. When the napalm is scattered out of the bomb, it sticks to things so that the intense fire burrows deep and cannot be easily quenched. This compound was actually developed during World War II by Harvard scientists and the army. Indeed, some of the first great wartime firestorms were produced during that war when there seemed to be a military consensus that fire was faster in many cases—in the bombing of Dresden, for instance, or Tokyo. But in Vietnam napalm was used everywhere and the news pictures of what it does to people were shown everywhere.

In fact, Rudolf Baranik's famous "Napalm Elegy" pictures derived directly from news photographs. Baranik began with wire service pictures of napalm victims and transfigured them into intense and universal symbols of the war-burned that are among the most compelling figures produced in present-day antiwar art. The obvious depiction of a burning head with burning bones showing through it summons up deep images in the language and in culture of a fire within, enlightenment, hell-fire, and many other types of light, as well as pain.

But Leon Golub may be the perfect master of napalm in art. His preference for painting nude figures was almost an absolute, but he had been working on the problem of representing clothing in the late sixties when napalm and his urge to make a political statement gave him the idea of wrapping up a nude in napalm. Golub's napalm men remain one of the most impressive and unforgettable antiwar artworks to come out of the Vietnam era. The classical attitude of the figures in the painting who are being decomposed by the fire might have made the work mere propaganda in the hands of some artists. What makes this painting so impressive as a statement against war is that it rises far above mere statement.

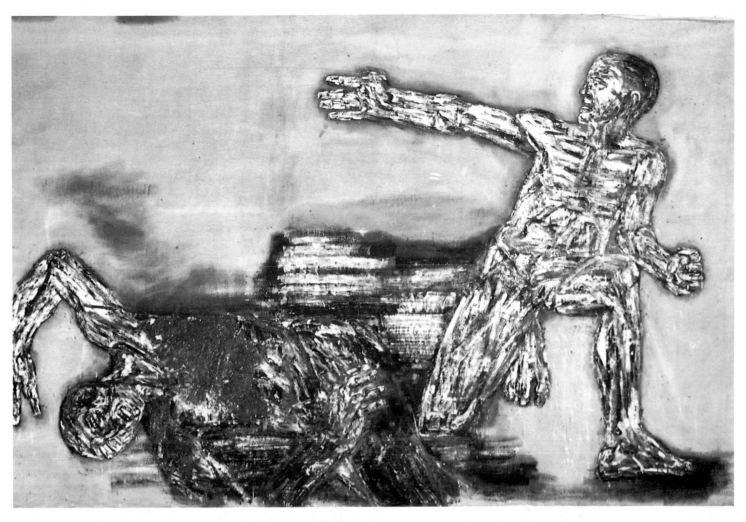

SILENT NIGHT

Robert A. Parker's illustrations of Randall Jarrell's poem, which was written in 1944 as a reflection of his wartime experience in the Army Air Corps, were made for an edition of the poem 28 years later. The poem needs no explanation:

> From my mother's sleep I fell
> into the State,
> And I hunched in its belly till
> my wet fur froze.
> Six miles from Earth,
> Loosed from its dream of Life,
> I woke to black flak and
> the nightmare fighters.
> When I died they washed me out
> of the turret with a hose.

James McMullan, an artist who had made animated film strips for advertisements, was asked in 1978 to contribute to a PBS Christmas program for television called "Simple Gifts." His text was a letter written home by a British captain after Christmas, 1914, describing a truce along his line of trenches in France that began on Christmas morning when the German soldiers stopped fighting and a delegation under a white flag approached the British

trenches to propose they stop the war for a bit and celebrate. The men on both sides came out of the trenches and started singing, each side their own songs, for the entertainment of the others, and the truce lasted two days. "It was absolutely astounding," the English captain told his mother, and Mr. McMullan has said he was greatly moved by the account.

To many, one of the more moving aspects of the event and of the television pictures is that neither the captain nor the artist betrays any knowledge that for 14 or 15 centuries truces unsanctioned by the military commanders were customary in wars in the West at Christmas and Easter. It is an odd case of reverence outliving the memory of the divinity, and it stands in contrast to the new divinity, the state, Mr. Jarrell identified in his poem.

RIGHT
From The Death of the Ball Turret Gunner, *an illustrated poem by Randall Jarrell. Robert Andrew Parker. 1972. Watercolor. (Collection of the artist).*

BELOW
Cell from the animated film Simple Gifts. *James McMullan. 1978. Watercolor. (Collection of the artist).*

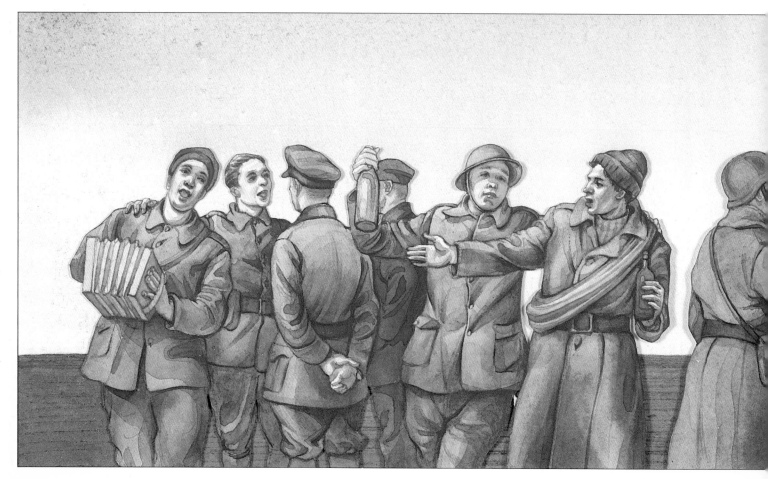

The Death of The Ball Turret Gunner

From my mother's sleep I fell into the state.
And I hunched in its belly till my wet fur froze.
Six miles from earth, loosed from its dream of life,
I woke to black flak and the nightmare fighters.
When I died they washed me out of the turret with a hose.

Randall Jarrell

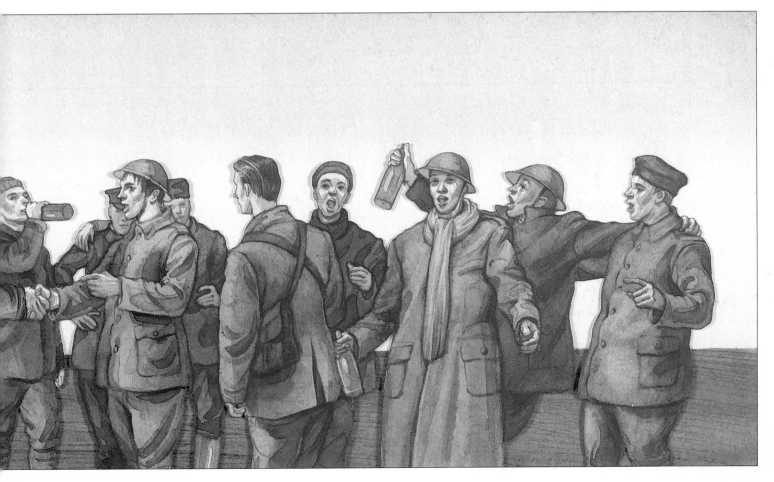

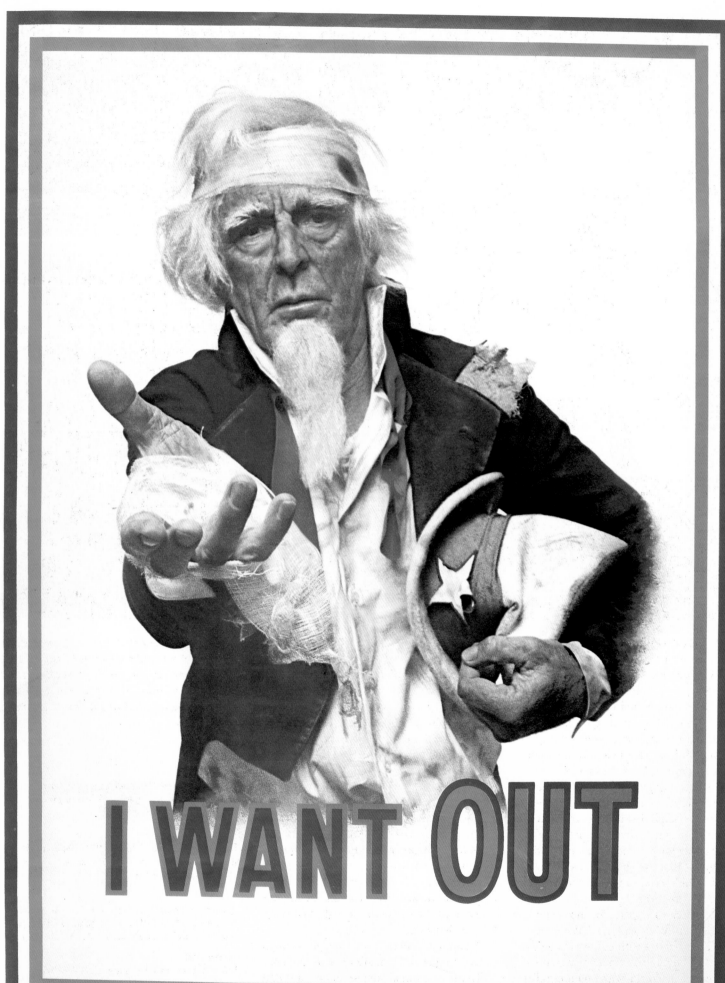

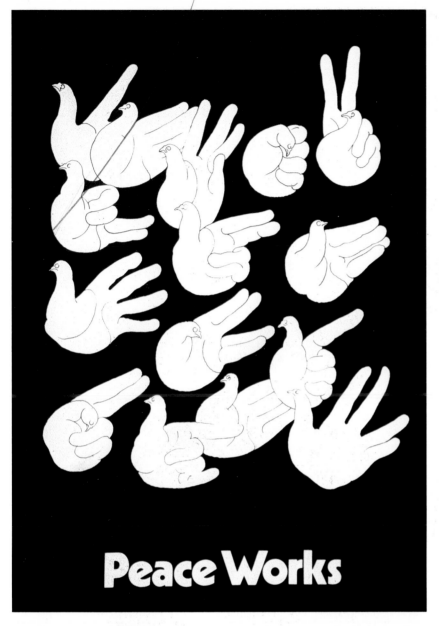

Peace Works

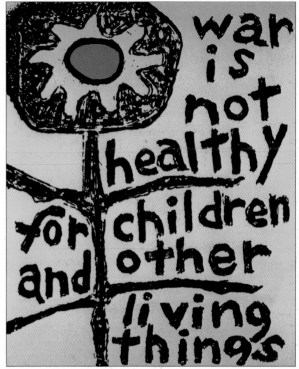

war is not healthy for children and other living things

AGAINST ONE WAR, OR ALL

A great deal of popular art against the war in Vietnam has simply disappeared with the war, for all kinds of reasons. Much of it was so closely tied to its subject that its voice was lost when the guns fell silent. Much of it was more passionate than thoughtful or made to a purpose other than illumination of the viewer.

But among pieces that appealed in different ways to the broadest possible public there are some that have an internal authority or that derive from ideas and images so long in the common artistic vocabulary that they have survived Vietnam and would speak to people who never heard of that war.

Steve Horn's poster for the Committee to End the War is a type that one normally associates with editorial page cartoons. The familiar Uncle Sam that had appeared in World War I pointing directly at the onlooker and announcing "I Want You"—an image that had been repro-

duced many times during World War II and reinterpreted by some very famous artists—is here wounded and bandaged in a way that reminds one of the famous wounded Revolutionary War patriots in the picture of the rifleman, piper, and drummer. And this Uncle Sam is simply fed up.

Anyone with eyes in his head has seen many times the poster Lorraine Schneider did for Another Mother for Peace, the California group protesting the war, in which the words would be a powerful sermon even without the art. And Milton Glaser's complex symbolism, in his 1971 poster, works in the opposite way; it has a kind of lyrical compulsion that makes one see what it means even though it cannot be articulated.

Among modern posters one of the more haunting is U. G. Sato's dove in the fence. There is a kind of simple candor in it that is not always apparent in posters opposing one war or another, and indeed the mes-

sage is very different. What restrains the dove is not war but a chain link fence, and the fence also forms the dove. It is a kind of visual haiku that springs not from a different language, but a different frame of mind.

OPPOSITE
I Want Out. *Steve Horn, photographer; Larry Dunst, art director. Photograph. Poster for the Committee to End the War.*

TOP LEFT
Peace Works. *Milton Glaser. 1971. Pen and ink wash. Poster protesting the Vietnam war. (Collection of the artist).*

TOP RIGHT
. . . never ceasing effort to remove its barrier shall we make . . . for PEACE. *U. G. Sato. 1978. Poster. (Courtesy of Graphis Press, Zurich, Switzerland).*

CENTER RIGHT
War is not healthy for children and other living things. *Lorraine Schneider. 1969. Poster for the California organization Another Mother for Peace.* (scpc).

121

SILENT GUNS

Brad Holland's 1983 acrylic painting, *Vietnam Memorial*, was done in response to the building of the Vietnam war memorial in Washington—those long dark walls bearing 58,000 names of the dead. Holland's memorial emerges also from stone, but as a troubling image. The soldier's approximation of the lotus position gives one message and the impenetrable expression of the face quite another, for one is not certain he is not about to spring to life.

Gunter Grass has long been preoccupied with the question of what peace is and why there is war, and whether war is not one of those activities that suggests man is fated not to be redeemed.

Three abstract prints dated 1979 are somber reflections on the Thirty Years War. His book, *The Meeting at Telgte*, published that year, is a story about two dozen writers who gathered at the end of that war to read passages from their books. A well-known author, Grass has said that he first found the way toward expressing his thoughts about the Thirty Years War in pictures, not in stories. For a novelist of his skill and stature, that is an extraordinary statement. In the etching of *The Writer's Hand*, whether the pen is mightier than the sword is debatable. In a print that he called *The Meeting at Telgte*, the pen is much closer to a weapon. And there is another change. The first hand, of the writer, seems to rise from stones. In the second etching what it rises from may be stones, but some could also be limbs or organs; there are traces of human shapes in them.

In the etching titled *The Peace of Westphalia II*, the opposing hands rise out of a bed of objects that are distinctly *not* like stones, but like torn limbs and fingers. The stones the hands hold in gestures suggesting they are about to throw them are themselves strange; the ghost of a skull lurks in one of them. But the overall irony in the picture is in its title. The first Peace of Westphalia, agreed to by the warring parties in 1648, is taken by historians to mark the official end of the Thirty Years War. Grass's doubts about the "peace" in the Westphalian settlement are evident in the picture, but it raises in turn many other questions.

TOP
The Writer's Hand. *Gunter Grass. 1979. Etching. (Collection of the artist,* LNFA*).*

CENTER
The Peace of Westphalia II. *Gunter Grass. 1979. Etching. (Collection of the artist,* LNFA*).*

BOTTOM
The Meeting at Telgte. *Gunter Grass. 1979. Etching. (Collection of the artist,* LNFA*).*

Vietnam Memorial. *Brad Holland. 1983. Acrylic. (Collection of the artist)*.

WHAT'S HE TO HECUBA?

Does the artist come out as a hero? Hardly. Intellectuals who define words can change images for a time, but not for long. Heroism belongs to people who have struggled, without regard to their own lives, for the survival of others, and their effort has been recognized as that kind of struggle for that kind of end. The artist against war faces that problem first, or he ends up competing with heroes, and if he does, he loses.

There is another problem for the artist. People have always needed heroes. Not the idea of heroes, but real ones who succeeded against the worst odds or who were killed. There is a sound popular suspicion that, if there are no battles, the qualities that make heroes will disappear. But the death of the hero is a profound tragedy to any nation. So, war becomes a mystery of evil that has baffled theologians, philosophers, statesmen, and soldiers alike.

The artist always has a problem that is not different from that of the urchin on the street corner or someone buying detergents in a market: how to define overall human purpose and how to divine the intentions of other people? When the artist takes up thinking about war, he is in the same position as everyone else. Either he is going to think about it himself or he is going to accept the norms. If he thinks about it for himself, he has the usual job of the independent thinker: he has to attack his own assumptions constantly. If he does, what he comes up with will tend to speak to people in much the same way anyone with much experience of life speaks when there is an extraordinary reason to speak. That is the foundation level, and it is important to remember in a time when fear and comfort lead a lot of people to say they are against war when what they mean is that they are for themselves.

In the end, the artist cannot distinguish his motives for himself. In the long run people who are not artists will do that. None of us involved in this book would have agreed with one another about any but a few of the selections in it. In the end, we have tried to give a selection— and it is small—of the work of artists we think have tried to think the problem through either in their art or before they did the art.

TOP
Atomic Brand. Ben Sakoguchi. 1977. Acrylic on canvas. (Collection of Pat and Phil Cornelius).

BOTTOM
Peter Kennard. 1981. Photomontage. Poster for the Campaign for Nuclear Disarmament. (Collection of the artist).

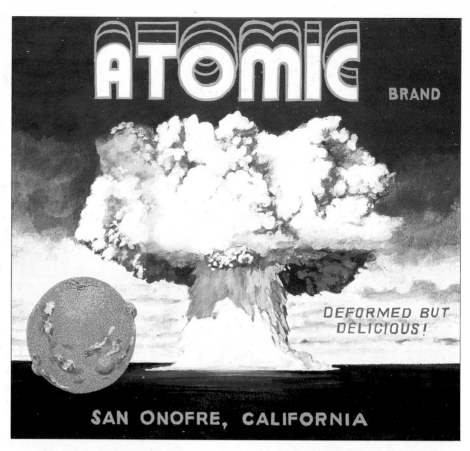

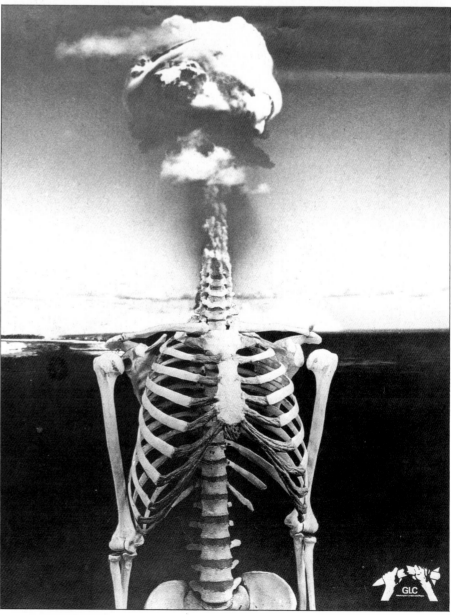

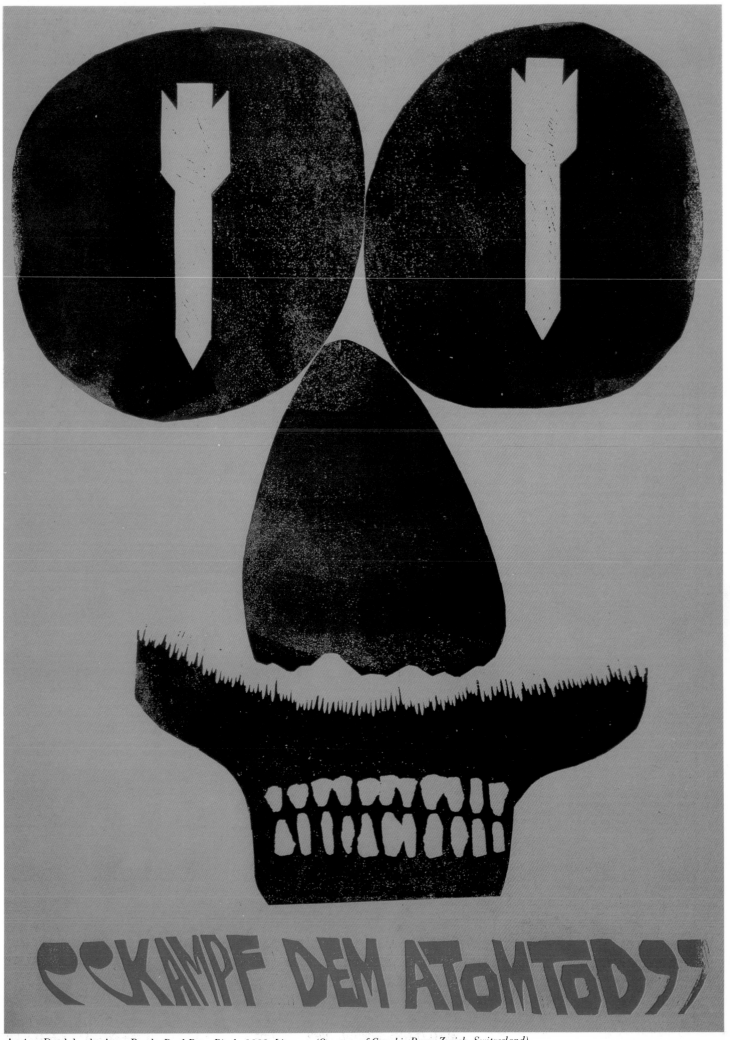

Against Death by the Atom Bomb. *Paul Peter Piech. 1982. Linocut. (Courtesy of Graphis Press, Zurich, Switzerland).*

LIST OF ARTISTS AND THEIR WORKS

BIBLIOGRAPHY

Alfred Kubin: Gedachtnisausstellung 1877–1959: Munich: Bayerische Akademie der Schönen Künste, 1964.

Baynes, Ken, *War: Art and Society One.* Boston: Boston Book and Art, 1970.

Blum, André, *L'Estampe Satirique en France.* Paris: M. Giard & E. Briere, 1913.

Boeck, Wilhelm, and Sabartes, Jaime, *Picasso.* New York: Harry N. Abrams, Inc., 1955.

Booth-Clibborn, Edward, and Baroni, Daniele, *The Language of Graphics.* New York: Harry N. Abrams, Inc., 1980.

Boselkov, Svetlen, *Bulgarian Posters.* Sophia: Bulgarian Artist Publishing House, 1973.

Conring, Franz, *Das Deutsche Militar in der Karikatur.* Stuttgart: Hermann Schmidts Verlag, 1907.

Daumier, Honoré, *Daumier on War: 64 Print Reproductions after the Original Lithographs.* New York: Da Capo Press, 1977.

Diederich, Reiner, and Grubling, Richard, *Politische Fotomontage in der Bundesrepublik und Westberlin.* West Berlin and Hamburg: Elefantan Press, 1979.

Dix, Otto, *Das graphische Werk.* Hannover: Fackeltrager-Verlag Schmidt-Kuster GmbH, 1970.

Dix, Otto, *Otto Dix zum 80.* St. Gallen: Erker-Verlag, 1972.

Dyson, Will, *Kultur Cartoons.* London: Stanley Paul & Co., 1915.

Eichenberg, Fritz, *Dance of Death.* New York: Abbeville Press, 1983.

Frasconi, Antonio, *Frasconi Against the Grain.* New York: Macmillan Publishing Co., Inc., 1974.

Fuchs, Eduard, *Der Weltkrieg in der Karikatur.* Munich: Albert Langen, 1916.

Fukuda, Shigeo, *Posters of Shigeo Fukuda.* Tokyo: Mitsumura Tosho Shuppan Co., 1982.

Gallo, Max, *The Poster in History.* New York: American Heritage Publishing Co., Inc., 1974.

Getlein, Frank, and Dorothy, *The Bite of the Print.* New York: Clarkson N. Potter Inc., 1963.

Gianeri, Enrico, *L'Intesa Cordiale.* Milan: Garzanti, 1940.

Goya y Lucientes, Francisco, *The Disasters of War.* New York: Dover Publications, Inc., 1963.

Grand-Carteret, John, *Caricatures et Images de Guerre.* Paris: Librairie Chapelot, 1916.

Grass, Gunter, *Gunter Grass: Werkverzeichnis der Radierungen.* Berlin, 1979.

Hess, Stephen, and Kaplan, Milton, *The Ungentlemanly Art.* New York: Macmillan, 1968.

Hirschfeld, Dr. Magnus, *Sittengeschichte des Weltkrieges.* Leipzig: Verlag fur Sexualwissenschaft Schneider & Co., 1930.

Hohn, Heinrich, *Deutsche Holzschnitte bis zum Ende des 16 Jahrhunderts.* Karl Robert Langewiesche, 1941.

Kauffer, E. McKnight, *The Art of the Poster: Its Origin, Evolution & Purpose.* London: Cecil Palmer, 1924.

Keegan, John, and Darracott, Joseph, *The Nature of War.* New York: Holt, Rinehart and Winston, 1981.

Klima, Dr. Anton, *Tier und Pflanze in der Karikatur.* Hannover: M. & H. Schaper, 1930.

Kunzle, David, *American Posters of Protest 1966–70.* New York: New School Art Center, 1971.

Lambert, Susan, *The Franco-Prussian War and the Commune in Caricature 1870–71.* London: Victoria and Albert Museum, 1971.

Margadant, Bruno, *Plakate der schweizerischen Arbeiterbewegung von 1919 bis 1973.* Zurich: Verlagsgenossenschaft, 1973.

Masereel, Frans, *Krieg und Gewalt.* Hanau: Verlag Karl Schustek, 1968.

Mayor, A. Hyatt, *Prints & People: A Social History of Printed Pictures.* New York: The Metropolitan Museum of Art, 1971.

Militant Graphic Art in Rumania. Bucharest: Meridiane Publishing House, 1963.

Mroszczak, Jozef, *Polnische Plakatkunst.* Wien and Dusseldorf: Econ-Verlag GmbH, 1962.

Mroszczak, Jozef, *Plakat Poster.* Warsaw: Krajowa Agencja Wydawnicza, 1977.

Murrell, William, *A History of American Graphic Humor.* New York: Macmillan, 1938.

Nagel, Otto, *Käthe Kollwitz.* Greenwich, Connecticut: New York Graphic Society Ltd., 1971.

Nelan, Charles, *Cartoons of our War with Spain.* New York: Frederick A. Stokes & Co., 1898.

Newton, Eric, *War Through Artists' Eyes.* London: John Murray, 1945.

Osborn, Robert, *War is No Damn Good!* New York, 1946.

Plakate gegen den Krieg. Weinheim and Basel: Beltz Verlag, 1983.

Philippe, Robert, *Political Graphics: Art as a Weapon.* New York: Abbeville Press, 1982.

Rickards, Maurice, *The Rise and Fall of the Poster.* New York: McGraw-Hill Book Co.

Shikes, Ralph E., *The Indignant Eye.* Boston: Beacon Press, 1969.

Steadman, Ralph, *America.* New York: Random House, 1977.

Ungerer, Tomi, *The Underground Sketchbook of Tomi Ungerer.* New York: Dover Publications, 1964.

Abbreviations of collections credited in the captions.

ADK Akademie der Kunst, West Berlin
AFG Allan Frumkin Gallery, New York
BG Berlinische Galerie, Basel
CG Castelli Graphics, New York
FDU Library, Florham-Madison Campus, Fairleigh-Dickinson University
FM Fogg Art Museum, Harvard University
GSE Galerie St. Etienne, New York
HIA Poster Collection, Peace, Disarmament Box, Hoover Institution Archives, Stamford University
HK Hamburger Kunsthalle, Hamburg
HSA Hispanic Society of America, New York
IWM Imperial War Museum, London
KD Kunstmuseum, Dusseldorf
KG Kennedy Galleries, Inc., New York
KKOK Kupferstichkabinett der Offentliche Kunstammlung, Basel
LNFA Lee Naiman Fine Art, New York
MDGM Musée des Deux Guerres Mondiales-B.D.I.C., Universités de Paris
MDP Museo del Prado, Madrid
MET Metropolitan Museum of Art, New York
MFA Museum of Fine Arts, Boston
MNW Muzeum Narodowe, Warsaw
MOMA The Museum of Modern Art, New York
NGA National Gallery of Art, Washington
NYPL New York Public Library, New York
OKH O. K. Harris Works of Art, New York
SCPC Swarthmore College Peace Collection
WL Institute of Contemporary History and Wiener Library Ltd., London
WMAA Whitney Museum of American Art, New York

D.J.R. Bruckner is an editor of the *New York Times Book Review*. He has been a reporter for the *Chicago Sun-Times*, a columnist for the *Los Angeles Times* and a Vice President of The University of Chicago.

Seymour Chwast has illustrated and designed posters, record covers, magazines, and animated films. He is a director of Pushpin Lubalin Peckolick, a graphics firm in New York. His work has been exhibited in museums and galleries around the world, with his posters in the permanent collections of The Museum of Modern Art and The Smithsonian Institution. He has produced and designed numerous books including, *The Art of New York*, *The Illustrated Cat*, *The Literary Cat*, *The Illustrated Flower*, and *The Connoisseur's Book of Cigars*.

Steven Heller is the art director of the *New York Times Book Review*. He has produced numerous exhibitions on satiric art, and writes regularly on the subject for *Graphis*, *Upper and Lower Case*, and *Print Magazine*. He has produced and edited numerous books including, *The Art of New York*, *Jules Feiffer's America*, *War Heads*, *Man Bites Man: Two Decades of Satiric Art*, and *Artists' Christmas Cards*.